R O O M 5

arcade

Editorial office and subscription information:
The London Consortium
Institute of Contemporary Arts
12 Carlton House Terrace
London SW1Y 5AH

First published in the United Kingdom
in 2001 by Lawrence & Wishart
99a Wallis Road
London E9 5LN

ISBN: 0 85315 950 5

Printed in Great Britain
by Cambridge University Press, Cambridge

Design: christopherpacker.com

Cover image: Lorens Holm

ROOM 5

arcade

edited by
Nina Pearlman

THE LONDON CONSORTIUM

editor
Nina Pearlman

associate editor
Francis Gooding

editorial board
Kathy Battista
Emma Hathaway
Lorens Holm
Mark Morris
Nick Telford
John Tercier

graphic design
Chris Packer

Do critical descriptions of female urinals and edible architecture relate to the notion of hypothermia as a primary fantasy of death? What do scatological elements in the work of Schwitters have in common with Fragonard's gravitational fantasy and the architecture of the museum? Many different answers are possible here, but is not the fundamental question whether the questions need to be asked at all? This volume is to be read and enjoyed for the pleasures and virtues of its heterogeneity.

Essays on the impossibility of writing, Walter Benjamin's image of the gambler and notes on Jazz as a form of protest come together with a graphic investigation of perspective as a suspect mechanism of representation and an architectural design project for a provincial museum of art. Richard Rorty discusses his views on anti-foundationalism and Dan Graham takes a stand on the architectural branding of the museum. The different themes in these articles cover the broad horizon of our

lived experience; our relationship towards the multiple forms of representation that come under the heading of 'culture'. In keeping with this diversity, each contribution puts forward a distinct method of writing and analysis. 'Arcade' is a collection of essays, discussions, architectural design and graphic projects, that come together as disparate things and people do in an arcade, in their communal attempt to escape the rain.

This second issue of *Room 5* – The London Consortium Journal, draws together work that reflects the commitment of the London Consortium to multi-disciplinary research. Since its inception in 1995, The Consortium has recognised both the ongoing need to analyse modern culture in its social context and to bring to this analysis the knowledges of the human sciences, as well as the need to combine this analysis with cultural policy and cultural production.

'Arcade' follows on from the first issue of Room 5 – 'Whiteness'.

You can take the first book you lay your hands on and with your ey
closed point to any line and say: A book could be written about th
When you open your eyes you will seldom find you are deceiv

— Georg Christoph Lichtenbe

Bruce McLean, *King For a D*
One-day 'retrospective' at the Tate Gallery, 11 March, 19
Each catalogue contained a list of 1,000 projected wor

ONLY BOOKS
I'LL NEVER READ
AREN'T TEDIOUS

Francis Gooding

Walter Benjamin's *Arcades Project*[2] offers those who open it an utterly dizzying array of elements: empirical observations, quotations (with or without commentary), reflections, short analyses, intuitive connections between disparate things, literary criticism, political and social theory, aphorisms, the occasional passage of hallucinatory surrealism, and so on. A manic work of compilation, it is ordered by a somewhat obscure system of lettered folios, or *convolutes*, each with a different ostensible subject. Gathered under the various headings – Fashion, The Collector, Modes of Lighting, Iron Construction, Baudelaire, etc. – are Benjamin's vertiginous accumulations of assorted evidences, a natural history of nineteenth-century Paris, its fauna and flora classified by affinity and according to his own vast capricious scheme.

1 | Georg Christoph Lichtenberg, *The Waste Books* Notebook D, note 21, trans. R. J. Hollingdale, New York: NYRB, 2000.

2 | Walter Benjamin, *The Arcades Projects,* trans. H. Eiland and K. McLaughlin, London: Belknap/ Harvard, 1999. Convolute L begins on p. 405.

As the reader proceeds with Benjamin through the undergrowth of history, it starts to become clear that many of the entries are simply signposts: here he has found a document whose implications would be worth investigating, there an idea has struck him, but there is no time to really pursue such things; a brief note will suffice to indicate the possibility of a later investigation, before moving on to the next entry. Opened at random, the first few pages of Convolute L (Dream House, Museum, Spa) yield the following: [L1, 1] observations about 'the dream house' and its relation to the panorama, the casino, the archaeological dig; the significance of the fountain in a covered space; the idea of Pompeii and Herculaneum related to the Revolution; the significance of the recovery of the baroque; a mental note – 'Antiquity'; [L1, 2] A quotation from an eighteenth-century work by Meyer concerning the desire of the French to appear to themselves as an antique people; 'Antiquity' again; [L1, 3] A statement: 'Dream houses of the collective: arcades, winter gardens, panoramas, factories, wax museums, casinos, railroad stations'; [L1, 4] A rather surreal description of railway stations: '…Through the mountains of luggage surrounding the figure of the nymph, looms the steep and rocky path, the crypt into which she sinks when the Hermaic conductor with the signal disc, watching for the moist eye of Orpheus, gives the sign for departure. Scar of departure, which zigzags, like a crack on a Greek vase, across the bodies of the gods'; [L1, 5] Short observation on the bourgeois domestic interior of the nineteenth century; the house façade as a new mode of the interior.

This plenitude is consistent with the material structure of the work – over nine-hundred pages of ideas meshing together, barely elaborated but through their close proximity to more and more notes and intuitions. There could be no final synthesis, no explanation; the manner of the work's construction precludes any such

closure. There is simply too much material – Benjamin has found a way of making a work which mirrors the making of the world. It is a work of excavation, of the uncovering of possibilities; as Benjamin explores the past and displays its traces, entrances to hidden worlds are revealed, doorways he does not enter but simply draws attention to, perhaps for the benefit of a later traveller. Co-ordinates are briefly noted, directing each entry to its proper place in the relevant loose-leaf file. Nothing is followed up; nothing needs to be – an idea is put together with its fellows, and they talk amongst themselves. The work appears as a sort of dictionary of ideas, a huge reservoir of untapped subjects – intuitions which ask to be examined in more detail, manifestos without readers, a catalogue of synopses for potential articles, commentaries which themselves need comment. The *Arcades Project* is a library of lost and unwritten books.

But it would be reckless to take up Benjamin's implicit invitations; his signposts point to false doorways. To open them would be to destroy the worlds on the other side, to snuff out the vitality which animates them. The hint, the unexplained and unelaborated idea, is an idea which is still incomplete and alive. To wrest the potential from Benjamin's intimations would be to still their life with the dead hand of the academic. He himself understood this, as the final proposition of the 'Writers Techniques in Thirteen Theses' demonstrates: 'The work is the death mask of its conception'.[3] The *Arcades Project* lives on, by itself, as definitively unfinished as Duchamp's *Large Glass*; any elaboration of the insights it contains would be pointless, a destructive act of illustration. It is filled with potential writing that will never be written, and this connects it to a related literary form, that of the deferred or reluctant piece.

Why do I write, if I can't write any better?
— **Fernando Pessoa**[4]

3 I 'The Writers Technique…' is part of the 'One Way Street' writings. *One Way Street and other writings*, trans. E. Jephcott and J. Shorter, London: Verso 1985, p. 65.

4 I Fernando Pessoa, *The Book of Disquiet,* trans. R. Zenith, London: Penguin, 2001, p. 137.

Didier Eribon: If you had to rewrite the book today, how would you begin it?

Claude Lévi-Strauss: First of all, I wouldn't write it.[5]

Marcel Benabou's *Why I Have Not Written Any of My Books*[6] is an exercise in anti-writing. It is a book about writing, or not writing, a book. Its subject matter, if it can be said to have one, is the problem of writing a book; not just any book, but this book itself. This grotesque paradox is handled lightly and wittily: on page twenty-one – after some discussion with the reader about why the book should be read in the first place, if it should be read at all, the difficulty of writing the first line, and some discussion about a possible title – we arrive at the third chapter, entitled 'The First Page':

> In the beginning, a short sentence. Only a half a dozen words; simple words, the first to come along, or almost the first. Assigned above all to mean that here ends a sentence. But immediately after, without so much as a paragraph break, there would commence a long sentence in the conditional, one of those old-fashioned periods in which everything would be combined and balanced with care...
> ... What followed would, of course, maintain this brilliant level. Each sentence would strike the reader. By virtue of its precision. By virtue of its force. And in their rapid succession, together they would form a dazzlingly logical chain.

The book continues without progress. 'What sort of book is it?', the author asks. Perhaps it is a novel, and there follow some possible scenarios, and conversations with imaginary readers – 'Readers, I can see your reactions from here... None of these scenarios appeals to you'. Further on, Benabou settles down to a more relaxed series of considerations. Why has he never managed to

5 | Claude Lévi-Strauss and Didier Eribon, *Conversations with Claude Lévi-Strauss*, trans. P. Wissing, Chicago: University of Chicago Press, 1991, p. 10. Eribon is referring to th[e] book *Elementary Structures of Kinship*.

6 | Marcel Benabou, *W[hy] I Have Not Written Any of My Books*, trans. D. Kornacker, London: Bison 1998.

write? He has always wanted to, but he has never managed to get anything done – why not? Will he ever manage to write his first book? How to proceed now, at the halfway point of this non-book? Is the reader bored or irritated? Such questioning is accompanied by skilfully deployed erudition and autobiographical details – his love of plain white paper and stationary, his life of reading and literature. These games – the book itself is a game – are one thing, but the work is far from frivolous; on the contrary, it is suffused by a crippling anxiety. For why should one want add another book to the vast mountains of books, the endless cities of libraries? Why write at all? There are quite enough books in the world. Benabou has chosen to address this fact directly: he writes about what it is not to write, to abstain from writing. He writes his own book out of the running; he is too nervous to write it. Better to describe the process of writing with all its attendant difficulties; to imagine the book which he never wrote and then describe what was in it and how it was written. This eliminates both the problem of writing it, and the subsequent bother of having to read it. To really sit down and write it – why, that would be a pointless game. Having made this point, the need to write the book at all is obviated.

Do not make a book out of material actually suited to a piece in a magazine, nor out of two words a sentence. What an idiot says in a book would be endurable if he could express it in three words.

— **Georg Christoph Lichtenberg**[7]

What tiresome and laborious folly it is to write lengthy tomes, to expound in five hundred pages on an idea that one could easily propound orally in a few minutes. Better is pretending that the books exist already and offering a summary or commentary.

— **Jorge Luis Borges**[8]

7 l *The Waste Books*, Notebook E, note 28.

8 l I do not know where this quotation comes from; it is quoted by Benabou on p. 20 of *Why I...*, but I have never been able to find the original source. Borges being Borges, it may not even exist.

13

This last comment goes some way towards illuminating Borges' endless obsession with arcane and esoteric sources, his evident love of heretical tracts, unworkably elaborate and ridiculous metaphysical systems, magic and paradoxes. His enthusiasm for such materials, apparent in all aspects of his literary output, seems to stem in part from the wealth of possible fictions which can be gleaned from them – they are a ready made source of improbable tales, replete with unlikely characters, secret knowledges, and mysteries. Most esoterica seems as though it could have been made up by Borges; any hidden text or forgotten sect which by some chance does not exist could easily be invented by him if necessary. However, to actually write a cod treatise or detail a bogus metaphysic would be to descend into dull-minded pedantry. Instead, as he notes, it would serve the purpose just as well to find or invent a book and its contents, or a man who finds a book, or a story inside the book which has been found, and so on. Such infinite regress has its effect on Borges' production. His stories are often concentrated to little more than a short explanation of the idea which informs them, becoming footnotes to their titles, shorthand notes conveying an idea which needs no further development – as of a one-sided disc for example, or of a man who cannot forget anything, or of an infinite library, or of the author's *doppelgänger*, or of a book without end or beginning.[9]

A whole novel by Borges would be unthinkable and probably unreadable. The contracted brevity of his tales reflects a reluctance to ruin his sparkling ideas by pointlessly elaborating them in words, as in the redundant explanation of a joke.

And the non-reading of books, you will object, should be characteristic of collectors? This is news to me, you may say. It is not news at all. Experts will

9) The stories referred to here are 'The disk', 'Funes the memorious', 'The Library of Babel', 'The other' and 'The Book of Sand'. 'Funes...' and 'The Library...' can be found in the collection *Labyrinths,* trans. N. T. di Giovanni, London Penguin, 1974; the others are in *The Book of Sand,* trans. N. T. di Giovanni, London Penguin, 1979.

bear me out when I say that it is the oldest thing in the world. Suffice it to quote the answer which Anatole France gave to a philistine who admired his library and then finished with the standard question, 'And you have read all these books, Monsieur France?' 'Not one-tenth of them. I don't suppose you eat off of your Sèvres china every day?'

Incidentally, I have put the right to such an attitude to the test. For years, for at least the first third of its existence, my library consisted of no more than two or three shelves which increased only by inches each year. This was its militant age, when no book was allowed to enter it without the certification that I had not read it. Thus, I might never have acquired a library extensive enough to be worthy of the name...

— **Walter Benjamin**[10]

Alongside those books which remain unwritten, we should consider the complementary phenomenon of existing books which will never be read. Some of these are books which are very well known to all, remain in print and sell well, have an established place in the literary canon and large bodies of scholarship in orbit about them, but which nevertheless remain largely without readers. The work of Proust falls into this category – many more people have started than have finished *A la récherche du temps perdu*, its excessive length, the slowness of the narrative, and the stifling detail no doubt being factors towards their failure. Marcel Duchamp remarked that Proust was amongst the things 'which I never will read... one doesn't feel obliged to read him'.[11] To be aware of Proust is to be aware of his significance; reading him is another matter. Perhaps, though, the definitive representative of the class of unread classics is Joyce's *Finnigans Wake*. Borges notes

10] Walter Benjamin, 'Unpacking My Library' in *Selected Writings*, Vol. 2, trans. R. Livingstone et al, London: Belknap/ Harvard, 1999, p. 488.

11] In conversation with Pierre Cabanne, *Dialogues with Marcel Duchamp*, trans. R. Padgett, London: Thames & Hudson, 1971, p. 105.

951	Transmission of visual sensitivity piece.
952	Art is only a memory anyway piece.
953	The Institute of Contemporary Aromas present "Spring" piece.
954	The instantaneous impression piece.
955	Money grows on trees piece.
956	Index Card piece.
957	The Retrospective "piece" "The Piece" work.
958	The picture window piece, 12 photos.
959	The suburban growables, 1 conifer piece/work.
960	12 suburban objects piece (photos).
961	The window box work piece.
962	Installations work things etc., suburban domestic thing piece.
963	McLean in Argyll Street, work possibility? work.
964	Suburban earth? art work piece.
965	Mrs. Rae coming out of Mrs. Dewar's house piece.
966	Mrs. Rae going into Mrs. Dewar's house piece.
967	The Big storm door syndrome piece (suburban).
968	The next piece really is going to my greatest piece/work.!
969	Another breakthrough piece.
970	Dazzle piece/work.
971	A sculpture of the undergrowth, work.
972	I predict piece.
973	Well it's not really a painting piece.
974	Sculpture of the seasons piece I spring piece.
975	The Institute of Universal International Ideas, presents: - "Spring" piece.
976	Hallo, hallo, hallo, hallo piece.
977	Little blue nude revived piece.
978	Henry Moore revisited for the 10th time piece.
979	There's no business like the Art business piece (sung).
980	Painting those blue skies blue piece.
981	Mr. Sculpture lend me your art piece.
982	Large lavatory glass door works a selection.
983	Conte works, "A bonny drawin' piece" work.
984	This is it piece; no? piece.
985	Place and process piece.
986	Love made a sculptor out of me piece.
987	I'm just a love sick sculptor piece.
988	A quick song and dance piece "Scottish version".
989	Another masterpiece piece 3rd piece.
990	Live in your head piece/work.
991	Rosi starts a rumour piece, thing.
992	10 steps to heaven and the new art piece.
993	Somewhere over the rainbow that's where it might be piece.
994	Domestic light pieces "shades" etc. work.
995	Project for suburban pub, lights, piece.
996	Sculpture for the pocket (tactile).
997	£1,000,000 sculpture piece.
998	998th piece a look at the last 998 pieces, piece/work.
999	Bruce McLean "Superstar" piece 999 1st version.
1,000	Goodbye sculpture, art pieces - things/works/stuff/everything, piece (incorporating the Fastest 1,000 pieces in the World, Show, "Song and dance art". Love pieces, etc. etc. etc. piece/work/ thing/stuff.

Bruce McLean, *King For a Day*
Final page of one of the catalogues.

that even *Ulysses* is 'indecipherably chaotic to the unprepared reader'; for him, readers of *Finnigan's Wake* are 'no less inconceivable than C.H. Hinton's fourth dimension or the trinity of Nicaea'.[12] Discussing the book, he mentions the 'terror-stricken praise' of other reviewers: 'I suspect they share my essential bewilderment and my useless and partial glances at the text.'[13] Yet such works are rightly considered classics, for that they exist is enough. The novel would be an impoverished genre without them; it does not follow that readers are necessary or even possible.

Other books will not be read for quite different reasons. There are of course books which are merely obscure or unobtainable; but there are also those books which are beyond reading, books which exist in the regions to which readers seldom journey, for there is little or no purpose to the expedition.

The Ambonese
Curiosity Cabinet
Containing a Description of all sorts
both soft as well as hard
Shellfish
to wit rare
Crabs, Crayfish,
and suchlike Sea creatures
as well as all sorts of
Cockles and Shells
Which one will find in the Ambonese sea:
Together with some
Minerals, Stones,
and kinds of Soil, that are found on the
Ambonese and on some of the adjacent Islands.

12) Jorge Luis Borges, 'A fragment on Joyce', in *Collected Non-Fictions*, trans. E. Allenn, S. J. Levine, E. Weinberger, London: Penguin, 1999. p. 221. Borges here again demonstrates his love for the obscure and obsolete.

13 Jorge Luis Borges, 'Joyce's latest novel', in *Collected Non-Fictions*, p. 221.

The seventeenth-century German scholar Georg Everhard Rumphius[14] is the author of a number of natural history works which concern the flora and fauna of the island of Ambon in the Malaysian archipelago.

Born in Hesse in 1627 to a professional family with noble connections, Rumphius was trained in Wölfersheim before moving to the town of Hanau, where his father was architect and *Baumeister*, superintendent of public works. Not wishing to follow his father into architecture, the young Rumphius left Hanau in 1645, determined to travel. Attempting to join the armies of Venice which were engaged in fighting the forces of the Ottoman Empire, it appears that Rumphius was conscripted onto an unsuccessful voyage to Brazil to relieve Dutch colonials. The vessel he and his fellow conscripts were on made it no further than Portugal, where he remained for three years; after a short period at home in Hesse, and some time spent working in Hanau and Idstein as an engineer, Rumphius gained a position with the Dutch East Indies Company. After working in the colonial capital Batavia (now Jakarta) and in the Moluccas – the Spice Islands – Rumphius acquired a post as a merchant on the small island of Ambon, where he was to spend the rest of his life. It was here that he began to take a serious and systematic interest in the local flora and fauna. In 1681 he was elected to the Academia Naturae Curiosorum, a German scientific association of some standing, where he was awarded the cognomen 'Plinius', a title which led to him be known as 'Plinius Indicus', the Indian Pliny. It remained the only recognition he received during his lifetime.

14) The following information, and all following quotations are from Georg Everhard Rumphius, *The Ambonese Curiosity Cabinet,* trans. and introduction E. M. Beekman, London: Yale University Press, 1999

At the age of forty two he went blind. He had already begun his largest work, the *Ambonese Herbal*; both this, and his *Ambonese Curiosity Cabinet* were completed after he lost his sight. The huge *Ambonese Herbal* was his magnum opus; its seven volumes contain 876 chapters, and are devoted to the plants of the island, as well as corals, 'which do not wax upon the land but in the Sea, and which have a mixed nature of wood and stone, and which are called Sea-trees, or *Coral-plants'*. After he lost his eyesight, work on the *Herbal* had to begin again in Dutch, as there was no-one on Ambon to whom he could dictate the Latin of his original. The first set of illustrations, along with his entire library and his zoological and botanical collections, were destroyed in a fire in 1687. It was eventually completed in 1690, with the seventh volume being added in 1701. Work on the *Curiosity Cabinet* had started whilst he was writing the *Herbal*. It was completed in 1698, four years before his death in 1702. None of his work was published while he lived; indeed, the Dutch East Indies Company actually suppressed the *Herbal* – in 1700 it considered the work 'inexpedient', judging that publication 'cannot be permitted in any way' as it might prejudice the Company's monopoly on the trade in spices and botanicals.

The *Ambonese Curiosity Cabinet* bears out the likening of Rumphius to Pliny the Elder, whose *Natural History* it was consciously modelled on. It is divided into three sections – the first and second parts deal with Soft Shellfish and Hard Shellfish respectively; the third is concerned with Minerals, Stones and Other Rare Things. There are 60 etched illustrations. The first two parts are

devoted to the careful description of different sea
creatures, with detailed accounts of their physiology,
habits and usefulness to man, their place in the local
economy and folklore, local terminology, recipes and
anything else worthy of note. In these sections we find
close descriptions of shrimp, Horseshoe crab, land crabs,
starfish and soft corals, sea-apples and sea lice, conches,
sea-snails, volutes, clams and mussels, as well as other
more exotic creatures and phenomena which are harder
to identify – the 'Bloody or Fiery Sea-Red Sheets', often
caused by swarms of red shrimp, but on other occasions
appearing as a mysterious 'white and fiery' effect in the
sea which caused 'beautiful blue spots, which could not
be washed out' to appear on white linen; the 'Wawo'
worms of the sea, which cluster in great quantities 'like
silken Floss' around a larger worm 'considered to be the
Mother' and which are thought locally to be the
excrement of rocks; the 'Tethyis', 'fleshy outcroppings…
some are like a piece of meat… some are like nipples or
fingers, wherefrom they got their Greek name', which
burn the hand when touched.

However, it is in the third and largest section that we find
the most marvellous and Plinyesque of Rumphius'
entries. Though he describes familiar minerals and
materials such as lapis, agate and ambergris, the final
part of the *Cabinet* is a collection of strange and
mysterious objects, many of which are beyond
interpretation. Just as in the earlier parts, the section has
an ethnographic quality; without comment, and always
attentive to local usages and terms, Rumphius describes
in detail the customs and considerations of the island
people, their medical skills, superstitions, and technical

achievements, always in relation to the various 'stones' which were evidently of great interest to them. Many of the descriptions are of concretions formed in the bodies of living creatures, and the various usages to which such stones can be put. Rumphius gives us instances of stones taken from the brains of tigers; a stone recovered from the head of an eagle; stones found inside giant millipedes which shine at night and cure the stings of venomous creatures; various 'Snakestones'; the particularly rare and much counterfeited monkey stones, cultivated in the following way:

> The mountain people set out at a certain time and shoot these Monkeys with blunt arrows or with the darts, which they blow from a pipe, and which wound the animal but do not kill it; now this Monkey has the habit that, when it gets a hole in its body, it will enlarge it by scratching the same, whereafter it goes looking for Medicinal herbs, which it chews in its mouth, and then uses to stopper the holes, and the skin grows over them and from this in time come these stones, to wit from the animals blood; after several years have passed they go back to the same place in the mountains, where they wounded the Monkey before, kill it with sharp arrows, and feel all over its body, until they find a lump, cut it open and discover the *Bezoar* within…

We are also shown crabs which have turned to an 'easily pulverised' stone, and given a long list of ailments which can be treated with this powder; various stones which can be found on different parts of the island (examples of the Preacher's Stone can be found in the river behind the

colonial castle; a *Boatana* stone which 'oozes a white milk from both ends' was found by a slave 'in a brown, fat, clay-like soil beneath the root of the tree Ubat Tuni...'); and a entry devoted to 'Stones Which Happen to Have an Unusual Shape'.

Rumphius' work is of great significance for a small number of specialists, mostly historians of various kinds: of zoological and botanical science, of the Dutch East Indies Company, of Malaysia, of Ambon itself. To most people, it can offer only the 'lazy pleasure' of 'useless and out-of-the-way erudition'.[15] Ambon is a very small island, one of over thirteen thousand which fell within the jurisdiction of the Company; a seventeenth-century compendium of the indigenous marine arthropods and molluscs, and the different types of stones one can obtain there is a work for which there is limited practical use in the contemporary world. That Rumphius' concern is Ambon in particular serves to underline the profound arbitrariness of the selections. Like the volumes of Pliny's *Natural History*, it is a marvellous work to open at random; but to read it thoroughly from cover to cover would serve no end. The substitution of the detailed entries in the *Curiosity Cabinet* for an entirely different collection of observations would make no difference to the disinterested reader. This fact in no way diminishes the importance of such works; the magnificently useless *Curiosity Cabinet* and *Herbal* remain amongst the greatest scientific achievements of any age.

> A man of true wisdom... can enjoy the entire spectacle of the world from a chair, without knowing how to read and without talking to anyone.
>
> Only landscapes that don't exist and books I'll never read aren't tedious.
>
> — **Fernando Pessoa**[16]

15 ⟩ Jorge Luis Borges, *The Book of Imaginary Beings*, trans. N. T. di Giovanni, Londo Penguin, 1974 , p. 11.

16 ⟩ Pessoa, both quote from *The Book of Disquiet*.

Look on – make no sound

— Heyst the elder

Perhaps, though, the most perfectly unrealized of all written works is the philosophical treatise by Heyst the elder, entitled *Storm and Dust*. Heyst wrote of everything in many books – of space and time, of animals and of stars; analysing ideas and actions, the laughter and the frowns of men. The grim pessimism of his philosophical views eventually developed into a guarded asceticism. Described as a 'destroyer of systems', a 'bitter contemner of life', Heyst spent his years 'blowing blasts on a terrible trumpet which filled heaven and earth with ruins'. Of his works, only an enigmatic fragment is known, a misanthropic passage railing against the hopelessness of the human condition, the impossibility of an escape from the vagueries and cruelties of life: '... Men love their captivity. To the unknown force of negation they prefer the miserably tumbled bed of servitude. Man alone can give one the disgust of pity; yet I find it easier to believe in the misfortune of mankind than in its wickedness.' These notes, from the last page of *Storm and Dust*, are of special interest. Not only does the weariness of the sentiment suggest the advocacy of inertia and inactivity, these words are the final sentences of a book which shares both the quality of never having been read with that of never having been written. To these virtues is added the further distinction that the author never existed.

Heyst the elder is known to us from Conrad's *Victory*.

But the Egyptians themselves in their manners and customs seem to have reversed the ordinary practices of mankind. For instance, women attend market and are employed in trade, while men stay at home and do the weaving... Women pass water standing up, men sitting down. To ease themselves they go indoors, but eat outside in the streets, on the theory that what is unseemly but necessary should be done in private, and what is not unseemly should be done openly.

— Herodotus
'Odd Practices of the Egyptians'
The Histories, Book II

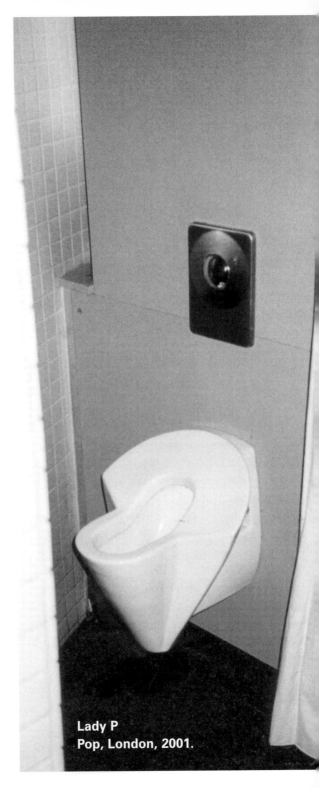

Lady P
Pop, London, 2001.

FEMALE URINALS: TAKING A STAND

Barbara Penner

Recently a flurry of public excitement broke out when Pop, a trendy Soho bar in London, installed a female urinal in its ladies' washroom. Known as the Lady P, the urinal was designed in 1999 for a Dutch bathroom supply company.[1] Though the owner of Pop claimed he'd installed the urinal 'just for fun', the media immediately seized upon the potential of the Lady P to end one of the most common female complaints – the endless line-up for the 'ladies'.[2]

Reporters eagerly interviewed Pop's patrons for their reactions: what were the chances of the Lady P radically transforming the female washroom? Perhaps predictably, users were sceptical. A typical response was given by Justine, 22:

> If you think I am going to squat there with my worst grey knickers around my ankles and my fanny to the world, you've got to be joking. I don't care how long the queue is. I'll wait.[3]

1) The Lady P, designed by Marianne Loth, has been in production by Royal Sphinx Gustavsberg since 1999.

2) John Arlidge, 'Women make a stand in fight to end loo queue', *The Observer*, 5 December, 1999: *Guardian Unlimited*, online, 4 December, 2000.

3) Arlidge, December 5, 1999.

While Justine's comments were misleading – the Lady P actually shields fannies with a well-placed curtain – the media's take was more revealing. Writers uniformly adopted a jovial, nudge-nudge, wink-wink tone in their pieces as they talked of the Lady P's 'revolutionary' aims. No journalist discussed it as anything other than an isolated curiousity. And certainly none recognized that the Lady P is just the latest of a string of attempts to completely rethink the female toilet.

This lack of awareness is by no means unusual: female lavatories, while a highly visible feature in everyday life, remain more or less invisible in serious discussions of design. While, thanks to queer theory, some scholarly interest in how public washrooms are used and experienced has been initiated, there is almost no discussion of how they are currently produced or how they might be produced in future.[4]

This myopia is reproduced in legislation like the American 'potty parity' bills.[5] While it is undeniably important that women have adequate provision in public buildings, 'potty parity' simply ensures that more female lavatories are built, without encouraging new (and more spatially compact) design solutions. The ladies' room – complete with toilet, stall, lock and door – is still ubiquitous, having not been seriously reconsidered for well over a hundred years.

My aim in this paper is to highlight three attempts to redesign the female toilet from the 1890s to present. I will argue that each project, in a different way, demonstrates that the true problem with rethinking the female toilet is that it is not simply a functional response to a physical need but a cultural product shaped by discourses about gender, the body, privacy and hygiene.

4) Two queer theorists particular have produce detailed discussions of the link between toilets and sexual identity: Lee Edelman, 'Men's Room' *Stud: Architectures of Masculinity*, ed. Joel Sanders, New York: Princeton Architectural Press, 1996, pp. 152-6 and Judith Halberstam, *Female Masculinity,* Durham: Duke Universi Press, 1998.

5) A wave of potty parit bills were passed in the United States in the 1980s and 1990s, varyi their requirements from state to state (some demand equal provision for women, others demand more). The mov towards potty parity wa reputedly given impetus after a landmark court case in 1990 in Texas when a woman arrestec for entering the gents' during a concert was quickly acquitted, as the jurors sympathized with her desperation. Grace Bradberry, 'Why are we waiting?', *The Times*, Monday September 6, 1999, p. 41.

As such, the planning of ladies' rooms owes less to female physiology than to deep-rooted historically and culturally specific conventions, from prohibitions on bodily display to the binary gender division. Motivating my excavation of these projects is a question: can challenging the assumptions that underlie the design of female lavatories open up the possibility of subverting them?

Urinettes

There is only one known image of a short-lived experiment that took place in London, ca. 1898. These so-called 'urinettes' were installed on a trial basis in an unnamed female public lavatory. Smaller than conventional water closets, with curtains instead of doors, they were automatically flushed like a man's urinal. What was perhaps more progressive than their design, however, was that only a halfpenny was to be charged for their use.

In order to understand why this proposal was so radical, it is important to place it into the context of late-Victorian London.

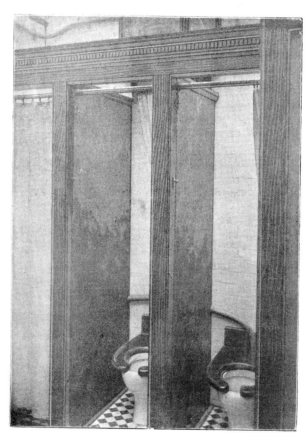

Urinettes, London, circa 1898
— Davis & Dye

Women then seeking public lavatory accommodation had to contend with two major obstacles: first of all, they had to locate facilities; and second, they had to be able to pay for using them. While men were able to use urinals at no cost and paid a penny only for a water closet, women were charged one penny every time – which, as George Bernard Shaw correctly observed, was an 'absolutely prohibitive charge for a poor woman'.[6]

According to Shaw, 'no man ever thought of [this difficulty] until it was pointed out to him'. Shaw blamed this widespread ignorance on 'the barrier of the unmentionable' which prevented the open and free discussion of female needs.[7] For the most part, women's bodily functions – pregnancy, menstruation, defecation, urination – were uncharted territory, a 'tangled snaky darkness' which evoked the spectre of sexuality and the uncontrollable female body in the popular mind.[8]

'Urinettes', however, attempted to provide an engineering solution to the penny charge problem. Like urinals, urinettes were cheaper and more space-efficient than traditional water closets. Furthermore, despite the fact that women's dress in the 1890s was still restrictive, their underclothing would have been open at the crotch, without buttons or fastenings. That openness, combined with the widespread use of skirt grips, meant that urinettes may well have been more convenient for women than the Lady P today.

However, urinettes never appeared to catch on. I have found only one other reference to them: a female patient of Havelock Ellis, Florrie, refers to the presence of a urinette in Portsmouth, but notes that it was spectacularly unpopular.[9] Though there is no historical evidence for why such experiments failed, I would suggest that they were most likely the victims of a larger problem facing women's conveniences.

6) George Bernard Sha 'The unmentionable ca for women's suffrage', Practical Politics, ed. Llo J. Hubenka, Lincoln: University of Nebrask Press, 1976, p. 104.

7) Shaw, p. 103.

8) Jennifer Bloomer, 'The Matter of the Cutting Edge', Desiring Practices, eds. Duncan McCorquodale, Katerin Rüedi and Sarah Wigglesworth, London Black Dog, 1996, p. 15

9) Florrie notes that th women ran away from the urinette 'in horror'. Simone de Beauvoir, The Second Sex, ed. a trans. H. M. Parshley, 1949, London: Vintage 1997, p. 303.

10) This asymmetry continues to the prese A study by the Americ Department of the Environment in 1992 determined that the average ratio of male t female toilets in theatr and cinemas is 53/47. The ideal would be abc 38/64. Bradberry, September 6, 1999, pp. 37, 41.

**Plan of gentlemen's and ladies' convenience
(with urinettes), circa 1898.
— Davis and Dye.**

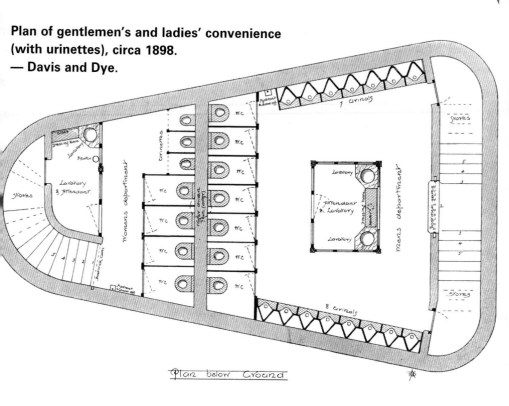

Plan below Ground

Looking at the ground-plan for the convenience with urinettes, one is struck by a strangely familiar sight: while the women's side is equipped with four water closets, three urinettes, and one lavatory, the men's side has seven water closets, 15 urinals and two lavatories. This asymmetry was no accident but was standard in conveniences at this time.[10]

As the engineers George Davis and Frederick Dye explained in 1898, the problem was that women often did not make use of their side, with the consequence that conveniences for 'the weaker sex' were 'more often failures, financially and practically, than a success'.[11] Consequently, fewer were provided for them.

11 | George B. Davis & Frederick Dye, *A Complete and Practical Treatise upon Plumbing and Sanitation Embracing Drainage and Plumbing Practice etc.*, London: E. & F.N. Spon, 1898, pp. 171-2.

The reason why ladies' conveniences were notorious financial duds, however, was not simply because poorer women could not afford to use them. The reality was that, far from being universally put to use by women, public lavatories were often shunned by them, whether out of fear, distaste or, as Davis and Dye put it, a 'peculiar excess of modesty' which forced their closure.[12]

With this revelation, the picture becomes considerably more complex. The example of the urinettes indirectly emphasizes not only that the discourses on decency and femininity infused the design and use of female public lavatories, but that Victorian women were as invested in these discourses as Victorian men to the extent that it often overrode their experiences and physical needs.

The Bathroom

Writing sixty years later, the architect Alexander Kira recognized the degree to which toilets continued to be caught up in societal taboos. However, he believed that these taboos could be sympathetically accommodated within design – and set about to do just that.

Between 1958 and 1965, Kira directed a major study at Cornell University whose purpose was to completely rethink bathroom design according to the principles of human engineering (or 'ergonomics'). Published in 1966, the book detailing the study's results, *The Bathroom*, is a unique document; the only serious study of the toilet published in the twentieth century, it attempts to consider all aspects of human lavatory requirements, physical and psychological, in an objective, scientific way.[13]

Perhaps the best example of this attempt at neutrality was how Kira, keen to break away from the prejudices surrounding his subject, invented a 'scientific terminology'

12) Davis & Dye, p. 1?

13) Alexander Kira, *The Bathroom*, 1966, New York: Bant Books, 1967.

30

to describe bathroom activities: hence, toilets became 'hygiene facilities'; bathing became 'body cleansing'; and urinating or defecating became the rather sinister 'elimination'. By reducing what takes place within the toilet to a mechanical function, Kira attempted to contain its psychosexual dimension, treating the body as machine.

Similarly, Kira blanked out the faces of the female models in his photographic studies of cleansing activities, though this was probably simply a pre-emptive (and unsuccessful) gesture to head off public outrage. It is worth noting, however, that by the book's second edition just ten years later, the models not only appeared naked but were also photographed urinating.

The Bathroom's most significant section, Part II, records laboratory investigations into the 'functional and physiological' activities of the bathroom. The purpose of these explorations is to establish a basic set of criteria for bathroom design and to suggest how these might be ultimately applied to new equipment.

As Kira wanted to design for the optimal number of users, he made abundant use of diagrams and statistical charts. These set out anthropometric data, drawn from military studies of body dimensions, on the height, width and range of movement of potential users. Despite designing for a universal user, however, Kira was sensitive to the anatomical and cultural differences between men and women and studies them performing their various 'personal hygiene' activities separately in order to provide, eventually, for both.

**'Experimental Squat Water Closet Incorporating Suggested Criteria'
— Kira,
*The Bathroom***

On the subject of female urination, however, Kira was bleak. He observed that many experiments had taken place over the years to provide a 'stand-up' public urinal for women but that all had, due to the unwieldiness of female clothing and women's 'psychological resistances to being publicly uncovered'[14] – been met by objections similar to Justine's to the Lady P. But Kira also noted that women face a third, equally pernicious problem: that of aim.

"Typical Squatting Postures." – K

He noted that, while men learn the 'ability to control the trajectory of the urine stream' early on, women have no such control and soil themselves when they attempt to urinate standing up. Subsequently, although men 'can urinate equally conveniently [...] from either a sitting/squatting, or standing position', Kira recommended that women pee exclusively from a seated position.[15]

Normally attentive to mental factors and how they affect behaviour, Kira left what this element of control might mean psychologically to men and women unexplored – in a less surprising oversight we recall that *The Bathroom* opens with Freud's famous maxim: 'anatomy is destiny'.[16] Kira, above all a pragmatist, observes the status quo and reproduces it unapologetically in his design.

14) Kira, p. 140.

15) Kira, pp. 140-1.

16) Kira, p. 1.

17) de Beauvoir, pp. 3●
304. de Beauvoir argue●
that the freedom boys
exhibit when urinating,
and their seeming
omnipotence, contribut●
to the penis envy of gi●
She stresses, however,
that it will only have th●
effect on girls who hav●
not been 'normally rear●
Freud also cited cases ●
young girls urinating
standing up as evidenc●
of their 'envy for the
penis'. Sigmund Freud●

32

FEMME?pissoire

But others have been much more interested in the psychological consequences of urinary control, from Karen Horney to Simone de Beauvoir, who devotes several pages to the subject in *The Second Sex*. de Beauvoir believes that the Western convention that women squat to urinate 'constitutes for the little girl the most striking sexual differentiation.' She explains: 'To urinate, she is required to crouch, uncover herself, and therefore hide: a shameful and inconvenient procedure.'[17] The erect position in our society, she notes significantly, is reserved for men alone.

This question of control, among others, also intrigued the architect Yolande Daniels in New York, when she began working on FEMME?pissoire in 1991-92. To what extent is controlling the flow of urine a personal freedom for men? What might mastering this act mean for women?

To give a brief description: FEMME?pissoire consists of a basic ensemble (stainless steel bowl and spout, supply and return hose, mirror, instructional floor mat) which has been installed at a series of different locations, from hotel rooms to art galleries, between 1996-98. With each shift in site, there is a corresponding shift in the project's theoretical emphasis.[18]

While it is engaged with a changing bundle of questions, a key interest of the project is how the relationship between designed objects, social convention, female anatomy and subjectivity is mediated. By playfully challenging every custom currently governing toilet design and protocol, Daniels puts them all to the test: is anatomy (and social convention) destiny?

'The Taboo of Virginity', *The Pelican Freud Library*, vol. 7, ed. Angela Richards, trans. James Strachey, Middlesex: Penguin, 1977, p. 278.

18 I As part of Daniels' interest in provoking a public discourse, FEMME?pissoire was installed in two hotels: the Gramercy Hotel, New York, and the Chateau Marmont, Los Angeles. The urinal, hooked up to the existing sink and toilet, was fully functional in both sites but was used more frequently in the Chateau Marmont where there was a door. Interestingly, it was used by both sexes. The project was also installed in two galleries: in the Whitney Independent Studios and the Thomas Healy Gallery. In the former, it functioned as a fountain and in the latter it was installed as a pure object. Yolande Daniels, e-mail to author, 5 March, 2001.

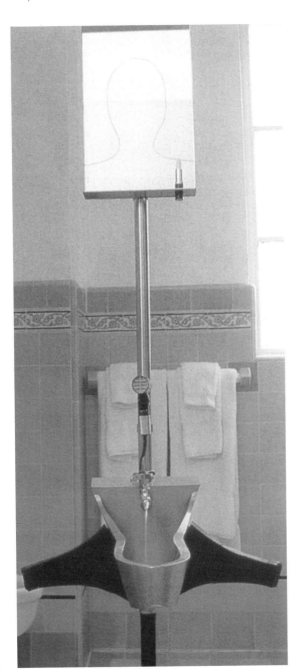

FEMME?pissoire
Chateau Marmont, Los Angel‹

Before answering this question, we must first consider in greater detail the specific ways in which FEMME?pissoire transgresses custom. To begin with, it challenges the way women are trained to urinate, by enabling them to stand directly over the toilet bowl without squatting. Standing up encourages women to direct the stream of urine themselves, as boys are trained to do from a young age. As de Beauvoir observes, this aspect of boys' toilet training contrasts strongly with that of girls: whereas boys are taught to control their urine stream through handling their own penis, the girls are taught that their sexual organs are taboo.[19] With FEMME?pissoire, women have to touch themselves in order to direct the urinary stream: over time, this gesture would become everyday and unremarkable, 'an automatic reflex'.[20]

FemmeP-system pant

Like men's urinals, FEMME?pissoire is stall-less and curtain-less (hence more open visually and acoustically). In part to counteract this lack of privacy, Daniels has designed a pair of trousers for women, the FEMMEp-system pant, with two zippers: one that opens like a conventional zipper, and the other that opens at the crotch.[21] The redesigned trousers become an integral aspect of the redesigned toilet, addressing not only the 'pant-round-the-ankle' complaint that repeatedly surfaces with female urinals, but also the way in which female genitalia is generally left unarticulated in design, a 'lack', in comparison to the male. In the same way the front zipper on trousers articulates male anatomy, the FEMMEp-system pant now articulates and makes visible the female.

19 | de Beauvoir, p. 302.

20 | Daniels, 5 March, 2001.

21 | Yolande Daniels, e-mail to author, 13 March, 2001.

35

FEMME?pissoire's project of rendering women visible is pushed further by the mirror. Typically used for the application of make-up, the mirror is, in Daniels' words, where we 'verify the surface application of the feminine – the proper':[22] not merely a reflective surface, it is a point of mediation between the personal and collective self, where women may 'put on' their public face. By contrast, the mirror of FEMME?pissoire, placed directly at eye-level for use while urinating, challenges fixed ideas about what is 'proper', highlighting the unstable relationship between bodies, self-image and the normative mask of femininity. Watching themselves, standing erect in the act of urination, female users may see in the mirror the possibility of reconfiguring these relationships – and perhaps even their selves.

All the elements of FEMME?pissoire then answer the question, 'Is anatomy destiny?' with a resounding no: far from determining design, female anatomy and subjectivity are shown to be interpreted and reinterpreted through it. Daniels wants to push this conclusion to its logical limit, by one day mass-producing FEMME?pissoire. For her, the true emancipatory potential of FEMME?pissoire lies here: in the possibility that the urinal might become ubiquitous, banal, perhaps even unnecessary. As she observes: 'In using the object, the object [will] itself become obsolete.'[23]

Taking the Stand

Though perhaps this sounds overly ambitious, pieces of equipment are already available for female users which challenge the ubiquity of the sit-down toilet. As anyone who does rock-climbing or other adventure sports knows, relatively cheap and uncelebrated devices are available which effectively function as prosthetic penises,

22) Yolande Daniels, 'OURStandard FEMMEpissoire', *Young Architects: Scale* New York: Princeton Architectural Press, 2000, p.20.

23) Daniels, 5 March, 2001.

allowing women to urinate in any situation. And, though for years women were shut out of the air force and space programmes like NASA which in no small part was due to the urination problem, devices now exist which allow them to relieve themselves comfortably in flight.[24]

I have tried to demonstrate in this paper that the current design of female toilets responds not to the experiences or needs of women as much as to an ideologically dominant idea of femininity as modest, discrete and hidden. However, as female urinals so powerfully remind us, the dominant ideal of femininity is not unassailable. While one does not want to claim too much for female urinals as yet, given that they exist mainly in extreme conditions where space is limited, their existence alone effectively highlights the flexible nature of design.

Moreover, as an intervention into the status quo, female urinals push against collective expectations and stretch them to include new objects and conventions of behaviour (for instance, women standing to urinate). While not a grand gesture which will single-handedly bring the binary gender system crashing down, the female urinal does point to the fact that small subversions can be built into design: small shifts in existing boundaries which can be embraced – or contested – in their turn.

This paper was first presented at the Harvard Interdisciplinary Graduate Gender Studies Conference, 'Beyond No Man's Land: Exploring the Limits of Gendered Bodies and Boundaries', in March 2001. The stimulus for expanding it further was several long e-mails with Yolande Daniels about her project FEMME?pissoire. I am grateful for her generous help with this piece.

24 I The design solution NASA finally adopted on the Space Shuttle was conventional: their Waste Collection System is located in a 29-inch-wide area, with a door and two privacy curtains, a commode (basically a standard toilet) and a urinal. Catherine Watson, 'Waste Collection Management', online, NASA HumanSpaceFlight – The Shuttle, Internet, 2 July 2001.

'Well, I'll eat it,' said Alice,
'and if it makes me grow larger,
I can reach the key;
and if it makes me grow smaller,
I can creep under the door;
so either way I'll get into the garden,
and I don't care which happens!'

Lewis Carr
Alice in Wonderla

ARCHITECTURE, YUM!

Mark Morris

There is a memorable scene in the children's film *Willy Wonka and the Chocolate Factory* where Wonka (played by Gene Wilder) invites a group of select guests to inspect his candy factory. 'My dear friends, you are now about to enter the nerve centre of the entire Wonka Factory. Inside this room, all of my dreams become realities. And some of my realities become dreams. And almost everything you will see is eatable. Edible. I mean, you can eat almost everything.'[1] And they do, from gumdrop trees to chocolate waterfalls, the group journeys through a hothouse landscape that is entirely edible. The group comes to a room where the William Morris fruit-patterned wallpaper can be licked, the printed orange tasting like an orange and so on. This is a curious fantasy for the architect where the built environment – so solid, so lasting – becomes mere foodstuff. Then again, some architects liken their work to food by way of

1) *Willy Wonka and the Chocolate Factory*. Dir. Mel Stuart. Warner Brothers Studio, 1971.

analogy. Philip Johnson has his pear project, Zaha Hadid her orange peel. In the 1970s Charles Moore derived planning schemes from Lucky Charms breakfast cereal. Rem Koolhaas equates his externally homogenous but internally heterogeneous buildings to fruitcake.

The critic Adrian Stokes wrote of the 'oral invitation of Veronese marble', referring to Ruskin's own wish to 'eat up this Verona touch by touch' after exhausting all other architectural analysis.[2] The wish to literally taste the built environment is undeniably regressive, an infant's register of the world, but it is a desire so strong that chefs, especially *patisseurs*, strive to meet it again and again. A relatively new tradition (replacing vestigial Masonic rites) has evolved around the dedication ceremonies for new buildings, particularly large commissions and public works like theatres, museum and libraries. At these events politicians, board members, trustees, benefactors, the press and architects are brought together. Increasingly the highlight of the party features champagne and a cake in the shape of the edifice being commemorated. The cutting of this cake – always the image featured in local newspapers and television – and its demolition at the hands of those that built the project, borrows much from associations with wedding cakes and gingerbread houses. The cake-as-model disappears into the mouths of the patrons and designers to mark its real manifestation and the end of the relationship between client and architect, an amicable divorce cake. It is poignant to watch the architect chew his own building, something akin to 'eating your own words' or 'eating your hat'. The expression is always slightly pained and the comment invariably the same, it tastes better than it looks.

It is at the site of the scale model that food can effectively mimic architecture, the full-scale Wonka factory being the exception to the rule. That food should attempt to mimic

2 | Adrian Stokes, *Crit.*
Writings. Vol. II, Londc
Thames & Hudson, 19
p. 316.

architecture in this way is a reverse exercise of sorts. Architectural representation, plans and sections, are likened to 'slices' through a building. Models are useful for many reasons, not least because they empower by virtue of their diminution; and what better road to completely conquering something than through eating it? The scale model, whilst not literally edible, is visually so, totally consumable in a glance. Chefs inspired by architecture use the model to fulfill a latent dream that the world can be swallowed whole.

First Course, Appetiser (prawns)

Hors d'oeuvres and appetisers from fanciful canapés to prosaic pigs-in-a-blanket are preciously constructed objects that are offered as proof of the calibre of subsequent courses. The one rule to all hors d'oeuvres recipes is that it must be portioned in such a way as to be eaten whole with the fingers, in one bite. Whimsy and artifice is their main attraction. Even when these do not resemble miniature structures on their own, their presentation on triple-tiered silver platters resembles a savoury cityscape. That such a small foodstuff could be so complex is parodied by Woody Allen with his send-up of Manhattan restaurant reviews in *Fabrizio's: Criticism and Response*. The chef Jacobelli offers, 'four garlic-drenched shrimp arranged in such a way that says more about our involvement in Vietnam than countless

books on the subject.'[3] The joy of eating these delicacies has much to do with their smallness and the diner's relatively large size, that hint of Lilliput. This is the thrill of King Kong's rampage through New York City and his fingering of an elevated train as if it were an eclair.

Second Course, Pasta (*gnocchi*)

The opposite of the compact, high design starter is the messy floppy pasta course – the bane of designers. Formlessness is always dreaded; Dalí hated spinach for 'its utterly amorphous character', preferring 'things with well-defined shapes that the intelligence can grasp.' Marinetti used to fret that the Italian army would be wise to avoid spaghetti in favour of foods that kept their shape and require a knife. Rem Koolhaas illustrates nightmares about limp skyscrapers. Peter Eisenman points out the weak condition of pasta, deconstructing *nuova cucina*:

> The other day, we went into a restaurant and I had four courses, from none of which I could tell what kind of food I was eating. I knew I was eating Italian food, so the primary was still present. As in deconstruction, one does not go totally away. You still recognize you are eating Italian food but it is not Italian food you would recognize in any primary sense. For example, there were gnocchi – which are potato pasta – or rather, they looked like gnocchi but they were made from fish; but they were not just fish, they were not fish patties, they were pasta. It is not dialectical, it is not montage, it is some strange collage, a very strange addition, or, as I would call it, a superposition of things of which you do not know what they really are.[4]

3) 'Fabrizio's: Criticism and Response', *Side Effects*, New York: Ballantine, 1981, p. 1

4) 'An Interview with Peter Eisenman'. *Date* 14, Department of Architecture, Tamper University of Technolo 1991, p. 68.

Potatoes, of course, are well-known for their mutability. English children always find a thrill in mounding their mashed potatoes into a mountain ready to receive a volcano's blast of gravy. The film *Close Encounters of the Third Kind* features a protagonist who becomes obsessed with modelling a mountain in mashed potato where aliens will land. Greg Lynn, an architect noted for his embrace of the formless, derived techniques from mapping the surface of potatoes.

Third Course, Jellies (fruit salad in aspic)

More mutable still, truly plastic and a sculptor's dream, jelly or jello moulds come out of the medieval English tradition of formed puddings. Gelatin was commercially available in the eighteenth century and flavoured with citrus fruits; before crude jellies were made with agents from fish bone, but these did not hold their shape for long. Ceramics companies like Wedgwood created ever-more complex moulds for this most malleable delicacy.

Molds are found in the Gothic style, some have Doric motifs, while others are influenced by Egypt and by Indian architecture, assimilated, no doubt through the influence of the Raj. The wandering Art Nouveau line proved unsatisfactory for jelly but Art Deco crispness made a very successful 'shape' which, incidentally, was the term for jelly and

blancmange in some circles. The use of flora and fauna — fruit, flowers, cornucopia, wheat sheaves and all the traditional iconography of folklore ran for two centuries, concurrently with the purer architectural molds.[5]

Special combinations of Victorian moulds with hidden armatures allowed jelly towers to rise high off a table, a wobbling, transparent metropolis. The cream and white earthenware gave way to pressed copper and tin and, after the war, aluminium moulds. The American Jell-O Company added new flavours of gelatin and created their own line of architecturally ambitious moulds, some out of plastic. These became the norm in American middle class entertaining during the 1950s.

The 1958 science fiction cult classic, *The Blob*, featured an ever-growing jelly arriving on a meteor and slowly sucking up anything that gets in its way. Originally quite small and agile, the Blob attacks the first person that finds it. 'The old man makes the dubious mistake of allowing the Blob to touch him, where it immediately engulfs his hand and begins to consume his flesh, growing larger in the process and turning red with his blood.'[6] For some reason all the teenagers know of the menace, but the authorities refuse to believe them as the Blob oozes towards town, covering and dissolving everything in its wake. By the time the police do come on the scene, the now enormous Blob is moving rather slowly and is finally contained in a large civic building until it can be destroyed. That the Blob becomes trapped in architecture, serving like a jelly mould, is telling. By itself it has no body, its borders are shifting and permeable. All it does is eat and consume, orally satisfy, expanding like an amoeba. One could imagine that left in the building long enough it would set, become an inverse

5 I Margot Coatts, artic on-line, quoted from a British cookery periodi published Nov 1986; available from http://www.azantique. m/molds.html, access September 2001.

6 I James Kendrick, film review on-line; available from http://100.com/movie, accessed September 2001.

of the architectural shell, like a Rachel Whiteread sculpture. Lynn, of course, credits *The Blob* for much of his career and if there is a salient style at avant-garde architectural schools at the moment, it is blobby.

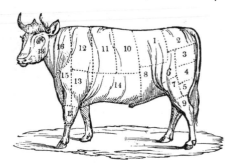

Fourth Course, Main (roast beef and *carni plastici*)

Cow and pig diagrams that used to be displayed in every butcher's shop owe much to architectural drawings, particularly the section 'cut'. A butcher's diagram is better than a real side of beef, a pure cross-section down the spine, because the drawing can allow the section to jump and better display those organs or cuts of meat that are not symmetrically disposed within the carcass; for example, the liver. Meat in substance would not seem a prime candidate for architectural expression, but its symbolic power cannot help but to inspire. Barthes writes of the role of steak in French national identity.[7] In *The Futurist Cookbook*, Marinetti insists upon 'absolute originality in the food' and offers up *carni plastici*:

> The invention of appetizing food sculptures, whose original harmony of form and colour feeds the eyes and excites the imagination before it tempts the lips. Example: the sculpted meat created by the Futurist painter Fillia, a symbolic interpretation of all the varied landscapes of Italy, is composed of a large

7 | See Roland Barthes, *Mythologies*, London: Vintage Books, 200), pp 62-64.

45

cylindrical rissole of minced veal stuffed with eleven different kinds of cooked green vegetables and roasted. This cylinder, standing upright in the centre of the plate, is crowned by a layer of honey and supported at the base by a ring of sausages resting on three golden spheres of chicken. [...] These flavourful, colourful, perfumed and tactile food sculptures will form perfect simultaneous meals.[8]

Such cuisine recalls a history of artistic cookery going back to the Middle Ages. Sir Arthur Conan Doyle describes a thirteenth-century banquet with 'Roasted peacocks, with the feathers all carefully replaced, so that the bird lay upon the dish even as it had strutted in life.'[9] The Futurist recipes make meat the superlative building compound, moulded and forced into geometric forms, making the most organic substance into perfect Platonic solids. 'Hence a cookery which is based on coatings and alibis, and is for ever trying to extenuate and even to disguise the primary nature of food-stuffs, the brutality of meat or the abruptness of seafood.'[10] Tenderised or minced, the effort is always toward erasing its original form and associations with the slaughterhouse. Adolf Loos, the author of *Ornament and Crime*, was not as enthusiastic about such manipulations: 'The dishes of past centuries, which display all kinds of ornaments to make peacocks, pheasants and lobsters look more tasty, have exactly the opposite effect on me. I am horrified when I go through a cookery exhibition and think that I am meant to eat these stuffed carcasses. I eat roast beef.'[11]

8 I FT Marinetti, *The Futurist Cookbook*, translated by Suzanne Brill, San Francisco: Bedford Arts. 1989.

9 I Arthur Conan Doyle, *The White Company*, Chapter XXI: 'How Agostino Pisano Risked His Head', London: Smith, Elder & Co, 189▮

10 I Barthes, p. 78. In ▮ chapter 'Ornamental Cookery', Barthes also notes: 'Ornamentation proceeds in two contradictory ways [.. on the one hand, fleein▮ from nature thanks to ▮ kind of frenzied baroqu▮ (sticking shrimps in a lemon, making a chick▮ look pink, serving grapefruit hot), and on the other, trying to reconstitute it through incongruous artifact (strewing meringue mushrooms and holly leaves on a traditional Christmas cake, replacing the heads of crayfish around the sophisticated bechame▮ which hides their bodie▮

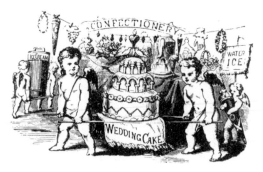

Fifth Course, Dessert (assorted cakes)

The sweet course reaffirms the designer's complete control. Pastry is nothing but architecture and form-making. Cakes, formed like bricks in the oven, can be tiered and decorated to resemble anything so long as it does not resemble itself. The cake's long history is tied to its supreme ability to mimic and represent. This tendency had precedent in medieval Sotelties and, later, Marchpanes.

Both the French and English king's 'official' state duties ended on Twelfth Night. A cake called King's cake or Galette du Roi was eaten. A large cake with a hole in the center was placed on bull's horns for Twelfth Night Games and wine and ale was consumed by all. Cake was originally a symbol of the Goddess in pre-Christian times. The bull's horns symbolized her consort and ale and wine was spirit. This is the origin of communion. Twelfth Night festivities ended during the 19th century.[12]

Napoleon's chef Marie-Antoine Carême, 'le roi des chefs et le chef des rois', who also served Talleyrand, Czar Alexander I, George IV and Baron Rothschild, wrote treatises like *L'Art Culinaire au XIXe Siècle* and *Le Patissier Pittoresque* proclaiming 'The main branch of architecture is confectionery'. The father of French cuisine looked to

11) Adolf Loos. *Spoken into the Void: Collected Essays 1897-1900*, republished by Oppositions Books, Cambridge: The MIT Press, 1981.

12) Encyclopaedia Britannica. on-line entry for 'Twelfth Night'; available from http://www.britannica.com accessed Sept 2001.

architects like Vignola and Durand rather than to other chefs for inspiration. Fantastic dishes were served up resembling neo-classical temples and palaces. For the Prince Regent, Carême created model-cakes in various 'oriental' styles influencing the design of the Brighton Pavilion.

Queen Victoria's Twelfth Night cake weighed some three hundred pounds, measured three yards across and was fourteen inches deep! Her chefs set the standard for the lavish wedding cake. The cake for the Princess Royal was arranged in tiers mounting to over seven feet tall.
This cake included niches for iced sculptures, buttresses, bridges, staircases and busts of Victoria and Albert in tinted sugar.[13] The traditional tiered wedding cake represents a Renaissance architectural fantasy. The successively smaller layers are iced white and decorated with piping spoofing cornice details, all of this is topped by a circular colonnade, a temple of Venus, offering a miniature plastic representation of the bride and groom. Even entirely secular wedding receptions include the model-cake, its image and consumption so central to the image of matrimony. The messy mutual taste of cake shared by the couple, one offering cake to the other simultaneously by fingertips, reaffirms a desire to consume the other. The night before the wedding day a different sort of cake or, rather, a faux cake – often resembling a wedding cake – is presented to the stag party.

Cakes are not always the architect's friend. After losing an international competition for the design of the Palace of the Soviets in the early 1930s, Le Corbusier famously criticised the conservatism of the winning entry by Russian Boris Iofan. Other critics concur: 'In models of the building he [a 200 foot statue of Lenin] resembles an angry, brideless groom on the upper tier of a wedding cake, sentenced to a lonely Siberia of icing.'[14] The colossal structure was never completed and its basement foundation served for decades as the Moscow Swimming Pool. Another competition, for

13 | S. R. Charsley, *Wedding Cakes & Cultural History*, London Routledge, 1992.

14 | Peter Conrad, *Modern Times modern Places, Life & Art in the 20th Century*, London: Thames & Hudson, 1998, p 249.

the Vittorio Emanuele Monument or Altar of the Nation in Rome, was won by Giuseppe Sacconi in 1885. The enormous structure, universally derided, is referred to by locals and tourists alike as 'the Wedding Cake'. Clearly, architecture that emulates cake is not as popular vice versa.

The Primitive Gingerbread Hut

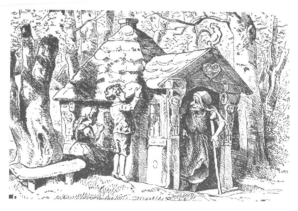

Much rarer than cake, and traditionally made only once a year at Christmas-time, the gingerbread house is the most architectural of foods. It enjoys all the decorative options of cake with a more rigid substructure. The reason behind the gingerbread house's presence at Christmas is twofold. Gingerbread, formed into spiced cakes or men-shaped cookies, has long been holiday fare. Its formation as house comes from childhood associations with the Brothers Grimm fairytale *Hansel und Gretel*. Originally published in 1812, the story describes a small edible house. The tale puts two children – abandoned by their parents – into a dark forest alone and hungry until...

... they came to a little house, which was built completely of bread and covered with cake, and the windows were of pure sugar. 'We'll sit down and eat our fill, said Hansel, 'I'll eat some of the roof, you eat some of the window, Gretel, that is deliciously sweet for you.' Hansel had already eaten a good piece of the roof and Gretel a few round windowpanes, and was just breaking out another, when they heard a delicate voice calling from inside: 'Nibble, nibble, gnaw, who is nibbling at my little house?'[15]

15 | Jacob and Wilhelm Grimm. *Kinder- und Hausmärchen, Gesammelt durch die Brüder Grimm*, Berlin, 1822.

49

In successive reworkings, including Humperdink's ballet, the story is elaborated, the house of 'bread covered with cake' becomes a gingerbread house studded with every conceivable confectionery. Modern versions of the story make much more of the edible house than the original. *The Oxford Companion to Children's Literature* notes: 'A house built of food, which is the most distinctive feature of Hansel and Gretel, is found in a 14th-century poem in a British Library manuscript, which describes an abbey far out to sea, west of Spain, which is made of pasties, cakes, puddings, and meat.'[16]

Eating the little house satisfies not only hunger, but also the desire for home (after being expelled from their own), a desire so strong that only consuming the house will satisfy and then, just fleetingly. When the witch serves the children dinner once inside the house, another desire is met, that of the mother. This sequence also fulfils a childhood dream about eating dessert before dinner. That the house in numerous treatments and illustrations becomes progressively more scrumptious, tantalising and delicious (dripping with candy) only underscores the effectiveness of the trope. A building 'of bread' grows in the imagination and transforms into a pastry palace. The gingerbread house is strangely paired with the Nativity on the mantelpiece, the crèche all about display of interior figures and the gingerbread house entirely enclosed and usually unpopulated.

The Primitive Hut, the origin of architecture according to Vitruvius, is curious for its lack of enclosure. Meant to prefigure the Classical temple, the mythic structure is fashioned from standing trees for columns and sloped

16) Humphrey Carpenter, and Mari Prichard. *The Oxford Companion to Children': Literature*, Oxford University Press, 1984, see entry for 'Hansel an Gretel'.

branches for a roughly pedimented roof. It is the original shelter, except that it doesn't really shelter anything. But the image of the Primitive Hut, especially Laugier's celebrated frontispiece to his *Essay sur l'Architecture*, persists in the architectural imagination. Like the witch from *Hansel und Gretel*, the personification of architecture gestures to the hut in a forest clearing whilst fondly looking at a chubby cupid, a winged Hans. If the Primitive Hut represents the origin of architecture structurally and scenographically, then the gingerbread house must represent its analogue in terms of desire. If the Primitive Hut is about origins, then the gingerbread house is about endings. Edible models allow a certain fantasy after 'King Kong', the wish to become impossibly large and to destroy architecture. Ingesting buildings allows one to fuse with the built environment, to be the walls and the roof even if these are sugar surrogates, a bodily communion with architecture.

It is a mixture of cake and gingerbread house that produces the edible architectural model of the building dedication ceremony. The architect is hesitant to eat his own project as it is really a kind of regurgitation.

Having created the building, from sketches to drawings to models, in order to free the project from the intellect and communicate it to the outside world, it is perverse to be asked to consume it, to have your cake and eat it too. For everyone else, feasting on a building is a delicious fairytale, a fantasy of superabundance. Mannerist architects like Zuccari presented the doorway as a giant mouth swallowing everyone who entered. It is only natural to want to invert the relationship from time to time.

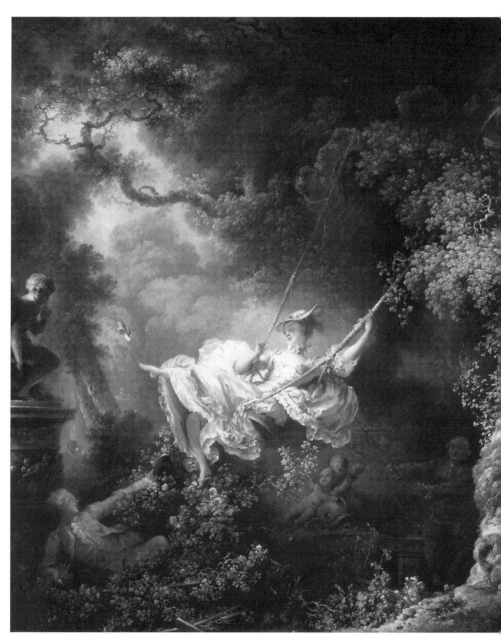

Jean-Honoré Fragonard, *The Swing*, **1767, oil on canvas, 81 x 64.2 cm, Wallace Collection London**

FRAGONARD'S SWING: THEME AND VARIATIONS

Catherine James

A pretty damsel, all curls and frills, reaches a climactic moment in the swing's flight. Her dress and petticoats billow up and she kicks off her slipper, forming a delightful and privileged gaze for the recumbent lover. Fragonard's image of *ancien régime* pleasure, *The Swing*, painted in 1767, has been the subject of some interesting parodies by two contemporary artists. Yinka Shonibare's *Swing: After Fragonard* (2001) and Karen Knorr's *In the Green Room* (2001) are appropriations of Fragonard's image which speculate with renewed curiosity on issues of identity, authenticity and culture.

Such mimicry of a petrified high-culture canon is not unusual amongst contemporary artists. In the 'Going for Baroque' exhibition of 1995, at the Walters Art Gallery, Baltimore, Cindy Sherman reproduced herself, on

Limoges porcelain plates, as Madame de Pompadour.[1] The reasons for curiosity in this particular piece of high-rococo art are complex. On a surface level, it is easy to be drawn to the painting's flamboyant gestures and sumptuous colour as well as its titillating subject. However, it is the work's own subversive undertones that may have made it susceptible to parody.

First, a little should be said about the painting's provenance. It was the painter Gabriel-François Doyen who was originally commissioned by an unknown gentleman of the court to paint this expression of *ancien régime* indulgence, and records relating to its inception show how the slipper motif was chosen to 'enliven' the picture yet more. The writer, Charles Collé recorded his conversation with Doyen on October 2nd 1767:

> 'Would you believe', the painter said to me, 'that just a few days after the exhibition of my picture [*The Miracle of Saint Geneviève des Ardents*] in the Salon, a gentleman of the Court sent for me in order to commission a painting of the kind that I'll describe? This gentleman was at his "pleasure-house" [*petite maison*] with his mistress when I presented myself to find out what he wanted. He started by flattering me with courtesies and finished by avowing that he was dying with a desire to have me make a picture, the idea of which he was going to outline. "I should like", he continued, "to have you paint Madame (pointing to his mistress) on a swing that a bishop would set going. You will place me in such a way that I would be able to see the legs of this lovely girl, and better still, if you want to enliven your picture a little more..." 'I confess', M. Doyen said to me, 'that this proposition, which I wouldn't have expected, considering the character of the

1) David Carrier, 'Going for Baroque',exhibition review of 'Going for Baroque: 18 Contemporary Artists Fascinated with the Baroque and Rococo' in *The Burlington Magazine* 138 (1114), Jan. 1996, p. 9.

picture that led to it, perplexed me and left me speechless for a moment. I collected myself, however, enough to be able to say to him almost at once: "Ah! Monsieur, it is necessary to add to the essential idea of your picture by making Madame's shoes fly into the air and having some cupids catch them." But since I was far from wanting to treat such a subject, which is so different from the genre in which I work, I referred this gentleman to M. Fragonat [sic], who has undertaken it and is at present making this singular work.'[2]

Fragonard's image, therefore, emerges from a pre-revolutionary background of privilege and wealth, the idle fancy of an aristocratic gentleman of the French court. In the painting, the shadowy male figure in the right-hand corner of the painting provides momentum for the swing's flight and is placed in a vertical posture on a rigid stone seat, where the woman and her lover are respectively cushioned on upholstery and lolling in the grass. The pleasure attained by the lady and her lover is illicit. The lover is lying low in the vegetation, hidden from view with further suspense created by the inclusion of the vertical male figure who signifies the moral propriety and dignified decorum the lovers are resisting.[3] The bishop or husband's position is made quite poignant by the fact that unbeknown to him, his mechanical labours support the lovers' pleasure.

Weight is discharged in the meaning of the pastime depicted; an activity of unproductivity. The weight of living and its contingent responsibilities fall away in the pleasurable act of swinging. Fragonard's swing has reached a vertiginous angle with the woman swaying energetically, and the image captures the climactic 'high' of the swinging experience. The physical excitement

2 | Donald Posner, 'The Swinging Women of Watteau and Fragonard" in *Art Bulletin*, March 1982, Vol. 64, No. 1, pp. 82-83.

3 | According to Donald Posner this figure has been variously interpreted as the gardener, the unwitting husband or a clergyman. It is believed that the patron was Baron de Saint-Julien who was Receiver-General of the French Clergy, which might explain the figure as a conceit that the bishop is offering him a mistress. According to Posner it seems likely that the figure was depersonalised to mask identity, but given the data relating to the painting's conception, this character should be taken to represent moral decorum. See Posner, p. 84.

from swinging is in eloquent sympathy with the emotional excitement of the encounter with her lover. The situation of the lovers comes perilously close to signifying coitus, or that proximal moment of abandon, signified also by the slipper floating in mid-air. As Donald Posner confirms:

> A straightforward description of what one sees proves to be almost embarrassingly frank: the woman is in motion, her legs are parted, her pink dress opens. The man is in the rose bush, hat off, arm erect and well-aimed. And suddenly, to her own delight, as she reaches the peak of her ride, the woman's shoe flies off her foot.[4]

Swings, seesaws, childhood games of blind man's buff are the reiterated iconography of the rococo period, and this appropriation of childhood playthings by the adult world is unsettling and provocative, with the child's natural engagement with movement and play transformed by artifice and desire. The meaning of the swing motif shifts through a number of associations. In the early seventeenth century, the image of a girl on a swing functions as an emblem of air. Gradually, the motif becomes euphemistically skewed to a more physical and less metaphorical reading of this activity. A woman enjoys a pleasurable movement with the pressure and momentum provided by a male companion that prolongs her joy.[5]

This dislocation of meaning is underlined in Fragonard's 1767 version of *The Swing*, in the detail of the floating slipper, a fetish that obscures genital difference.[6] The visual displacement of the desired object onto the shoe prolongs pleasure by leaving the lover's gaze

4 | Ibid., p. 88.

5 | Ibid., p. 79.

6 | Norman Bryson, *Word and Image: French painting of the Ancien Régime*, Cambridge University Press, 1981.

insatiated. In this economy of visual pleasure, libidinal tension is discharged in the frisson of the brushstroke.[7] The aimlessness of swinging offers up the body as spectacle with all evidence that the body has other functions, suppressed.

By severing the body from the realm of everyday functions, Fragonard creates an alternative space of existence. His swinger is placed in a terrestrial transcription of the aerial world, a green cloudscape. Cloud, vapour, milk, and water are amorphous substances used by painters such as Fragonard and Boucher to translocate the body from the hard world of objects and activities to realms of fantasy.[8] Paintings based on mythological themes by Boucher such as *Aurora and Cephalus* (1769) or *Venus and Vulcan* (1754), utilise vertical space and the frontal plane. Spatial alterity is emphasised by cloud-like substances which dissolve hard ground and deep space.

Perspectival space is defused in Fragonard's fantasy by the pyramidal shape of the swing; its ropes and trajectory suggest a vanishing point located high up in the trees to which the swing is tied. This subversion of *point d'appui* becomes more radically changed in the works by Shonibare and Knorr with the introduction of three dimensions, and in Knorr's work, the careful interplay between two and three dimensions. Shonibare's installation, *The Swing (after Fragonard)* juts the swinger forward from the corner of the room in a more frontal and confrontational alignment. In Knorr's work, *In the Green Room*, some three-dimensional, stuffed birds are photographed in front of Fragonard's painting, creating a layering of two-dimensional and three-dimensional objects. The birds are set in the indexical register by the shadows they cast on the painting, captured in the photograph.

7 | Ibid., p. 100.

8 | Ibid., p. 95.

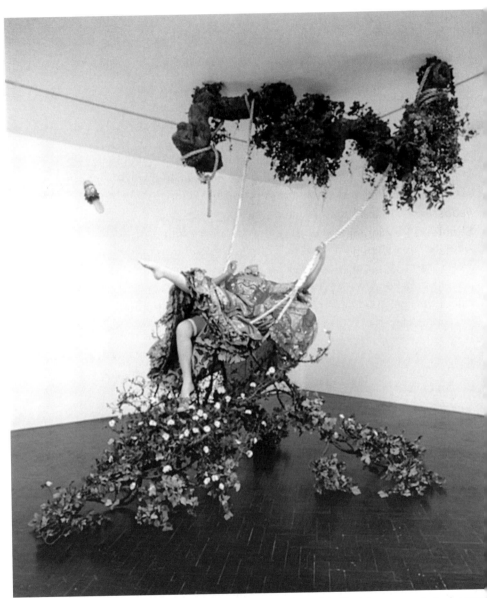

Yinka Shonibare, *The Swing (After Fragonard)*, 2001, Dutch wax printed cotto
textile, life-size mannequin, swing, foliage, dimensions variable, courtesy of
Stephen Friedman Gallery, London

What has attracted Shonibare to the Fragonard is perhaps the availability of the idle body. Shonibare is a master at seeking out historical corners of aristocratic habitat and leisure, insinuating himself into these spaces with discursive effect; Shonibare plays a game of billiards with a group of white upper-class gentlemen or enjoys the drawing-room respectability of a musical *soirée*.[9]

The hallmarks of Shonibare's style and wit are captured in this particular parody of *ancien régime* manners. As in his piece entitled *Mr and Mrs Andrews without their heads* (1998), based on the painting by Gainsborough, Shonibare's swinging mistress is decapitated, possibly a retroactive anticipation of revolutionary revenge. All the details of Fragonard's swinging woman have been retained down to the choker, stockings and garters and slippers, however, the soft flesh-tones of the swinger's dress have been resuscitated in colourful 'batik'. The story of this fabric is complex. This textile became popular in West Africa after its independence for being constructed as an 'African' cloth. The fabric is in fact Indonesian-influenced, manufactured in Holland and marketed in Manchester. It is this hybridity of origins that Shonibare uses in order to furnish his post-colonial perspective. Fragonard's painting is used paradigmatically as a manifestation of the impoverished concept of 'pure culture', which is then diffracted through the post-colonial lens to more challenging and complex ideas of origin and identity. Use of this 'ready-made' allows Shonibare to navigate the privileged spaces of colonial power. If anger is present, it is sublimated in the energy and sheer enjoyment of his engagement with Western culture. Playing with subjects such as Fragonard's swinger, Shonibare gains entry into this 'primitive state of perpetual indulgence'.[10]

9 | Yinka Shonibare, *Diary of a Victorian Dandy*, 1998.

10 | Kobena Mercer, 'Art that is ethnic in inverted commas', in *frieze*, Nov/Dec 1995, p. 39.

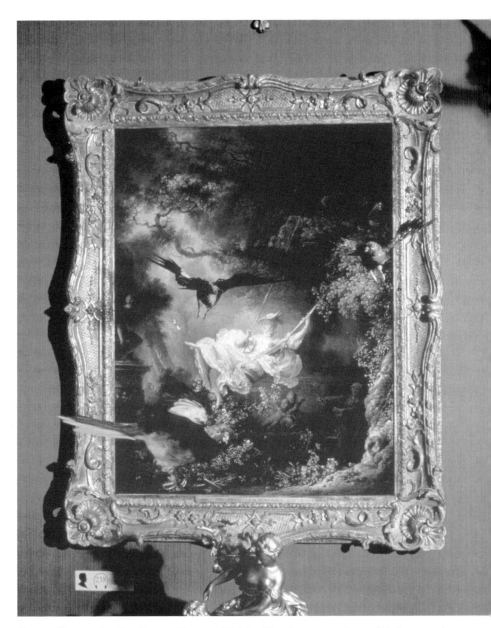

Karen Knorr, *In the Green Room*, 2001, cibachrome print with brass plaque, 144 x 144cm, from Sanctuary, London

Karen Knorr's *In the Green Room* is one of a series of photographs entitled *Sanctuary*, displayed at the Wallace Collection where the Fragonard is actually hung. With these photographs, wild animals, including sheep, wolves and birds, have ventured into the museum space. Within each photograph, Knorr sets up an allusory juxtaposition between a wild animal and an Old Master painting in a process of deconstruction and re-conception. Fragonard's *Swing* is one of the works chosen for such treatment, using, in this instance, brightly-coloured, stuffed birds. These birds of paradise, apparently startled, fly through and out of the painting. *In the Green Room* releases certain metaphorical tensions between the swinging woman and the birds of paradise. The woman's location in a cultivated wilderness brings to the fore the relationship in Fragonard's work between the tamed and the wild, artifice and nature. It is part of Knorr's project to reinvigorate those mythologies and allegories that link human beings with animals, exploring our affiliations to the untamed within a high-art, Western canon.

The bird of paradise is itself associated with the boundary between wildness and domestication, and the resonance of this association between bird and swinging woman is amplified in the prelude installation of an empty birdcage. Read in conjunction with the empty birdcage, Knorr's work is mindful of how the domestication of wild birds includes the miniaturised apparatus of the child's playground such as swings. Moreover, the bright plumage of these birds of paradise does not suggest an indigenousness within a European context, and so throws into question the notion of origin and identity where wildness does not adhere to national boundaries.

The autogenic pleasure of swinging is emphasised in Knorr's work by the way one of the birds occludes our vision of the furtive lover. With the lover removed, voyeuristic gaze resides more firmly with the audience, rather than displaced onto the lover's privileged viewpoint. By removing the courting male from our view, the painting's narrative is cut short. Similarly, Shonibare's decapitation of the swinging woman mutilates speech. This removal of speech is significant. The switch away from narrativity, silencing the human propensity to speech, validates Bryson's analysis of rococo painting as a shift from logos to eros where the rococo body can only emerge as it destroys the counter-erotic effects of speech.[11] In revoking the functions of narrative in Fragonard's work, the domestic and cultivated sense of the image starts to flounder.

Though the point is not explicitly made, the actual historical context of the works gives another slant on the idea of sanctuary, since Fragonard's image is based on those safe havens of idle pleasure that, for the next twenty-five years at least, were preserved from common view. I would suggest that both Knorr and Shonibare's parodic reinventions are drawn from the idea of exposing the sanctuaries of Western culture. The voyeurism of Fragonard's work reflects an unsanctioned and therefore titillating invasion into this corner of privilege and pleasure, which starts to allow such liberties of interpretation. It is those unavailable refuges of wealth and culture, displayed in such images of *ancien régime* life and frozen for perpetuity within the rigid picture frame, that are made accessible. The friction set up by the indexical register of the birds' shadows, and the three-dimensional element in both works, disrupt rococo's fantasy dissolution of real space. Fragonard frees up the spaces hidden behind the aristocracy's

11 | Bryson, p. 92.

normative places of power, and presents a spectacle of uncorseted freedom where fantasy and play coalesce. In those recreational arenas, rococo space becomes charged with its hallmark mix of instability and imagination. It is where recreation takes place that Knorr and Shonibare can insert their post-modern variations on an idealised past.

TIME IN HELL:
BENJAMIN, GAMBLING AND THE CHARACTER OF MODERN EXPERIENCE

Robert Clough

The image of the gambler in the work of Walter Benjamin is both significant and ambiguous – it is a crucial motif in the *Arcades Project* and in his studies of Baudelaire. For Pierre Missac, it is the image that 'best allows us to grasp certain disconcerting aspects of Benjamin's life and work.'[1] The figure of the gambler has nevertheless remained a marginal one, largely neglected in academic discussions of Benjamin's work. This is disappointing, since of all the philosophical reflection to have touched upon the theme of gambling and the aleatory, the work of Benjamin is in many ways the most fascinating.

Benjamin's portrait of the gambler is an important element of his 'primal history' of the nineteenth century. He employs a gallery of types from which the gambler, along with other, more central characters, such as the flâneur and the collector, emerges. These types are fundamental to Benjamin's radical historical intuition, and share a marginality and ambivalence that his method

1 | Pierre Missac, *Walter Benjamin's Passages*, Cambridge, Massachusetts: MIT Press, 1995, p. 43.

seeks to exploit. All resist facile social categorization, existing as figures on the threshold, in the middle – 'between the worlds of money and magic'.[2] These figures are arranged in varying constellations to invoke dialectical images of nineteenth century experience. In this sense Benjamin's gambler is an ideal-typical figure – and a protean one also – the importance of which can only be established according to these aspects of experience. For Benjamin, the nineteenth-century, under the spell of the commodity, manifested a new temporal regime. The experience of gambler represented the apotheosis of this temporality.

Given the ubiquity of gambling throughout the nineteenth century, Benjamin could hardly have ignored it. The transition from *ancien régime* absolutism to revolution and democracy was an important historical moment for gambling in Europe. The Napoleonic armies played a fundamental role in establishing gambling as a social practice throughout Europe.

Gambling as a social phenomenon had exploded in late eighteenth-century France: by 1791 there were over 3000 gambling houses of various sizes in Paris. Over one hundred of these were found at the Palais-Royal, which was established as the centre of gambling in Paris by the early part of the nineteenth century. The Palais-Royal was owned by the Duke of Orléans, who, having bankrupted himself through his gambling activities, turned the palace into a commercial enterprise.[3] This marked an important transition, allowing the middle-classes to gamble respectably for the first time. As gambling developed under the forces of commercialisation, it shifted from being a purely aristocratic pursuit to a popular bourgeois pastime. Connected to this shift was a new scientific compilation of odds through the use of theories of probability, the 'tamer

2 I Howard Eiland, in Walter Benjamin, *The Arcades Project,* Cambridge, Massachusetts: Belkna[p] Press, 1999, p. xii.

3 I Russell T. Bernhard, *Gambling in Revolutionary Paris – T[he] Palais Royal: 1789-183[0]* New York: The Author, ca.1990 p. 6.

of chance'. Rather than competing with individual players, gambling houses placed themselves within the probability equation, so that they could not lose.[4] With these changes came new games and a new style of playing – the ostentatious displays of wealth and the 'leviathan' bets of the aristocratic gambler gave way to moderate stakes and an increased rate of playing.[5] The gambling experience became a commodity like any other, bought by losses at the table. The figure of the gambler that Benjamin constructs emerges out of these changes.

According to Benjamin, the temporal aspect of gambling was the most crucial in the modern period. He noted: 'Time is the material into which the phantasmagoria of gambling has been woven.'[6]

Benjamin was by no means the first to establish a link between time and gambling. The various forms of fascination which have attached themselves to the culture of gambling have consistently articulated its strange and distinct temporality. From its origins in the ancient practices of divination, in which the future would be foretold by the falling of lots, the experience of gambling has always had a complex and fundamental relationship to time. The divinatory trace endures: gambling in all its forms seeks ultimately to predict the future. Yet beyond this, there is something in gambling that changes the very shape of time – stretches it, compresses it, freezes it.

Anatole France saw in gambling 'the art of producing in a second the changes that Destiny ordinarily effects only in the course of many hours or even many years, the art of collecting into a single instant the emotions dispersed throughout the slow-moving existence of ordinary men, the secret of living a whole lifetime in a few minutes.'[7]

4 | Gerda Reith, *The Age of Chance: Gambling in Western Culture*, London: Routledge, 1999, p. 80.

5 | Gerda Reith, *The Age of Chance*, p. 81.

6 | Walter Benjamin, 'On Some Motifs in Baudelaire', in *Illuminations*, London: Pimlico, 1999, p. 194.

7 | Walter Benjamin, *The Arcades Project*, O°4a, p. 498-99.

In a similar vein, Edouard Gourdon wrote of gambling:

> I live a hundred lives in one. If it is a voyage, it is like
> that of an electric spark... If I keep my fist shut tight,
> and if I hold onto my banknotes, it is because I
> know the value of time too well to spend it like
> other men.[8]

There is a sense in which the accounts of France and
Gourdon articulate the notion of time found in Bergson's
concept of *durée* – 'true duration, lived by
consciousness': the gambler is subject to a form of
temporal estrangement, a vertigo induced through his
own proximity to chance, and ultimately, fate. This
experience of playing witnesses the collapse of
homogenous time understood as discreet measurable
units. In this respect it is significant that modern casinos
contain no clocks – the absence of a temporal consensus
reinforces the gambler's subjective experience of time.
This distinction – between subjective and objective time –
finds its expression in many accounts of gambling, as for
instance in the final sequence of Jean-Pierre Melville's
film *Bob le Flambeur* (1955). As the eponymous hero,
having planned a robbery of the casino in order to
recoup his substantial losses, becomes increasingly
immersed in his play at the table through the night, the
theme of time is continuously reasserted. The temporal
precision of the gangster genre eventually gives way to
the drunken temporality of the gambler, as, 'luck, so long
his lady, had made him forget the reason he was there.'
Bob breaks the bank at the casino, but, late for his
rendezvous, is arrested upon his exit.

Whilst the gambler's experience of time is a subjective
one which resists the notion of homogenous and
independent time, this experience remains the antithesis
of Bergson's concept of *durée*. For Benjamin, *durée* was

8 | Walter Benjamin, T*
Arcades Project, 0°2a,
p. 495.

an essentially organic conception of time, in which the past is continuously actualised in the present through the process of memory. The gambler, by contrast, exists always within an evanescent present, continuously repeated, each coup divorced entirely from the last. As such, gambling lacks the historical element so central to the concept of *durée*.[9] Benjamin therefore argues that the accounts offered above by France and Gourdon fail to probe the relationship between gambling and time deeply enough – only engaging with this relationship with regard to winnings and the expenditures they may facilitate. For Benjamin, this relationship is more essential, determined by the repetitious nature of the play itself.

'France is bored', remarked Lamartine in 1839,[10] and it is against this backdrop of an oppressive *ennui* – invoked also by Blanqui and Baudelaire – that the nineteenth century mania for gambling was established. The 'great charm' of games of chance resided in their capacity to free people from the waiting that had so come to characterise the administered society.[11] Since the resolution of each round of play at the table is over in an instant, the condition of the gambler is essentially a temporal one – he seeks to kill time, to expel it: 'time spills from his every pore.'[12] Yet in spite of this frenzied desire for expulsion, the experience of the gambler can only manifest the new temporal regime of industrial society. Benjamin's notion of a 'phantasmagoria' of gambling places the character of the commodity – and the ideological consciousness that it engenders – at the centre of his analysis of nineteenth-century culture. For Benjamin, the phantasmagoria was a deceptive, dazzling image – the lustre with which the commodity producing society surrounded itself.[13] The focus upon the commodified character of nineteenth-century culture is fundamental to Benjamin's use of the gambling motif. If the nineteenth-century proliferation of gambling occurred

9 | Gerda Reith, *The Age of Chance*, p. 141.

10 | Walter Benjamin, *The Arcades Project*, D°4a, 3, p. 110.

11 | Walter Benjamin, *The Arcades Project*, D°10a, 2, p. 119.

12 | Walter Benjamin, *The Arcades Project*, D°3, 4, p. 107.

13 | Rolf Tiedemann, 'Dialectics at a Standstill', in Walter Benjamin, *The Arcades Project*, p. 938.

partly in response to the modern malaise of boredom – an ideological malaise built upon the economic infrastructure of factory labour[14] – this boredom is found to be reinscribed within the gambling experience. The gambler comes to embody the atrophy of experience within industrial society. This atrophy of experience was 'already underway within manufacturing... it coincides, in its beginnings, with the beginnings of commodity production.'[15]

For Benjamin, the experience of gambling was devoid of substance: the play of the idler at the table was the correlate of the factory work of the labourer – the 'ever, ever, ever' that Michelet heard within the 'true hells of boredom' that were the spinning and weaving mills.[16] Forever starting all over again was the 'regulative idea of the game', as it was of work for wages – a 'time in hell, the province of those not allowed to complete anything they have started.'[17] This was the new temporal regime of the nineteenth century – 'a *Now* which is incessantly emptying, always already past.'[18] The condition of the gambler was symptomatic of this temporality. Since the past could never be actualised in each isolated round of betting, the gambler comes to represent an a-historical figure without memory. As Georg Simmel noted: 'On the one hand, he is not determined by any past... nor, on the other hand, does any future exist for him.'[19]

This is the overriding concern of Benjamin's essay 'On Some Motifs in Baudelaire'. Through the reading of Bergson, Freud and Proust he develops a notion of experience in which the function of memory is paramount. What Benjamin identifies in gambling is the negation of this experience. The play of the gambler is likened to the drill of the unskilled machine worker. The experience of the worker within industrial commodity production is a degraded one, with each operation screened off from the

14) Walter Benjamin, *The Arcades Project*, D°2a, 4, p. 106.

15) Walter Benjamin, *The Arcades Project*, M°3a, 3, p. 804.

16) Jules Michelet, 'Le Peuple', in Walter Benjamin, *The Arcade Project*, D°4, 5, p. 109

17) Walter Benjamin, 'On Some Motifs in Baudelaire', p. 175.

18) Walter Benjamin, quoted in Gerda Reith 'The Age of Chance', p. 143.

19) Georg Simmel, 'The Adventurer', in S. J. Levine (ed.), *On Individuality and Social Forms*, Chicago University of Chicago Press, 1971, p. 196.

past. Alain's judgement that 'gambling gives short shrift to the weighty past on which work bases itself'[20] does not hold for the unskilled industrial worker. The emptiness and futility inherent in the work of the wage slave is mirrored by the gambler:

> Gambling even contains the workman's gesture that is produced by the automatic operation, for there can be no game without the quick movement of the hand by which the stake is put down or a card is picked up. The jolt in the movement of a machine is like the coup in a so-called game of chance. The manipulation of the worker at the machine has no connection with the preceding operation for the very reason that it is its exact repetition... The drudgery of the labourer is, in its own way, a counterpart to the drudgery of the gambler.[21]

This vision of degraded compulsion finds its modern corollary in the ubiquity of the slot machine in contemporary gambling cultures, illustrating the prescience of Benjamin's judgement on the effects of commodification and commercialisation on the character of gambling experience.

The modern industrial age brings with it also a new range of stimuli, testing the responses of the individual within the city. Developing the notion of the shock-defence from Freud's *Beyond the Pleasure Principle*, Benjamin described the modern urban condition as one which begets the shock experience, an experience he viewed as being central to the work of Baudelaire. Moving through city traffic or a large crowd would subject the individual to collisions with the anonymous metropolitan masses; new technologies such as photography and film established perception in the form of shocks, as did the commodified signs of

20 | Alain (Emile-Auguste Chartier), 'Les Idées et les ages', in Walter Benjamin, 'On Some Motifs in Baudelaire', p. 173.

21 | Walter Benjamin, 'On Some Motifs in Baudelaire', p. 173.

advertisements in the street. The gambler indulged himself in this shock experience. It is in this respect that Benjamin describes time as being a 'narcotic' for the gambler. The experience of the gambler at the table is immediate. The affective component of games of chance, the acceleration of time that they engender, is decisive in this process of 'intoxication' in the gambler. Benjamin writes of the tendency of gamblers to place their bets at the very last moment, 'when only enough room remains for a purely reflexive move.'[22] As such, the gambler's reaction to chance is a reflex response rather than an 'interpretation'. The image of the gambler in Baudelaire is, for Benjamin, the modern complement to the heroic figure of the fencer. The gambler parries fate just as the fencer parries blows.

Benjamin's gambler is a protean figure: there is much crossover between the characteristics of his various 'types' – the gambler embodies aspects of the physiognomist and the forger, as well as the flâneur. Yet Benjamin finds in the flâneur an idea of resistance, suggesting his idleness is 'a demonstration against the division of labour.'[23] Unlike other thinkers who employed the gambling motif – most notably Bataille and Nietzsche – Benjamin identifies no such resistance in the idleness of the gambler. This may in part be a consequence of the difficulty that he had in 'assigning' the gambler to a specific historical period. For Benjamin, the image of the gambler determinedly reflects the reified experience of the industrial age. Yet, as Missac notes, 'the true gambler is outside the economy, outside time and history.'[24] Benjamin certainly sensed this, and within his image of the gambler a principle of negation may be recognised in the form of waste. The nineteenth century had witnessed an intensification of the relationship between time and money. Gambling squandered them both. Benjamin made

22) Walter Benjamin, *The Arcades Project*, O°12a, 2, p. 513.

23) Walter Benjamin, *The Arcades Project*, M°5, 8, p. 427.

24) Pierre Missac, *Walter Benjamin's Passages*, p. 77.

much of the link between gambling and bourgeois trading on the stock exchange, citing the predisposition of the bourgeois to the gambler's frame of mind.[25] However, the correlation is plainly not that simple, and the gambler's relation to money maintains a necessary ambivalence. As the gambler leaves the casino, money and riches are 'absolved from every earthen weight.'[26] In this regard Benjamin finds in gambling 'a certain structure of money that can be recognised only in fate.'[27]

Yet what is the fate of the gambler? For Benjamin the idea of fate was bound up with the idea of catastrophe. He argues that the gambler is plainly 'out to win', and yet was well aware of the various psychoanalytical positions, elucidated by Freud, Simmel and Bergler, which state in one sense or another that the gambler exhibits a masochistic desire to lose. Through his compulsion always to win the next game, the gambler seals his own fate. As Benjamin notes, 'idleness has in view an unlimited duration'[28] – the gambler never has enough, will always want more. In the term of the neurotic, he maintains always a compulsion to repeat. Missac argues that many of Benjamin's 'types' share with the gambler the creation of an equivalence between the two meanings of the word *Glück* – happiness and luck. The collector who makes a chance discovery or wins a bid at an auction, or the reader who stumbles upon an important passage – both experience the euphoria of the gambler, a euphoria which can endure: the object of the collector can be displayed and admired, the reader can revisit the passage.[29] For the gambler the traces of such euphoria cannot remain. With the odds stacked against him, winnings secured serve only to keep him in the game. The fate of the gambler, ultimately, is annihilation. Through the constant repetition of the shock-experience, the stakes raised ever higher, the gambler 'steers toward absolute ruin.'[30]

25 | Walter Benjamin, *The Arcades Project*, O°4, 1, p. 497.

26 | Walter Benjamin, *The Arcades Project*, O°1, 1, p. 489.

27 | Walter Benjamin, *The Arcades Project*, O°3,6, p. 496.

28 | Walter Benjamin, *The Arcades Project*, m°5, 1, p. 806.

29 | Pierre Missac, *Walter Benjamin's Passages*, p. 80.

30 | Walter Benjamin, *The Arcades Project*, O°14, 4, p. 515.

I would like to thank the Arts and Humanities Research Board for their generous support over the last year.

Albrecht Dürer's third woodcu

REJOINDERS 1
THE SCENE OF THE CRIME

Lorens Holm

Dürer's house

At the end of *The Painter's Manual*, Dürer includes four woodcuts illustrating perspective machines. These scenes are in perspective. They are interiors. In some, a landscape can be seen from a window. The operator stands on one side of his device, his object – sometimes a she – poses on the other. The device, with paper, is always interposed between them. The *Manual* is one of a few early treatises on perspective to include such scenes; most are more interested in the geometry of projection and worked examples.

The third woodcut has several points of interest that distinguish it from the others. The room containing this little drama is ambiguous, not the least because it is situated between light and darkness (see the two windows), as if to indicate that perspective is bracketed

by the two extreme conditions of optical experience. The object of the scene is not a person, but a lute. Although two people are present, the second person is assisting the draughtsman. The device is entirely mechanical, involving no input from the draughtsman's eye. Indeed his eye is not at the eye point or *occhio*; nor is either of them looking at the drawing. (It raises the possibility that the draughtsman is not the artist but only a hireling, and that another person, unseen, directs the operation. From the position of the reader/viewer, or the eyebolt? Only the reader of the *Manual* sees the drawing of the lute; no one else. Finally, the presence in the drawing, of both the lute and the representation of the lute, suggests a regress of representations and representations of represent-ations, which threatens to engulf the reader/viewer.

still life

The two operators appear to be preparing a cartoon of a lute for insertion into Holbein's *The Ambassadors*, which is itself a virtuoso demonstration of perspective. The ensemble on the table demonstrates the logic of perspective projection. The lute (object) is projected from the *occhio* (the eyebolt) onto a picture plane by means of the string (the extrinsic rays), the successive positions of which define the visual pyramid (thank Alberti for the jargon). Paradoxically, the eyebolt is an impossible viewing position, for the wall is in the way. Whence a passable definition of Lacan's gaze as a subject position necessary for the construction of the image but impossible for the subject. The sitting operator can never see the lute from the position from which it is projected on the paper. As if to affirm what we knew anyway – the light and dark windows notwithstanding – that perspective has nothing to do with optics and nothing to do with vision, even though it solicits them.

the scene of the crime

The present project will look at the space implied by Dürer's third woodcut from a number of different viewpoints, in addition to the one from which is it presented, the viewpoint of the reader/viewer. It will speculate about what would happen if you saw the space from someone else's point of view, as for example, the operators', or from one of the windows. A perspective image is always the image for someone. This is a consequence of the fact that a perspective image is projected from a point. So in a sense, this project is no more ambitious than an attempt to generalise the conditions of perspective space. From this completely ordinary space, a simple woodcut of a rather bare, constricted room with no ceiling, we attempt, with the *modus* offered by the evidence and *operandi* of perspective, to reconstruct the subjective conditions that made it possible.

[2.01] Reader's view: the lute slips off the page

[1.02] Plan of the room, of which Dürer's woodcut is the image, including the reader's pyramid of vision

The space of which the Dürer woodcut is the image, is constructed by a process of perspective in reverse. Instead of making a drawing of a lute, from a lute, we make a lute from a drawing. This task is similar to published reconstructions of, e.g., Piero's *Flagellation...* and Velasquez's *Las Meninas*. Or nineteenth-century forensic photography. Except that it was done on a computer using VectorWorks8© – a latter-day perspective machine. Instead of producing drawings of the pictorial space, which – like the painting – are also 2-D, and which therefore can at best give the illusion of 3-D space, it was possible to build and then view a 3-D space with 3-D objects in the computer. For reasons that will become clear, 2-D tracings were then produced of these views. The project depends on the difference between 2-D and three dimensional computer space – the drawing of the view and the view – in a way that the earlier reconstructions could not. You may ask what the difference is between a view and a drawing of a view, especially if both can be printed out, and both appear on the screen. Nothing and Everything. Patience.

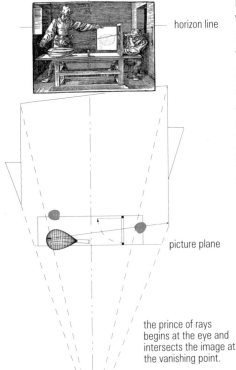

horizon line

picture plane

the prince of rays begins at the eye and intersects the image at the vanishing point.

subject position a

imagine

Dürer's space is represented in plan [1.02]. Like the 'still life' apparatus, it includes the pyramid of vision, with the *occhio* at the apex, and the room at the base. Dürer's image is the picture plane, set into the plan at a point where it sections the visual pyramid. (Start thinking about what the operators [the two football helmets] would see.) Plan [1.05] spins the logic of

perspective out one more step: the drawing of the lute is treated as a picture plane, and an imaginary lute is constructed in a second 3-D space. The relation of imaginary lute to paper to *occhio* is the same as lute to frame to eyebolt, except rotated 90°. In addition, a window has been projected onto the rear wall from which someone might look back at the viewer, as if the drawing of the lute were to be mistaken – following Alberti's formulation of perspective – for a window. (The standing operator has just flung open the window in the back wall and outside floats a lute. He says with a flourish, 'behold!… a lute'.) Every drawing has a rear window.

[2.02] Second position: the rear window slips off the page

Due to the spatial ambiguity of all perspectives we can
ask which plane it lies in: back wall, drawing, or woodcut.

**[1.05] Plan
including the rear
window and lute**

accidents happen

In view [2.01], someone walked into the space and
stopped at the occhio. What he saw should correspond
with what you see, the Dürer woodcut,
for it is the view of the space from the
point from which Dürer's image was
projected, (except that Dürer did not
dwell in the pedant's need for
accuracy). There is an unfortunate but
undeletable diagonal line that bisects
the rear and right walls of Dürer's room.
This has to do with the way
VectorWorks8© constructs surfaces with
holes in them as two separate
U-shaped pieces fit together. As long
as we are viewing a 3-D space, these
lines cannot be removed (the structure
of our world should be so visible).

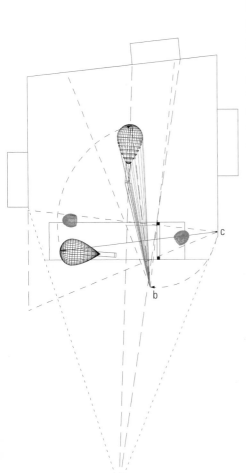

Dürer's room seems rather small
because it is far away. That is the
distance it has to be viewed at in order
to achieve the correct foreshortening
(assuming Dürer's room is right-
angular). Although it looks rather small
on the page, it is not so much smaller
than the size of the postcard of the
Dürer woodcut - relative to your visual
field – sitting on your desk, next to
your keyboard and coffee and half a
dozen paperclips and pencils, as you
read this paper.

The main difference between [2.01] and Dürer's woodcut is that in [2.01] the drawing of the lute seems to have slipped off its page. You can see passed the page to the lute floating behind it. The position from which the drawing of the lute was projected is not the same *occhio*. In Dürer's image, we are already seeing someone else's view of the lute. The woodcut contains two *occhii*, the one from which its picture space was constructed and the one from which the drawing of the lute was constructed. From this second position (view [2.02]), the lute is correctly positioned on the drawing, but now the rear window has slipped.

[2.03] View from the eye-bolt (sitting operator's head deleted for clarity)

From what we might call a common-sense point of view, seeing from a position other than your own, or seeing from two different positions at once is a visual accident. Something about the perspective apparatus, with which we are now familiar, seems not to be functioning. When the apparatus is functioning, there is a unique relationship between the image and the *occhio*, such that only one view is projected upon the plane at a time, which allows for normal viewing relationships. The picture plane is both open window and screen. It lets in a view, but screens out other views. It is a defence against accidental views. Something funny happens when it fails to screen these views; in the case of the lute and rear window, the difference is minimal. It could be worse.

[3.01] Lacan's visual field

How do accidents happen? According to Lacan, our relation to reality is accidental. Reality is only ever encountered as an accident and usually this involves shock or anxiety. When I think of accidents I think of running through the forest on a moonless night and bumping into trees. The trees are not accidental – they may even be an olive grove – it is your relationship to them, which is. Lacan's model of the relation between reality and the viewer is derived from the perspective apparatus. He calls it the visual field [3.01]. A screen is interposed between the subject, who is situated

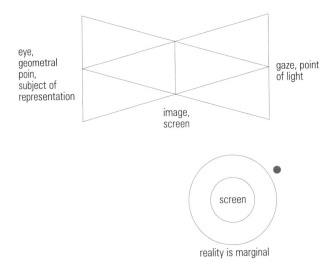

eye,
geometral
poin,
subject of
representation

gaze, point
of light

image,
screen

screen

reality is marginal

at the *occhio*, and reality. Reality is out there, in the form of a focal point of anxiety (i.e. the gaze), but it is screened off by the sensory and conceptual apparatuses, by which we understand and navigate space. One consequence of this model of the psychic apparatus is that even perspectival space, projected upon this screen, screens reality. We never see space itself, whatever that may be, just the image of space projected upon a screen. Even depth of field, in this case Dürer's room which supports our penetrating gaze, is a function of the screen. Once in a while we run into a tree, or get hit by a truck: that's reality, the screen is jolted, the large glass is cracked, even.

[2.04] Standing operator's view (both lutes are outside his pyramid of vision)

and reality is marginal

[3.07.3] Reality slips out from behind the screen

[3.08] Visible/ invisible/unseen

Let's look at the status of the second lute for a moment. The lute's not really there, so it must be imaginary. But its not there in an imaginary 'there'. By invoking the double negative, we could follow Lacan and call it real. Within the imaginary 'there' represented by the woodcut, the drawing of the lute functions as Lacan's screen. When, for whatever reasons, the positions of *occhio*, screen, and object are unstable, as in this 'there', reality – in this case the lute – threatens to slip out from behind the edge of the screen [3.07.3]. Like an inversion of that cruel childhood game, piggy-in-the-middle, the screen tends to stabilise the relationship between the subject and its objects by remaining between them, thus ensuring that the subject remains clothed in its images. This is consistent with Freud's principle of constancy, whereby the subject seeks to maintain or to return to a minimum level of excitation.

If the projection of an image upon the screen is the condition of an

eye, geometral point

screen

gaze, the real lute emerges from behind its image

an unseen object which is outside the apparatus of vision. it registers as anxiety

a visible object

an invisible object which will be made visible when it is clothed in visibility

object's visibility to the subject, then when the lute slips out from behind the screen, it must become invisible. Invisible implies that it could become visible once it were dressed in visibility (like the invisible man), whereas what happens here is that the lute slips outside the apparatus of visibility. See diagram [3.08]. Unseen might be more correct, like the trees at night, with whom our relationship is not so much visual (visible/invisible) but accidental. Accordingly, it does not appear in Dürer's woodcut, and nor do the two operators notice it.

[2.09] View from the real(?) lute

the string gallery

[5.02] Opposite: view from the second subject position, including the picture plane implied by the rear window

[1.07] Plan of the visual field

If [2.01] was the reader's view of the space, [2.04] is the standing operator's, and [2.03] is the view from the eyebolt. [2.09] is the view from the real(?) lute, in which you, the reader, should appear in the background. Altogether, the Dürer image implies a space with at least nine views. Plan [1.07] represents this space as a compilation of nine picture planes with corresponding visual pyramid plus *occhio* (there maybe more, but the criss-crossing complexity of the space is clear). Like Dürer's woodcut, and the drawing of the lute within it, each of these picture planes is a potential drawing. The space is shown to be comprised of all the images – of objects and actual and potential viewers – captured on these picture planes. The plan accounts for the space in terms of the total possible perspectival relationships that occur in the space; at least in so far as these relationships are implied by Dürer's image, the view of the reader. This is as good a demonstration as any of what Lacan means by the visual field. The visual field has the structure of the screen, and is the visual complement to the field of the Other, i.e. language, within which inter-subjective relationships are possible

pp: picture plane

a: the reader

b: the subject position of the drawing

c: the position of the keyhole in the wall

d: standing operator

e: sitting operator

f,g: positions for which the windows are picture planes

h,i: positions of the gaze

[5.03] Opposite: I see what you see me to see, from the eyebolt (sitting operator's head deleted for clarity)

and desire is articulated. The remainder of this project develops the spatial consequences of inter-subjectivity, brings the Other into vision, as it were, a first formulation of which might be who sees who seeing who.

enjoy your private language now

[4.01] is a drawing of the reader's view [2.01] of the space of which Dürer's woodcut is the image. It is in effect a cartoon of the Dürer. It was traced on a separate layer on top of the view. In exactly the same sense, someone might stand in a space, say, the porch of Florence cathedral and trace a *veduta* of the Baptistery (the originary space of modern architecture) on a pane of glass held between the eye and the space. This technique is illustrated in Dürer's first woodcut.

[4.01] A drawing of the reader's view (2.01)

The view and the drawing are different. In the views, walls with windows contain the diagonal lines; in the drawings, those lines can be deleted. The view and the

drawing correspond roughly to perception versus representation, a view of a lute versus a drawing of a lute. Except that a view of a space and a perspective of space become conflated because we think we see both the view and the perspective under the same conditions and they look similar.

(And, since views unfold in space, what difference could there be between a view of a space and a real space, the space itself?) Nowhere is this more so than in the computer, where both appear on the monitor. And yet they are different. The space is 3-D, at least from the point of view of the computer, and hence inhabitable by the computer. By using the walkthrough function, it is possible to glide anywhere in the space, causing the lutes et. al. to look as if they shift alignments, generating any number of views. But you cannot do anything with 3-D space except view it in the monitor.

In contrast, the 2-D space traced from the view, is a plane surface like a sheet of glass that can be selected, cut, pasted, re-inserted into a 3-D space and viewed like any other object in the space. (In order to compare view [2.01] to the Dürer, you have to convert it into a 2-D image, like printing it on mylar).

There is a lesson here about real life. In real life, you cannot do anything with your views except live them privately, whatever that means. They can no more be captured and shared, than your red can be shared with me, until they are represented in words or images. These comments pose problems for any doctrine of the image that holds that the experience of perspective space is prior to its perspective image.

Let's spin the logic of perspective out one more step. From any view of a space, it is possible to do a drawing, and then insert that drawing into the space. This is what happened with the drawing in Dürer's image, this is what happened in plan [1.02] which includes the picture plane. Delete the objects (we no longer need them because we have their images). The resulting space is built only of picture planes, to produce a new space corresponding but not identical to, the original. We can walk around in

it. [6.04] is the standing operator's view of such a space: 3-D, constructed of two picture planes, set at right angles to each other, a drawing of his view [2.04] plus the drawing of the reader's [2.01] (drawings [4.04] and [4.01] respectively). He sees a composite of a) what he sees (a kind of tautology: 'I see what I see') and b) what the reader sees (a kind of inter-subjective relation, for which the corresponding linguistic form is not 'I see what you

[6.04] I see what you see me to see, from the standing operator's position

see' but 'I see what you see me to see'). From this angle, the reader's picture plane aligns more or less with the image of itself on the standing operator's picture plane. [5.03] is a similarly constructed space viewed from the position of the eyebolt. Any other viewer's views could have been used, and viewed from any position. The views get pretty wild. View [5.02] from the second subject position includes the picture plane implied by the rear window. View [7.i-3] is from somewhere in a space which can only be described as refractive. Although these views look like drawings of views, they are actually views of drawings.

[4.04] A drawing of the standing operator's view (2.04)

A word needs to be said here about the numbering system, which may be arbitrary, but at least its almost systematic. Except for the [01.00] series which are plans and the [03.00] series which are explanatory diagrams, all the other series relate to 3-D space. Within these latter series, the decimal number always refers to the same view. Hence view [2.04] and [6.04] are both views from the same position, the standing operator's view. This allows us to get corresponding views from different spaces constructed from different combinations of picture planes. VectorWorks8© remembers view positions via its 'save sheet' function.

[7.i-3] View of a refractive space

This allows you to keep views while changing a space by deleting elements and inserting new ones. I repeat: the [06.00] series space was created from the [02.00] series by deleting all the elements in [02.00] and inserting picture planes instead; only the view positions remain coded in the files. For obvious reasons, I call 'save sheet' the 'absolute space function'. These view positions become the steel rods of absolute reference which pin together these otherwise very different spaces. They are fourth-dimensional.

anamorphism

In these compound views, at least one of the picture planes will always be seen at a raking angle. The image on it is an anamorphism. Anamorphism is a perspectival distortion, in which the image is projected from a point other than the viewer's. Anamorphism is thus the model and sign for inter-subjectivity in the visual field, which is why Lacan was so keen on it. We have to understand these strange and distorted spaces as a consequence of the fact that, because we can share our views, they must have the logic of the 2-D drawing. Shareable – inter-subjective – spatial experience is represented to the viewer as a series of views from someone else's viewpoint.

Delphi

Schemata

1.00 Series plans of Durer's 3-D space

2.00 Series views of Durer's 3-D space

3.00 Series diagrams, mostly Lacanian

4.00 Series drawings of 2.00 series views: picture planes

5.00 Series views of pp's in 3-D space: a, c, i

6.00 Series views of pp's in 3-D space: a, d

7.00 Series views of pp's in 3-D space: a, c + real lute

The question remains, why is someone else's view always an anamorphism? It's the difference between inhabiting a space and standing before a *trompe l'œil* (the view and the drawing of the view). Hubert Damisch says that every perspective, like every sentence, positions a subject. (Henceforth, we will call the *occhio* or the view position, the subject position.) Subject positions relate to perspectives, which are drawings of views, and not to views. (He is not the first, nor is he the last, to assimilate perspective to language.) If the position and orientation of the subject's view is fixed (a condition necessary for perspectival spatial effects) by an eyepiece in a perspective apparatus or certain centralised spaces, the conditions of inhabiting a space and standing before a *trompe l'œil* are indistinguishable. But as soon as the subject moves, it immediately discovers the difference. In real life space, as the subject moves, the space moves. Although the view is always the view of someone, there are only subject (i.e. fixed) positions in perspective

images. (Although we dream of Delphi, voice is always the voice of someone. Only when it is ossified by a sentence, is the subject position determined). Although *trompe l'œil* seems to be space, the rules of the perspective image operate nevertheless. When the subject moves out of the subject position, the subject finds itself out of place, something that rarely happens in real life. In real life, as in a dream, we are immersed in the world of visual experience. To put this in terms of the image, we are always in the picture. And within the frame there are no subject positions, although there may be a vanishing point. As soon as we set this experience aside – frame it – so that it may be communicated (to ourselves or to others, it makes little difference), we step out of the frame. Once out of the frame, once, in other words, we view the scene from the front, outside looking in, view it as if it were a drawing, there is a subject position, and it is possible to be out of place. To refer momentarily to the psychic register again, reality is screened. Because it is screened, there are Others. Because there are Others, it is possible to be out of place.

Why is this perspective scene the scene of a crime? And what crime?

Esau

This playground ditty says it all

> I saw Esau kissing Kate,
> The fact is we all three saw;
> For I saw him,
> And he saw me,
> And she saw I saw Esau.

I want to thank Yeoryia Manolopoulou, UCL, for her insightful criticism of the first draft of this project. She will no doubt see her comments reflected herein.

RICHARD RORTY:
AN INTERVIEW

FABRIZIO TRIFIRO

Richard Rorty is amongst the contemporary philosophers that have tried hardest to change the nature of philosophical activity. Drawing from the teachings of the American pragmatists, he wrote at length against the notion of philosophy as a foundational discipline, the discipline to which the different areas of culture should turn in order to find legitimisation. Philosophical reflection is not the moment at which our mind gets a privileged look at the intrinsic nature of reality. Instead it happens continually and simultaneously with the different intellectual and practical activities by means of which we attempt to deal with and give sense to the world. These are not attempts at getting to how things really are in themselves, but they are attempts at finding the best descriptions to fit with our purposes, our values and our most ingrained beliefs.

There is no place where one can get the privileged, God's-eye overview of the world. The anti-foundationalist stance at the core of this pragmatist position, lies exactly in the conviction of the impossibility of transcending the whole system of our values and beliefs, the impossibility of getting such an unprejudiced view of the world.

We cannot but stand somewhere if we want to think and do anything, we cannot but presuppose certain values and beliefs. These are the values and beliefs in terms of which we evaluate the level of satisfaction of different alternative descriptions of the world and of ourselves.

It follows from this that there is no way to resolve the clashes between different standpoints, practices and cultures in an unprejudiced way. Everyone will defend the beliefs and values that form the frame of reference for his own culture and practices by turning to those same beliefs and values.

Hence, the problem the existence of difference poses us is no longer considered as an epistemological problem, since there is no possible epistemological resolution to it, but as a moral and political one.
We cannot show the absolute superiority of one point of view over the others, we just have to choose what we consider the most appropriate way to deal with conflict situations in the light of our own beliefs and values.

Rorty's moral and political standpoint is the liberal one. From this standpoint the most appropriate way to deal with the plurality of practices and systems of thought is through the pluralist and democratic practice of facing the others in a domination-free conversation.
Once we are loyal to the practice of freedom there is nothing left to be loyal to, no intrinsic nature with which

to match the outcomes of our democratic conversations in order to see if they are the real rational ones. Rationality becomes a moral virtue and, from the liberal point of view, the reasonableness of a tolerant and democratic attitude towards others is a moral virtue. It is consistent with Rorty's anti-foundationalist position that the endorsement of the values and practices of liberalism cannot but be ethnocentric, as is the endorsement of that same ethnocentric conception of rationality.

The ethnocentric description of rationality fits better with the values of a conception of the place of human beings in the world which replaces the metaphysical reality beyond the world we live in, and the interests and values we live for, with ourselves and our fellow human beings as those to whom we are eventually accountable.

Most of Rorty's critics have, in his abandoning of metaphysical conceptions of reality and of rationality as thought corresponding to such reality, seen a threat to the notion of rationality itself and hence to the conquests that our culture has achieved through the practices of rationality. Of course, Rorty's anti-foundationalism is a threat to the metaphysical conception of rationality and hence to any culture that makes its ultimate frame of reference an extra-wordly reality, since it stands in direct opposition to such frameworks and conceptions.

But it is not the kind of relativist threat, which jeopardizes the critical faculties our secular culture stands on, as most of his critics have thought. His position does not lead to the conclusion that any position is as good as any other. On the contrary, his ethnocentrism points to the fact that we cannot but start from the network of beliefs and values that form our frame of reference in the world, and cannot but consider

those same values and beliefs as the best to live with. It is just that we do not have any reasons for considering those beliefs and values as the most appropriate ones to live with other than those furnished by those very same values and beliefs. It is actually the very metaphysical framework of thought that engenders relativist conclusions. Only by thinking that truth and rationality correspond to reality itself, could abandoning the project of reaching such a reality drive us to abandon also any sense of rationality, any way to distinguish between true and false.

FABRIZIO TRIFIRO

The position you have been exposing and developing in the last thirty years is often referred to as a form of neopragmatism. The major influence that James and Dewey have had on your thinking is something that you have acknowledged openly throughout these years. What are the main lessons to be learnt from the pragmatists?

RICHARD RORTY

The main lesson they taught us is not to ask: 'Are we being faithful to the way things really are?' But instead to ask: 'Are our ways of describing things the best ways we could use to fulfill our various purposes, or are there other descriptions the use of which would do more for human happiness?' In short, the pragmatists helped us to get over the idea that truth is correspondent to the intrinsic nature of reality and that we are responsible for something other than our fellow humans.

FT

The anti-foundationalism at the core of your thought breaks with a dominant tradition in philosophy, the one which sees the role of philosophy as that of a tribunal of reason adjudicating the truth of our beliefs and values, so that we are not led astray from the right path. What alternative account of the role and character of philosophical reflection do you prefer to the foundationalist one?

RR

I see philosophical reflection as a matter of thinking about alternative descriptions of ourselves and our situations, playing them off against one another and deciding which of the presently available alternatives might be best to use. I do not think that there is a neutral tribunal, using eternal standards before which such descriptions can come. We should substitute the notion of a tribunal with that of an ongoing conversation.

FT

Have your views on philosophy influenced your leaving the department of Philosophy for that of Cultural Studies?

RR

I find it easier to teach outside a philosophy department because it gives me more freedom in what to teach, and also because my unfashionable views create tensions with my colleagues in philosophy departments. But this is a matter of convenience and of making my life simpler, not a matter of ideology.

FT

Acknowledging the impossibility of grounding one system of beliefs and values over all others implies that when different points of view face each other there is no possible way to resolve the contrast without

prejudice. What do you think we are left with for handling conflicting beliefs and interests once the possibility of an appeal to a neutral ground has been denied? And similarly, considering the way you sketched your anti-foundationalist position in the context of the relationship between the concepts of 'freedom' and 'reason', writing that 'once we take care of freedom truth will take care of itself', what ways do you think are at our disposal for taking care of freedom?

RR

If we have what Habermas calls *Herrschaftsfrei* conversation, then we don't need neutral tribunals. The upshot of any such conversation will doubtless look partial and prejudiced to some later generation, but there is nothing we can do about that. We should just accept the fact that thought and civilization and morals will progress beyond the historical epoch in which we find ourselves. If free inquiry and free conversation continue, our descendants will hold less partial and less prejudiced views than ours. This sort of progress has no destined termination. It can go on forever.

FT

What means do you think are at our disposal for taking care of freedom once any appeal to a neutral tribunal has been discarded?

RR

We can keep inquiry and conversation free by the usual, familiar means developed in the west since the enlightenment: universal literacy, careers open to talents, a free press, free universities and the like.

FT

How do you see the relationship between anti-foundationalism and liberalism?

RR
Making freedom rather than correspondence to reality our goal means taking liberal politics as the ultimate frame of reference, rather than any set of religious or metaphysical beliefs about what sort of thing reality is.

FT
Though it is possible for an anti-foundationalist to be un-liberal, can a genuine liberal be a foundationalist? Is there not a clash between foundationalism and liberalism? What I mean is this: even if foundationalism were a viable project, how could a defence of freedom be anything but anti-foundationalist?

RR
Habermas believes himself to be giving a foundationalist defence of freedom. I don't think it works, but I don't think there is anything incoherent in the attempt. I've argued that there is nothing in the nature of communication that requires us to hear the other side and respect others' points of view. That's why I don't think that Habermas' attempt to use 'communicative rationality' as a grounding for democracy works.

FT
How do you see the relationship between the concepts of freedom and reason?

RR
Persuasion is rational just insofar as it is free. We say somebody has been irrationally persuaded rather than brainwashed or intimidated if he or she is able and willing to canvass all the relevant alternatives, discuss their advantages and disadvantages, patiently hear the other side, and so on. There is nothing more to being rational than making decisions as a result of that sort of reflection rather than as a result of threats of force or of deprivation.

FT

Although you deny the possibility to find the God's-eye overview from which it would be possible to give a metaphysical foundation of our beliefs and values, you recognise as utterly unproblematic the use of words like 'true', 'rational', 'good' and those of similar normative notions, when this use remains grounded within our metaphysically ungrounded languages. Could you clarify the character of this innocuous internal use of our normative notions? What are the characteristics of the normative notions that a satisfying account of them should take in considerations?

RR

We don't need a 'satisfying account' of these abstract terms. We just need to free them from the grip of what Heidegger called the 'onto-theological' tradition; stop treating them as the names of mysteries and start treating them as compliments to people or beliefs or actions. We know how to offer such compliments and we do not need definitions of these terms in order to do so.

FT

Yet the use we make of these abstract terms does have particular characteristics. I'm referring to the sense of transcendence and absoluteness typically attached to them. Do these characteristics of our normative notions represent a problem for an anti- foundationalist position?

RR

I cannot see that the attempt to endow these normative notions with transcendence or absoluteness comes to more than an attempt to find a God-surrogate. A way of keeping the advantages of religion without the belief in a deity. Trying to so endow them seems to me to just keep the philosophical pendulum swinging between scepticism and dogmatism.

FT

When critics of relativism present examples of intellectuals maintaining a relativist position your name is usually included in the list. Yet since your first works you have denied being a relativist, ascribing to yourself a position that in more recent years you have been calling 'ethnocentrism'. But many of your critics still think that your ethnocentrism is not enough. What do you think your critics intend when they call you a relativist and say that your ethnocentric position towards matters of justification is not enough to avoid the pitfalls of relativism? What do you understand a relativist position to consist of, and how do you see your ethnocentrism as differing from it?

RR

If there were any relativists they would be people who said that any belief is as good as any other. Nobody says that and nobody could act on such a maxim. The struggle among philosophers is not about whether to be relativists but about whether there is a way of getting outside of the historical situation we are in; the complex of beliefs and desires we presently share, other than hoping that the future will produce people wiser and better than ourselves.

FT

What do you think is at stake in these debates concerning the issue of relativism?

RR

The same thing that is at stake between the churches and the secularists, the issue about whether human beings have anything to rely on save each other, any recourse save further conversation. The issue is about whether there is something standing outside of the contingencies of our historical existence with which we might hope to get in touch.

To Archie Sh

IN A BLACK NIGHT, FIRES AS BURSTS OF LAUGHTER:
NOTES ON JAZZ AND PROTEST

Pierandrea Gebbia

Revolutions swing, they don't sing

— Malcom X

In his book *The Jazz Scene*, Eric J. Hobsbawm writes: 'Jazz is not simply an ordinary music, light or heavy, but also a music of protest and rebellion. It is not', he goes on to add, 'necessarily or always a music of conscious and overt political protest, let alone any particular brand of political protest; though in the West, in so far as it has had political links, they have been pretty invariably with the Left.'[1] If one agrees that protest means a *collective* form of criticism and rejection of the existing political or social order, which may well be organised by trade unions or by political movements, then Hobsbawm is perfectly correct when he states that, historically speaking, Jazz has not been a music of political protest because it represents a personal and basically individualistic form of expression.

1 | Eric J. Hobsbwam (Pseud. F. Newton), *The Jazz Scene,* Harmondsworth: Penguin, 1961, p. 253.

NOTES ON JAZZ AND PROTEST

Unlike Gospel music and the song of protest of the Whites, it constitutes a reluctant voice for collective aspirations and feelings. Moreover, Jazz has very rarely been associated with active, organised politics and when this has happened, direct, explicit and homogeneous links have never been established because 'a good many of the protests and rebellions which Jazz has at one time or another embodied leave politicians cold and unsympathetic'.[2] It cannot be held, however, that, leaving aside political protest, Jazz is a complete stranger to every form of protest. It would be untrue to say that Jazz has never expressed any attitude or form of behaviour reflecting opposition, dissatisfaction, discomfort, desire for change of a social, political or racial nature. Jazz as music genre 'lends itself to any kind of protest and rebelliousness much better than most other forms of the arts.'[3]

In the eyes of the white public in Europe and the United States, Jazz, because of its musical and extra-musical characteristics, has been particularly suitable as a means of protest capable of taking on a markedly political overtone, although to a lesser or greater extent unconnected with its creators and original public. This is demonstrated by the ongoing association between the left-wing cultural backdrop and, at times, the Left itself, and Jazz music in as much as it is music of an oppressed and exploited minority, subjected to heavy racial discrimination, but generally passive and lacking any sort of political awareness.

It is the anti-racist and pro-Afro-American character of Jazz that lies at the heart of the association between Jazz and left-wing political protest, related to the idea of solidarity with the proletariat and the anti-capitalist stance which has been a theme of the Left from the earliest days

2 I Ibid.

3 I Ibid., p. 254.

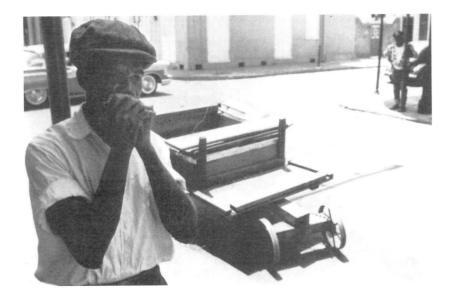

right through to the New Left of the Sixties and beyond. This association, although based upon the social and racial condition of the Afro-American community and above all colonialism, which led to their being brought to American soil with all the horrors associated with deportation and slavery exploitation, is to a certain extent much too mechanical and fraudulent and is strewn with contradictions, or at least has been so in the past.

Hobsbawm recollects that 'the French boys and girls who, in 1942, were arrested by the Germans in the Paris Métro dressed in "flash, impertinent, provocative suits and dresses, and wearing a badge with the words «un France swing dans une Europe zazoue»", can only just be fitted into the category of the anti-Nazi resistance, even though several of the poor things ended in labour camps'.[4] He vividly illustrates here the very vital nature of the protest expressed by Jazz music and the political characteristics its appreciation and diffusion has

4) Ibid., p. 253.

assumed, especially in police states or under oppressive regimes, such as Vichy France or the East European dictatorships. It was a vague and ambiguous form of protest, but nevertheless very dangerous for those regimes, in so far as it was spontaneous and individualistic and, rather than being political or politicized, at least up until the Sixties, it was libertarian and anti-authoritarian as it was linked, from the socio-psychological point-of-view, to that special phase in the process of self-individuation which is enacted during adolescence with its typical opposition to authority and the values of the family and society.

Hobsbawm's remarks show, furthermore, that long before the Sixties, during the Second World War, music was the principal means of expressing youthful protest and adolescent's dissatisfaction, along with their dress ('dressed in "flash, ... provocative suits and dresses"'), social behaviour ('... impertinent ...') and way of talking (*'swing'* and *'zazoue'*). 'Zazoue' is a slang term used by Jazz-lovers and French youths to express their passion for Jazz music and it was already imbued with an oppositional overtone, but also, as in the case cited, used to protest subtly or indirectly against the French situation, with the whole country occupied by German troops and run by the collaborationist Vichy government. The example is reminiscent of *Risorgimento*, when Italian patriots protested against the Austrian dominion by writing *'Viva Verdi!'*'on the walls of the cities. This to all appearances was paying homage to the Italian composer but, in fact, was a patriotic salute to 'Vittorio Emanuele Re D'Italia'.[5]

The fear and suspicion which Jazz music engendered in dictatorial regimes of the last century, and the opposition which arose between Jazz music and the ideologies on

5 | *Viva Vittorio Emanuele Re D'Italia* – (Long Live Victor Emmanuel King of Italy).

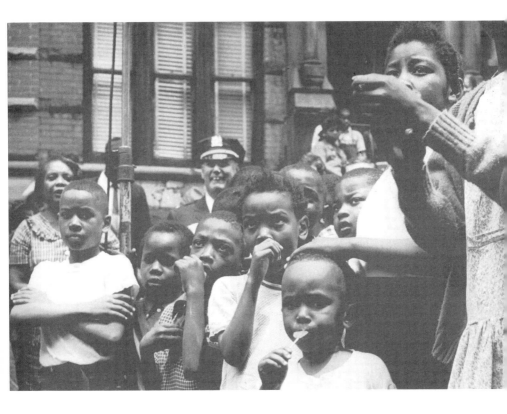

which those regimes were based – after a certain time
those from the Left included – can be explained by the
fact that the protest represented by Jazz, a form of
music that is based upon the refusal of the styles
followed by previous generations of musicians and
listeners, can be transformed under special social or
economic conditions, not all of them negative. The
transformation from a vague, ambiguous, unwilling or
veiled form of protest into a direct and self-aware
protest bordering on open rebellion, albeit neither
organised nor politicized, is due to an increase in the

pressure or repression of diverse and composite factors such as social, political, economic, generational and sexual factors. As the Czech writer, Josef Skvorecky, who, for political reasons, emigrated to Canada in 1969, has written:

> At the outset, shortly before the Second World War when my generation experienced its musical revelation, Jazz didn't convey even a note of protest ... And no matter what LeRoi Jones says to the contrary, the essence of this music, this 'way of making music', is not simply protest. Its essence is something far more elemental: an *élan vital*, a forceful vitality, an explosive creative energy as breathtaking as that of any true art, that may be felt even in the saddest of Blues. Its effect is cathartic. But of course, when the lives of individuals and communities are controlled by powers that themselves remain uncontrolled – slavers, czars, führers, first secretaries, marshals, generals and generalissimos, ideologists of dictatorships at either end of the spectrum – then creative energy becomes a protest.[6]

Irrespective of its ever varying, composite, multi-faceted nature, this protest may be more or less self-aware or spontaneous, forthright or veiled, active or passive, escapist or engaged. In any event it will never be able to be brought down to any single historical or, even less, political common denominator which eludes differences in nature and value – themselves political and historical – in so far as 'the protests which white intellectual Californian tramps, or British teenagers, or Johannesburg Africans, or Moscow *stilyagi*, seek to express through it that they differ from one another, and from those of various groups of American Negroes. They are also,

6 | Josef Skvorecky, *The Bass Saxophone*, trans. Kaca Polackova-Henley, London: Picador, 1980, p. 7.

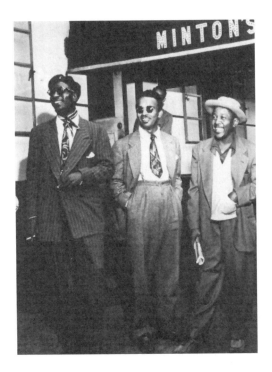

incidentally, of unequal seriousness. It would be foolish to reduce them all to a single denominator. They do, however, have this in common. Jazz by itself is not politically conscious or revolutionary.'[7]

The protest of Jazz therefore evades a universal specific definition and continually changes form and nature in such a way as to be hardly possible to cast upon it any specific connotation, as Skvorecky so well recalls in certain passages on the choice of the name of the Jazz band he played in as a young man:

> Our band was called Red Music which in fact was a misnomer, since the name had no political connotations: there was a band in Prague that called

7 I Eric Hobsbwam, *Th* *Jazz Scene*, p. 263.

itself Blue Music and we, living in the Nazi
protectorate of Bohemia and Moravia, had no idea
that in Jazz blue is not a colour, so we called ours
Red. But if the name itself had no political
connotations, our sweet, wild music did; for Jazz
was a sharp thorn in the sides of the power-hungry
men, from Hitler to Brezhnev, who successively
ruled in my native land.
What sort of political connotations? Leftist?
Rightist? Racialist? Classist? Nationalist? The
vocabulary of ideologists and mountebanks doesn't
have a word for it.[8]

Early Jazz, that sprang from the socio-cultural
background characteristic of turn-of-the-century New
Orleans, was the musical expression of the protest of the
poorest working classes. It was 'the product of
unselfconscious popular musicians, playing as such
musicians have always played, for an unselfconscious
public which wanted to be entertained'[9] and to have their
minds taken off the harsh realities of their daily life as a
socially oppressed minority, economically exploited and
racially segregated. In fact, there is no doubt that racial
segregation and social oppression have been the key
factors that influenced the development of Jazz. Over the
years they have assumed even greater importance as,
little by little, social and racial contradictions and conflicts
have gradually become more acute and Jazzmen more
and more aware of their conditions as Blacks and, above
all, as artists.

Worksongs had already been strongly coloured by the
experience of oppression which Afro-Americans had
undergone, as they were sung in order to establish the
rhythm which co-ordinated the movements of the slaves
in their toils and were especially necessary at moments

8 | Josef Skvorecky, *The Bass Saxophone*, p. 7.

9 | Eric Hobsbwam, *The Jazz Scene*, p. 65.

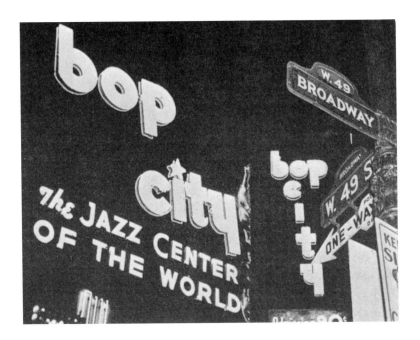

of greatest effort. Thus, the words which accompanied the forced labour expressed resentment at their condition of being slaves, and hatred for the overseers. However, singing was very often not a spontaneous activity but rather one that was imposed on the slaves by the overseers themselves who must have feared possible outbreaks of revolt or the development of fights. In this way they tried to fan the flames of social resentment which was also at the root of Jazz protest and had already found its expression both in the Spirituals, with the religious hope of overcoming the social oppression, and the Blues.

It was in the Blues that this sense of resentment, more often than not latent but at times manifest, had peaked coming to represent an original Afro-American form of expression that had already, for its musical

characteristics, represented an indirect protest against the dominant culture, made more explicit by the lyrics, referring as they often did to the hardships of day-to-day existence brought on by a hostile and unjust society. Theodor W. Adorno noted in relation to this early period that the 'Negro Spirituals, antecedents of the Blues, were slave songs and as such combined the lament of unfreedom with its oppressed confirmation.'[10] He went on to say that 'everything unruly in it [Jazz] was from the very beginning integrated into a strict scheme, that its rebellious gestures are accompanied by the tendency to blind obeisance.'[11]

Adorno presents a clear picture of the nature of the protest expressed in Jazz music as in the Negro Spirituals and the Blues, but it is the sort of protest which cannot hold any meaning for those who do not understand the reaction of Blacks to social oppression. This reaction clearly reflects the origins of Jazz and especially of the Blues, two forms of music that arose from the world of disorganised and exploited workers and the subproletariat whose complete lack of any social awareness, bordering on fatalistic acceptance, lay at the root of the tragic and hopeless outlook of the Blues. It was typically mixed with self-critical irony and self-contempt which, on the one hand, directed the protest of the oppressed upon themselves, for fear of possible repercussions if protest was expressed openly, and which on the other hand, permitted a socially acceptable expression of the protest against their own conditions and the resentment and social aggressiveness – for too long repressed – which ignites that protest.

We may state unequivocally that it is this socio-psychological root of the Blues protest which lies at the foundations of Jazz music. In the Blues we find a severe

10) Theodor W. Adorno, 'Perennial Fashion – Jazz', in *Prisms*, trans. Samuel and Shierry Weber, Cambridge: MIT Press, 1981, p. 122.

11) Ibid.

condemnation of the ruling classes and the dominant race, impossible to express this openly, but which, under a blanket of sadness and apparent desperation, conceals an almost militant form of protest and also a glimmer of hope, even if that hope can only be referred to in the future as a hope for better days to come.

This form of protest was a fundamental component of the Blues but, as in the case with Jazz, it is only with difficulty that it lends itself to a proper political use or interpretation. The same is true of choral singing, be it religious hymns or lay chanting, to whose forms the Blues singers always turned when they needed to sing about collective salvation, 'whether secular through the union, or religious through the churches.'[12] The Blues singers thus came to adopt the language of the church hymn or the Gospel song, which was more suitable than that of the Blues.

Jazz has the same social origins, with some distinctions, as the Blues and having been deeply influenced in musical terms by the Blues, it maintained all of the above characteristics. Its pioneers never openly protested against their condition at the very same time as musicians like William C. Handy or Louis Armstrong 'could write or sing about "darkies", "piccaninnies", and "coal-black mammies" as if they did not realize that these are insults and fighting words to the self-conscious Negro.'[13] Just as with the Blues, where awareness of one's social condition is masked by self-critical irony or revealed by self-contempt, Jazz represents a form of indirect and allusive, even veiled and hidden protest, the nature of which is vaguely social and partly racial and sexual, but by no means openly political or politicized.

This strategy of escapism from the unavoidable realities of oppression, which was considered 'eternal and

12 I Eric Hobsbwam, *The Jazz Scene*, p. 151

13 I Ibid., p. 203.

unchanging' and consequently accepted as such, did in fact have, as is usual in periods of relative social and political stability of the sort America enjoyed up to the Sixties, its own outcome in a music which could well be defined as accommodating, happy, almost cordial. Indeed, Jazz music – with the exception of Free Jazz – is 'almost certainly the socially best "adjusted" music ever evolved by American Negroes, the product of a cruel and unjust society, but one in which the Negro was allowed considerable emotional certainty and security so long as he "kept his place" within the ghetto where he played for other Negroes.'[14] Real protest was thus confined to a few rare exceptions where Blues singers without a trace of commiseration, even though not usually prone to protest, gave expression to the total lack of hope of the forsaken, the oppressed and exploited, in songs like Bessie Smith's *Gimme a pigfoot and a bottle of beer* and Billie Holiday's *Strange Fruit*.

Up to a certain point in its history, Jazz was a purely spontaneous musical genre, free from any strong commercial pressures and quite independent of its public's taste, created in a spontaneous and often extemporaneous fashion, in order to satisfy not the requirements of individual aesthetic expression, but the collectively felt need to enjoy oneself and to distract oneself from the difficulties of daily life, such as a hard day's work or a bereavement. In fact, in the social environment of New Orleans, a public endowed with musical and aesthetic awareness that was ready to be commercially exploited did not yet exist. While this music loving public developed at a later date and arrived to express its various preferences and tastes, it could be said that this minority, within certain limitations, rather than guiding the evolution of Jazz, simply accepted and followed it.

14 | Ibid., p. 259.

With the arrival of modern Jazz, from 1941 onwards,
musical creation was established almost exclusively as
an activity carried out *by* musicians *for* musicians. These,
in opposition to the social and aesthetic conventions of
earlier generations, approached Jazz with a spirit of
experimentation and were interested in technical
innovations, their results being destined for a select set
of *cognoscenti* who had all the sociological hallmarks of
a minority cultural group. These two characteristics – on
the one hand, spontaneity in the aesthetic expression,
and on the other hand, a tendency towards an ever
greater individuality both musical and extra-musical –
have been peculiar to Jazz from the early days and
visible throughout its history as they are interwoven with
the protest which Jazz itself represents in as much as
musical expression of the strength of a minority that 'has
also been played as a manifesto – whether of revolt
against capitalism or commercial culture, or of Negro
equality, or of something else.'[15]

If we consider the musical revolution and protest which
Bebop and Free Jazz represent as being in some respects
the natural consequence of the preceding Jazz music
styles and the outcome of its original characteristics and
tendencies – with their complement of a spontaneous
and individualistic protest – there is no doubt that we are
dealing with a conscious and intentional breakaway from
the past and an ideological revolt, besides the purely
musical aspects of it. Even the Dixieland Revival in
America and especially in Europe, while starting off as a
rebellion against modern capitalism and all its produce,
including modern Jazz which was considered far too
elitist or commercialized, and the exclusive stomping-
ground of a handful of white intellectuals, turned into a
genuine mass movement, because of its anti-
commercialism stance and its musical appeal. Not

15 | Ibid., pp. 65-66.

surprisingly, Dixieland was banned both in Germany, during National-Socialism, and in the USSR because of its 'subversive' potential and widespread popularity, after first being accepted during the pre-Stalin period. As Skvorecky recalls:

> Totalitarian ideologists don't like real life (other people's), because it cannot be totally controlled; they loathe art, the product of a yearning for life, because that, too, evades control – if controlled and legislated, it perishes. But before it perishes – or when it finds refuge in some kind of *samizdat* underground – art, willy nilly, becomes protest. Popular mass art, like Jazz, becomes mass protest. That's why the ideological guns and sometimes even the police guns of all dictatorships are aimed at the men with the horns.[16]

In the same way, modern Jazz and other forms of Afro-American dance music like Boogie-Woogie were looked at askance or even treated with open hostility by the political authorities of Socialist countries, ever ready to ban and suppress the playing of Jazz and to place obstacles in the way of the development of a community of Jazz musicians and listeners. This was due to the 'dangerous' diffusion among the young of a form of music that was considered a symptom of bourgeois 'decadence' and as such was to be fought against from within by every means available, including prohibition by law, but whose presence in other countries was considered instead an external revolutionary agency, according to Andrej Zdanov's axiom, who purported, as Minister of Culture under Stalin, that the Afro-American struggle had become by that time a revolutionary struggle and therefore their music was *ipso facto* revolutionary.

16) Josef Skvorecky,
The Bass Saxophone,
p. 8.

The fate of Jazz in Socialist countries until the second half of the Sixties was the same as that of the best Soviet musicians and composers, Dmitrii Shostakovich representing a case in point. Their fate was one of self-censorship and creative self-abasement or personal and professional marginalization with the burden of all the problems of daily survival – not only material, but also moral and artistic survival. They accepted abandoning themselves to a life based on double ethics and an attempt to slip somehow in-between the gaps and crevices left open in the edifice of society built by state censors, party theoreticians and police spies.

Hanns Eisler, who cannot be considered a dim-witted dogmatic party functionary, had this to say: 'It is quite clearly necessary to ban specific forms of mass hysteria, like American Jazz as it is practised by certain American religious sects. If this is the direction things are heading in, what with chairs being smashed up and cigarettes being stubbed out in the palms of unwilling ticket collectors in the underground by youths under the influence of Boogie-Woogie, then I am all for a police ban. In these circumstances I shall behave like the most obtuse of marshals'[17]

The worst threat, which Jazz and other types of music of Afro-American origin presented to the cultural and political authorities of Socialist countries, was inroads made by Americanism or more precisely the *political* influx in those countries of Americanism and of all things western that came hand-in-hand with the American culture industry and its aesthetic values. The political-aesthetic position towards Jazz, adopted by the Soviet authorities from 1935 onwards, of extreme opposition to it and imbued with anti-Americanism, anti-occidentalism

17) My translation from Hanns Eisler, *Con Brec* *Intervista di Hans Bung* trans. Luca Lombardi, Rome: Editori Riuniti, 1978, p. 52. Originally published as *Fragen Si mehr über Brecht. Han Eisler im Gespräch,* 1970.

and the refusal of any form of bourgeois 'decadence', fell into contradiction because of the tendency to approve of Jazz as being the musical expression of a socially oppressed and economically exploited minority that was a victim of the capitalist system.

This contradiction was felt to be a burden by every left-wing Jazz lover and particularly by the Afro-American intellectuals and artists sympathetic to the US Communist Party. It was combined with the theoretical and practical difficulties faced by American communists about how to deal with the political problem of the widespread racist attitude of the white working classes in urban areas as well as with the 'black question' – the question of race in its relationship with the long term prospects of the struggle for Socialism in America.

It was a question for which no proper solution was ever to be found on a theoretical level, and which, on a practical level, ended up seriously hampering the activities of the US Communist Party, eroding its influence over the whole revolutionary left-wing and Afro-American intellectuals and artists, especially after the end of the Spanish Civil War. Personalities like the great black poet Langston Hughes, who had become attracted to Marxism in the terrible Depression years towards the end of the 1920s, still envisaged, shortly after his experience as a war correspondent in Spain on the Republican side, a state of universal working-class solidarity in which a black might find his true identity. Just a few years afterwards he wrote: '"But Jazz is decadent bourgeois music," I was told, for that is what the Soviet Press had hammered into Russian heads. "It's my music," I said, "and I wouldn't give up Jazz for a world revolution."'[18]

18 | Quoted in Josef Skvorecky, *The Bass Saxophone*, p. 6.

While Communist Jazz fans in Europe, with the sole exception of the USSR, also felt the burden of these contradictions, at least until the end of the Second World War, they simply put them to one side or considered them 'as an aberration, due to ignorance, or at best as something due to purely local Russian conditions'.[19] In any case, 'far from taking notice of Russian views, British Communist journals printed serious Jazz reviews continuously even in the peak years of "Zdanovism".'[20]

Just as there is no doubt that for most of its history, Jazz has represented a meaningful form of protest both for those who played it and for those who listened to it, irrespective of the style of Jazz being played, there is also no doubt that the association between Jazz music and social or political protest derives from the fact that the slave origins of Jazz give it a cognitive connotation which is generally accepted, without a quibble, to be political. Nevertheless, the political character and effectiveness of music in general and of Jazz in particular – especially Free Jazz – is still open to debate since confusion has arisen between the political image of Jazz, which is a thorny issue, and the political influence of music, and above all Jazz.

If Jazz has functioned at times as a form of social protest, on rare occasions as a form of political protest, and sometimes as an individualistic and cultural protest, if in times gone by it was the mouthpiece of a spontaneous popular mass protest – expressed, perhaps, in a private or extra-musical fashion – and if today it increasingly represents an exclusively musical, elitist and even snobbish form of protest, throughout all phases of the development of its history and sounds, 'we must hear the distant roar of battle.'[21]

19) Eric Hobsbwam, *The Jazz Scene*, p. 253

20) Ibid.

21) Michel Foucault, *Discipline and Punish*, trans. Alan Sheridan, Harmondsworth: Penguin, 1991, p. 308.

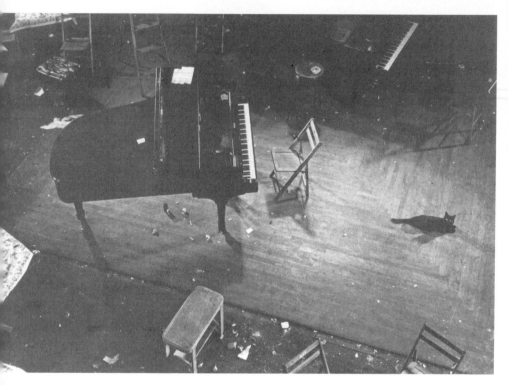

Five A.M

Photo: Gjon Mili

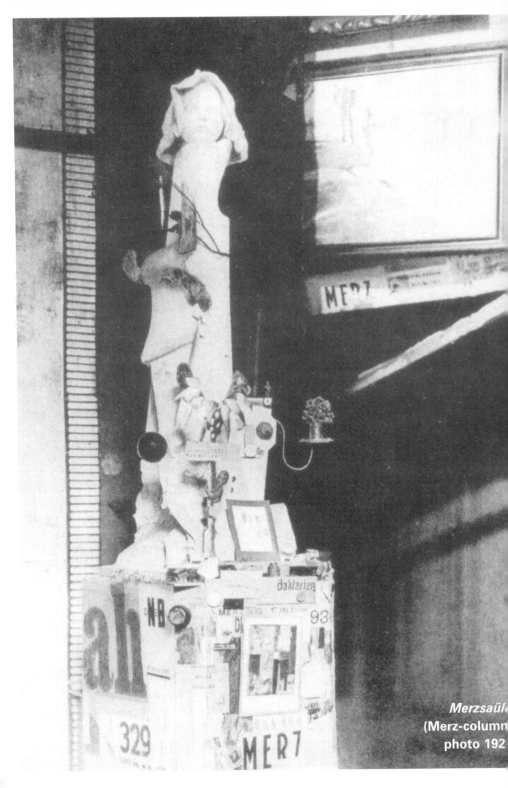

Merzsaül
(Merz-column
photo 192

'IT'S ALL CRAP'
SCATOLOGICAL ELEMENTS IN KURT SCHWITTER'S HANOVER MERZBAU

Bernard Vere

> The past exists as it is included, as it enters (into)
> the synchronous net of the signifier – that is, as it is
> symbolized in the texture of the historic memory
>
> — **Slavoj Žižek**[1]

The *Merzbau* was the vast interior sculpture/collage that
Kurt Schwitters, founder and sole practitioner of the *Merz*
movement, created in his own house in Hanover
between the late 1910s and his departure for Norway in
1936, just prior to his inclusion in the Nazi's 'Degenerate
Art' exhibition. The *Merzbau* grew out of Schwitters'
studio until it came to consume the space available to
him, even including a column extending through the
skylight, linked by stairs to a platform on the roof, and an
old well below the basement. Schwitters filled this space
with a combination of columns, collages, grottoes and
rooms, linked by a series of Constructivist-inspired
connecting sculptures.

The grottoes and rooms were given themes. In addition
to its overtly scatological elements (bottles of urine,
camel dung, the figure of the 'Female Lavatory Attendant
of Life' and a lavatory), there are numerous grottoes

1) Slavoj Žižek, *The
Sublime Object of
Ideology.* London: Verso,
1989, p. 56.

127

devoted to Schwitters' acquaintances: Walter Gropius; Mies van der Rohe; Hans Arp; Naum Gabo; El Lissitzky; Hans Richter; László Moholy-Nagy, Kazimir Malevich; Raoul Hausmann; Herwerth Walden, Theo van Doesburg; Sophie Täuber-Arp; Hannah Höch; and Piet Mondrian. Such grottoes typically contained some personal belonging, for instance, Richter's contained a piece of his hair, another contained a sample of the subject's urine. There were also grottoes devoted to wider cultural themes. Examples include a grotto devoted to Goethe, a Luther corner; a *Nibelungen* Hoard and the *Kyffhäuser*. Counterposed to these are other, less vaunted aspects of contemporary German culture: the cave of murderers; the cave of sex murderers; the cave of the deprecated heroes; and the cave of hero worship.

The whole work contained examples of Schwitters' *Merz* collaging technique, incorporating newspaper cuttings, street rubbish and personal artefacts in the work. In 1943 Hanover, a target of Allied air-raids, was bombed and the *Merzbau* destroyed, a fact which has only given the work a more enigmatic quality. SubsequentlySchwitters began two more *Merzbauen*, one in Norway (also now destroyed) and one in Elterwater in the Lake District (now at the Hatton Gallery of the University of Newcastle). If these owed something in form to the Hanover *Merzbau*, they owe nothing in scatological content and so have not been considered in the present essay.

The *Merzbau* has been a notoriously difficult work to define. It lacks the unity that classicism demands from its works of art. Three major books on Schwitters have attested to it as 'a baffling work';[2] one that 'demands close analysis, but has resisted it;[3] and its 'essential opacity'.[4] Instead of a unity, it is perhaps better to follow Mikhail Bakhtin and talk of a 'dialogic structure'. Although

2) John Elderfield, *Ku*
Schwitters, London:
Thames & Hudson, 19
p. 161. This represent
something of the
difficulties on writing
the *Merzbau*; four pag
previously (p. 157) it
been merely 'puzzling'

3) Dorothea Dietrich,
*Collages of Kurt
Schwitters: Tradition a
Innovation,* Cambridge
Cambridge University
Press, 1993, p. 167.

4) Elizabeth Burns
Gamard, *Kurt Schwitte
Merzbau: The Cathed*
of Erotic Misery, New
York: Princeton
Architectural Press,
2000, p. 115.

5) Ernst Schwitters,
Kurt's son, puts the
number of these work
around 4,000, roughly
equal to the number o
more abstract works
completed. Quoted in
Sarah Wilson, 'Kurt
Schwitters in England
catalogue *Kurt Schwit*
and the MERZbarn,
Hatton Gallery,

many of the objects, grottoes, and structures within the *Merzbau* are unmistakably related to Schwitters, the paradox here is that there is no 'Schwitters' as such. He was an artist who exhibited many contradictory tendencies, often simultaneously. Throughout his life, and alongside his work as an avant-garde artist, he painted thousands of naturalistic landscapes and portraits.[5] In particular the contrast between the earlier, more obviously 'Dadaist' elements of the *Merzbau*, and its later Constructivist tendencies can be explained by Schwitters' emerging friendships with Theo van Doesburg and El Lissitzky, but not exhausted by them. This essay is not therefore an attempt to explain away the *Merzbau*, to propose one overall scheme through which it is possible to read it. It is rather an attempt to listen to one of those dialogic voices, the Schwitters who demonstrates a fascination with excrement, and to produce a reading of this fascination, bringing in other elements of the work and his other works in relation to it (Schwitters was insistent that the elements of the *Merzbau* should be seen in relation to one another: 'I am building a composition without boundaries, each individual part is at the same time a frame for neighbouring parts, all parts are mutually interdependent'.[6]

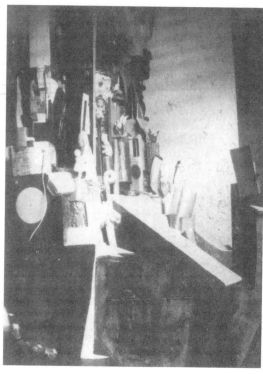

Merzbau: Kathedrale des Erotischen Elends (*Cathedral of Erotic Misery*) photo 1928

Newcastle upon Tyne, April-May 1999.

6) Kurt Schwitters, letter to Alfred Barr, 1936. Quoted in Elderfield, *Kurt Schwitters*, p. 156.

In introducing the 'Degenerate Art' exhibition in 1937, Hitler spoke of the 'flood of slime and ordure' released in 1918, vowing to wage a 'war of purification against the last elements of putrefaction in our culture.'[7] It is perhaps as well that Hitler never saw Schwitters' 'Grotto of Great Love', one of the largest grottoes in the *Merzbau* and which formed part of the column known as 'The Cathedral of Erotic Misery'. Here is Schwitters' own description:

> The love grotto alone takes up one quarter of the base of the column; a wide outside stair leads to it, underneath which stands the female lavatory attendant of life in a long narrow corridor with scattered camel dung. Two children greet us and step into life; owing to damage only a part of the mother and child remain. Shiny and broken objects set the mood. In the middle a couple is embracing: he has no head, she no arms; between his legs he his holding a huge blank cartridge. The big twisted-around, child's head with the syphilitic eyes is warning the embracing couple to be careful. This is disturbing, but there is reassurance in the little bottle of my own urine in which immortelles are suspended.[8]

7 | Adolf Hitler, 'Speech Inaugurating the "Great Exhibition of Modern Art"', Munich 1937, in Vassiliki Kolocotroni, Jane Goldman and Olga Taxidou (eds.), *Modernism: An Anthology of Sources and Documents,* Edinburgh: Edinburgh University Press 1998, 560 and p. 562.

8 | Kurt Schwitters, 'Ich und meine Ziele', 1930 p. 116, quoted in John Elderfield, *Kurt Schwitters,* p. 159. Unfortunately, there are no surviving pictures of the 'Grotto of Great Love', which formed a part of the 'Cathedral of Erotic Misery', see ph. p. 129.

It is perhaps obvious to insert the scatological elements of the *Merzbau* within a Dadaist/Surrealist trend that Schwitters was at times closely allied to. The 'Female Lavatory Attendant of Life' would then take her place next to Duchamp's *Fountain* (1917) and the camel dung strewn around her feet could perhaps have come from a distant relative of the beast in Max Ernst's *Celebes* painting (1921).[9] There is no doubt a trail to be followed here.[10] Richard Hülsenbeck, Schwitters' nemesis and the man who vetoed his entry into mainstream Dada on the grounds that he was 'too bourgeois', spoke of the difficulty that Hans Arp had in producing 'that bit of vulgarity we see so often in dada works.'[11] Schwitters clearly had no such anxiety. Despite Hülsenbeck's attempts to establish some distance between himself and Schwitters by pointing to the Berlin Dadaists' professed love of the 'dust that collects on the breasts of dead whores',[12] it was Schwitters who built the cave of sex murderers.

So in one sense we can incorporate Schwitters' scatological art into a movement deploying revolutionary shock tactics in the field of art. But in another sense this is unsatisfactory. The *Merzbau* was never exhibited. In contrast to those works of art which rubbed the public's noses in their excremental themes, Schwitters' work was only available to callers, and even then only a privileged few were allowed into all of the grottoes. Which is not to say that it went unnoticed.

9) Ernst told Sir Roland Penrose that he had based the painting on a German schoolboy rhyme beginning: 'The elephant from Celebes/has sticky, yellow bottom grease', see *Surrealism in the Tate Gallery Collection,* catalogue Tate Gallery Liverpool May 1988 – March 1989.

10) It is possible that one of Schwitters' grottoes, the *Hundezwinger* (Dog Kennel), refers obliquely to Duchamp's *Fountain.* The grotto contains a red dog and a toilet. Duchamp's work was signed 'R [rot/red?] Mutt'.

11) Richard Hülsenbeck, *Memoirs of a Dada Drummer,* Berkeley and Los Angeles: University of California Press, 1991, p. 99.

12) Ibid., p. 64.

On seeing the work, Sophie Lissitzky-Küppers describes how she and Lissitzky 'gazed in astonishment' at the *Merzbau*.[13] Alexander Dorner, a museum director who had been supportive of Schwitters' *Merzbilder* assemblages, went further, seeing the Merzbau as 'a kind of fecal smearing – a sick and sickening relapse into the social irresponsibility of the infant who plays with trash and filth.'[14] Dorner was no reactionary, indeed he was instrumental in the success of Constructivism, and in one sense he was right. There is of course a certain delight in playing with filth and Schwitters took pleasure in it. Freud observed that 'it is in particular the coprophilic impulses of childhood ... which are submitted the most vigorously to repression.'[15] Schwitters' work seems designed to undo that repression. He appears to have had some interest in psychology (in common with a number of the Dadaists/Surrealists with whom he was aligned). John Elderfield, in his excellent monograph *Kurt Schwitters*, gives a convincing reading of one of the earliest (if not the earliest) *Merzbild* collages, *Merzbild 1A. Der Irrenartz* (The Alienist), as portraying the figure of an analyst (or perhaps Schwitters as analyst), 'whose head is filled with the jumbled debris of his patients' obsessions.'[16] In his paper on infantile sexuality, Freud identifies many elements that lend themselves to comparison with the *Merzbau*. It is here that Freud associates defecation with pleasure: 'A baby choosing to defecate is not concerned with dirtying the bed, he is only anxious not to miss the subsidiary pleasure attached to defecating.'[17] Here also, the idea of shit as a gift is forwarded: it is 'clearly treated as part of the infant's own body and represents his first "gift".'[18]

These associations with pleasure and gift may go some way towards explaining why Schwitters believed his own urine with flowers suspended in it constituted a 'reassuring' presence. In his preceding essay, 'The Sexual

13 | Sophie Lissitzky-Küppers, *El Lissitzky: Li*[Letters, Texts, London: Thames & Hudson, 196[p. 36. The passage in which Lissitzky-Küpper[discusses the *Merzbau*[has been subject to some distortion. Elderfield quotes selectively (p. 162) tha[she was 'unable to dra[the line between originality and madness in Schwitters' creation[when the original quote (which ends 'both liter[and visual') makes it clear that this goes mu[further than the *Merzbau*. Burns Gama[replicates this and extends it to El Lissitzk[as well (p. 101). The e[result is that El Lissitzk[and Lissitzky-Küppers [presented as hostile to the *Merzbau*, a hostili[not present in the original.

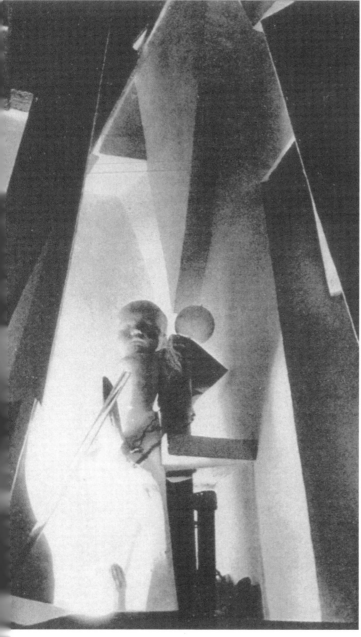

hwitters, Detail of *Merz-column*
incorporated into the *Merzbau*
1930

14 I Samuel Cauman,
The Living Museum:
Experiences of an Art
Historian and Museum
Director – Alexander
Dorner, New York: New
York University Press,
1958, p. 36.

15 I Sigmund Freud 'Five
Lectures on Psycho-
analysis', in *Two Short*
Accounts of Psycho-
analysis,
Harmondsworth:
Penguin,1991, p. 75.

16 I John Elderfield, *Kurt*
Schwitters, p. 51.

17 I Sigmund Freud,
'Infantile Sexuality', in
Three Essays on the
Theory of Sexuality,
London: Hogarth Press,
1962, p. 52.

18 I Ibid., p. 52.

Aberrations', Freud discusses substitutions for the sexual object. Examples of such fetish objects include the foot or hair, 'or some inanimate object which bears an assignable relation to the person whom it replaces and preferably to that person's sexuality (e.g. a piece of clothing or underlinen)'.[19] In a footnote added in 1910, he stresses 'the importance, as regards the choice of fetish, of a coprophilic pleasure which has disappeared owing to repression. Both the feet and the hair are objects with a strong smell which have been exalted into fetishes after the olfactory sensation has become unpleasurable and been abandoned.'[20] If we examine Schwitters' choice of objects to represent the people in the *Merzbau*, we find a striking correspondence between them and Freud's fetish objects. I have already mentioned the lock of Richter's hair and the unattributed urine sample. Further objects included Sophie Täuber-Arp's bra, nail clippings, a half-smoked cigarette, and László Moholy-Nagy's socks. If these items were there by proxy, then a Freudian reading would have that proxy doubled. Subsequent psycho-analytic work, in particular Ernest Jones' 'Anal-Erotic Character Traits', suggests further links to materials common in Schwitters' works. Jones asserts that 'books and other printed matter are a curious symbol of faeces.'[21] Schwitters' innovations in collage largely depended on his incorporation of detritus. Hans Richter describes how 'every tram-ticket, every envelope, cheese wrapper or cigar-band, together with old shoe-soles or shoelaces, wire, feathers, dishcloths – everything that had been thrown away – all this he loved, and restored to an honoured place in life by means of his art.'[22] Hülsenbeck described Schwitters' studio as:

> ... a mixture of hopeless disarray and meticulous accuracy. You could see incipient collages, wooden sculptures, pictures of stone and plaster. Books, whose pages rustled in time to our steps, were lying

19 I Ibid., p. 19.

20 I Ibid., p. 21, n. 2.

21 I Ernest Jones, 'An Erotic Character Traits in his *Papers on Psyc Analysis,* 5th ed., Lonc Baillière, Tindall and C 1950, p. 425.

22 I Hans Richter, *Dac Art and Anti-art*, Lond Thames & Hudson, 1! p. 138.

about. Materials of all kinds, rags, limestone, cuff
links, logs of all sizes, newspaper clippings.
We asked him for details, but Schwitters shrugged:
'It's all crap...'[23]

It is tempting then to portray Schwitters as the classic
anal erotic character, his attachment to his friends
expressed through a series of object fetishes, many of
which are precisely those objects Freud and Jones
associate with a coprophilic pleasure. The *Merzbau* itself
contains literal shit and at least two samples of urine, as
well as examples of lavatorial humour. Schwitters also
appears to have had a parsimonious side which Jones
associated with the anal erotic. Richter describes him as 'a
real bourgeois, miserly rather than generous.'[24] Elderfield
recounts a story which illustrates this: '[Max] Ernst,
however, was fascinated mostly with Schwitters' wife, for
when he had last seen her she had been dressed in an
assortment of ancient clothing so that she resembled a
walking thrift shop. Ernst records Schwitters' proud
comment: "I have never spent a penny on her clothes,
they were all passed down in the family."'[25]

Despite the obvious temptation, I think to classify
Schwitters as an anal erotic would be a mistake, or at
least premature. As Hülsenbeck's description of his
studio makes clear, Schwitters has no 'intolerance for
disorder'[26] that Jones claims characterizes the anal
erotic. Herbert Read (who knew Schwitters when he lived
in England) wrote that 'the bourgeois loves slickness and
polish: Schwitters hates them.'[27] We cannot dismiss the
possibility that Schwitters, with his interest in
psychology, is deliberately incorporating the scatological
object fetishes into the *Merzbau* in full knowledge of their
psycho-analytic value. What I wish to retain from this
analysis of anal erotism is not some psycho-analytic

23 | Richard Hülsenbeck, *Memoirs of a Dada Drummer*, p. 66.

24 | Hans Richter, *Dada: Art and Anti-art*, p. 143.

25 | John Elderfield, *Kurt Schwitters*, p. 146.

26 | Ernest Jones, 'Anal-Erotic Character Traits', in *Papers on Psycho-Analysis*, p. 431.

27 | Quoted in Elderfield, *Kurt Schwitters*, p. 90.

category in which to place Schwitters, but the series of associative links that are made between excrement and other objects to be found in the *Merzbau*.

To emphasize this point, I want to turn to Rosalind E. Krauss' essay on collage, 'In the Name of Picasso'. Krauss is adamantly against psycho-biography in general and in particular, an argument by William Rubin that a change in style between Picasso's *Seated Bather* (1930) and *Bather with Beach Ball* (1932) is founded on a change of sitter from Olga Picasso to Marie-Thérèse Walter, 'who function as determinants in a change in style.'[28]

In contrast, Krauss wishes to develop 'a rather more exacting notion of reference, representation, and signification' for cubist collage.[29] She produces such a reading based on Saussurean linguistics. Each element collaged functions as a Saussurean sign: the material content as signifier, the signified as an immaterial idea or concept. The signifier and signified taken together function as a sign, a 'substitute, proxy, stand-in, for an absent referent.'[30] Representation thus becomes grounded on absence: 'This structural condition of absence is essential to the operations of the sign within Picasso's collage.'[31] The second important facet of Krauss' reading is that meanings are never absolute. Each collaged element is diacritical and stands in relation to other elements. Finally, the collage opens up a play of representation. By obscuring patches of the master plane, the superimposed collage elements paradoxically 'represent that plane in the form of a depiction.'[32] The element functions as 'an index of the material presence now rendered literally invisible... it is this eradication of the original surface and the reconstitution of it through the figure of its own absence that is the master term of the entire condition of collage as a system of signifiers.'[33]

28 | Rosalind E. Krauss 'In the Name of Picasso' in *The Originality of the Avant-Garde and Other Modernist Myths*, Cambridge, MA: MIT Press, 1986, p. 24. Dorothea Dietrich has used this essay in relation to Schwitters' late collages. Although I am proposing a different reading based on the *Merzbau*, I found this essay very useful in forming my thoughts, see Dietrich, 'Absence Presences', in *Kurt Schwitters, I is Style*, Rotterdam: NAi Publishers, Stedelijk Museum, Amsterdam 2000, pp. 57-70.

29 | Rosalind E. Krauss 'In the Name of Picasso' *The Originality of the Avant-Garde and Other Modernist Myths*, p. .

30 | Ibid., p. 33.

31 | Ibid., p. 33.

32 | Ibid., p. 37.

33 | Ibid, p. 37.

The evolution of the *Merzbau* was long and complicated. Richter observes that the founding column (the *Merz-column* which later metamorphosed into the Merzbau itself) was 'always in a protean state of transmutation in which a new layer constantly covered, enclosed and hid from sight yesterday's shape' and noted that 'the whole thing was an aggregate of hollow space, a structure of concave and convex forms which hollowed and inflated the whole structure.'[34] Visiting Schwitters three years later, 'the pillar was totally different. All the little holes and concavities that we had formally "occupied" were no longer to be seen. "They are all deep down inside" Schwitters explained.'[35] Schwitters himself wrote that 'as the structure grows bigger and bigger, valleys, hollows, caves appear, and these lead a life of their own within the overall structure.'[36] The work was 'unfinished, and in principle',[37] so this process could have gone on indefinitely. By incorporating the grottoes dedicated to friends deep inside the work, Schwitters doubly marks them by absence. The fetish objects functioned as signs, with the people themselves absent. Their subsequent covering up functions to emphasize again that absence, this time by a literal effacement. Following Krauss, this absence serves as a master term for the organization of the *Merzbau*. Richter's comment that the Merzbau was an 'aggregate of hollow space' begins to look extremely perspicacious under this reading. What Schwitters was engaged in was a production of absence: creating space by a strange movement of adding elements to the work. It is, to use Jacques Lacan's definition of architecture something organized around emptiness.'[38] The emptiness here relates to Lacan's development of the Freudian *das Ding* (the Thing). This complex notion functions as the 'absolute other of the subject' *(SVII; 52)*, a 'dumb reality' *(SVII; 55)* which is 'the-beyond-of-the-

34 | Hans Richter, *Dada: Art and Anti-art*, p. 152.

35 | Hans Richter, *Dada: Art and Anti-art*, p. 153.

36 | Kurt Schwitters 'Ich und meine Ziele', p. 115, quoted in Elderfield *Kurt Schwitters*, p. 154.

37 | Ibid.

38 | Jacques Lacan, *The Ethics of Psychoanalysis 1959-1960, The Seminar of Jacques Lacan Book VII*, London: Routledge, 1999, p. 135. Subsequent quotations will be cited in the text as *(SVII)* followed by the page reference.

signified' *(SVII;54)*. Lacan goes on to claim that, 'to a certain extent, a work of art always involves circling the Thing' *(SVII; 141)*. The Thing itself is an originary loss that the subject tries to reclaim, but 'is to be found at the most as something missed' *(SVII; 52)*. The *Vorstellung* circles the Thing, operating under 'the fundamental laws of the signifying chain' *(SVII; 62)*. Because the Thing is constituted as the 'beyond-of-the-signifier', 'at the level of the *Vorstellungen*, the Thing is not nothing, but literally is not. *It is characterized by its absence, its strangeness.*' *(SVII; 63*, my italics). Slavoj Žižek expands on this when he terms the Thing 'a real-traumatic kernel in the midst of the symbolic order.'[39] It is this eruption of the Thing into the symbolic which allows Lacan, in Seminar VII, to make explicit a connection between *das Ding* and the death-drive *(SVII; 213)*. The disruption that *das Ding* wreaks on the symbolic order threatens to annihilate the symbolic order in its entirety.

The topological placing of *das Ding* reflects its ambivalent character: 'It is at the center only in the sense that it is excluded / in reality *das Ding* has to be posited as exterior / something strange to me, although it is at the heart of me' *(SVII; 71)*. This definition highlights the Thing's similarity to the Lacanian formation of the *objet (petit) a*, developed in *The Four Fundamental Concepts of Psycho-Analysis*, as 'in you something more than you'.[40] Both are situated in what Lacan classified as a relation of *extimité*, that is to say, an intimate exteriority. In his discussion of Freud's famous *fort-da* game, Lacan argues that the cotton reel the child throws away and retrieves, 'is not the mother reduced to a little ball by some magical game worthy of the Jivaros – it is a small part of the subject that detaches itself from him while still remaining his, still retained' *(SXI; 62)*. Both the Thing and the *objet a* are circled by drives. Both have strong

39 | Slavoj Žižek, *The Sublime Object of Ideology*, London: Ver 1989, p. 135.

40 | Jacques Lacan, *Four Fundamental Concepts of Psycho-Analysis*, London: Vintage, 1978, p. 26 Subsequent referenc to this, the eleventh book in Lacan's Seminars, will be cit in the text as *(SXI)* followed by the page reference.

affinities with the real. Lacan offers the same definition of the real in both Seminar VII (where he discusses the Thing) and Seminar XI (where he discusses the *objet a*) as: 'that which always comes back to the same place' *(SVII; 70 and SXI; 49)*. The *objet a* is also 'a privileged object, which has emerged from some primal separation, some form of self-mutilation induced by the very approach of the real.' *(SXI; 83)*. Žižek writes that 'we can inscribe, encircle the void place of the Subject through the failure of his symbolization, because the subject is nothing but the failure process of his symbolic representation.'[41] That failure is here characterized by the *objet a*: 'this point of the Real in the very heart of the subject which cannot be symbolized, which is produced as a remnant, a leftover of every signifying operation, a hardcore embodying horrifying *jouissance*, enjoyment, and as such an object which simultaneously attracts and repels us.'[42] Note here that the objet a is once more placed 'at the very heart of the subject', whereas in Lacan's discussion of the *fort-da* game it was described as detached. It is one of the paradoxical qualities of the *objet a* that both Lacan and Žižek are right (a paradox that exemplifies *extimité*).

Looking at the definitions of the *objet a* advanced here, it is not hard to see how Lacan came to connect it with excrement. His definition that it is 'part of the subject that detaches itself from him while still remaining his' reminds us of Freud's finding that, in childhood, excrement is 'clearly treated as part of the infant's own body.' Žižek description of the *objet a* as a 'a remnant, a leftover' is clearly pertinent in a scatological context, as is the simultaneous attraction and repulsion which the objet a holds for us. It functions as 'the object-cause of desire, that "unattainable something" / which, according to the Lacanian formula, could suddenly change into excrement.'[43]

41) Slavoj Žižek, *The Sublime Object of Ideology*, p. 173.

42) Ibid., p. 180.

43) Ibid., p. 96.

Shit seems to be equally connected to ideas of presence and absence, to ideas of inside and outside (oppositions that the *Merzbau* also works to disrupt). In Freud's famous case study, Judge Schreber, describing his (often frustrated) desire to shit, speaks of 'evacuation'. But when he actually succeeds in evacuating, 'the process is always accompanied by the generation of an exceedingly strong feeling of spiritual voluptuousness.'[44] Lacan picks up on this in a footnote to his essay 'On the Possible Treatment of Psychosis'; it is 'the very being of man that takes up its position among the waste matter in which his first frolics occur.'[45] Schreber is at his most present precisely when he is evacuating. What we would normally refer to as his internal self is at its most coherent when he is producing something external to it.

Returning to Schwitters' 'Grotto of Great Love', it is possible to see something of Žižek 'horrifying *jouissance*' in the grouping. From the 'shiny and broken' objects that 'set the mood' to the damaged figures of the mother and child, nothing is completed, everything is characterized by lack. The man has no head, the woman no arms. His penis is replaced by a huge *blank* cartridge. But there are also elements of a grotesque fecundity such as the 'big twisted-around, child's head with the syphilitic eyes' or the camel dung. Schwitters' own urine holding the Immortelles functions as a distorted pastoral promise, but the only way in which it could be seen as reassuring is by comparison to the horrors around it. The bourgeois setting of Schwitters' own house serves to emphasize the jarring incongruity of the objects within, objects 'hideously mutilated by the approach of the real'. The 'unfinished, and on principle' work is capable of replicating its distorted self to infinity, in a movement which has no sooner set up opposites ('inside/outside'; 'present/absent') than it collapses them in a process of incremental excrescence.

44) Sigmund Freud, *Case Histories II*, Harmondsworth: Penguin, 1991, p. 158

45) Jacques Lacan, 'C the Possible Treatmen of Psychosis', in *Écrit A Selection*, London: Routledge, 1977, p. 2 n. 39.

Postscript

There is a small work by Schwitters entitled *Immortality
is not everybody's thing* (1922). It is a piece of card with
a black oval shape upon it. Its German title, in Gothic
script, is given below the oval: *Die Unsterblichkeit ist
nicht jedermanns Sache*. It is not hard to make the
associations, the title gives us a clear reference to death.
The black oval is a little too close to faeces for comfort.
Following the links I have made above we can connect
to it the *objet a* (in the impossibility of its representation,
in the way that the rest of the work is organized around
it) and through this back to the Freudian/Lacanian *Ding*.
But here something strange happens. If we return to
what Lacan said about the Thing, we find him insistent
on a distinction between the two German words for
'thing': *Sache* and *Ding*. The example Lacan uses to
illustrate this is particularly interesting in regard to
Schwitters' work: 'One does not use *Sache* for religious
matters, but one nevertheless says that faith is not

jederman Ding – it is not for everybody.' *(SVII; 62-63)*.
Yet this is precisely where Schwitters has used *Sache*.
Sache, explains Lacan, is more akin to an affair, one's
bag, or 'kit and caboodle'. The English translation
conveys something of this (an alternative could be
'Immortality is not everybody's cup of tea'). *Sache* is
'always in range of an explanation' *(SVII; 45)*, whilst *Ding*
is 'the true secret' *(SVII; 46)*. Žižek feels that 'the most
radical dimension of Lacanian theory lies not in
recognizing this fact [the barred subject] but in realizing
that the big Other, the symbolic order itself, is also *barré*,
crossed-out, by a fundamental impossibility, structured
around an impossible traumatic kernel, around a central
lack.'[46] The title of Schwitters' work is therefore
inadequate. Its *Sache* cannot refer to the *Ding* hinted at
above. There is something characteristic of Schwitters in
this bathetic transposition, something (dare one say it)
bourgeois. But it also describes something that we all
do. Only by substituting *Sache* for *Ding* can we insert it
into a signifying chain and begin to make sense of it. In
doing so, we close our eyes to the horrifying
excrescence/ absence at the heart of Schwitters' work
which is the 'beyond-of-the-signifier'.

46 | Slavoj Žižek,
*The Sublime Object of
Ideology*, p.122.

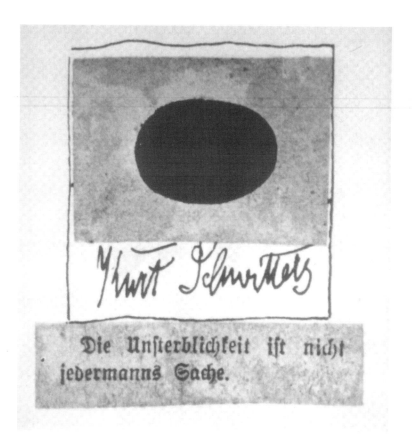

THEY SENT THEIR GUIDES TO

1) Taken from 'Exhibiti▮
A New Enthusiasm' in
J. Trescott, *The
Washington Post*, 21 Ju▮
1998. 'They' are the
management of the
Strong Museum in
Rochester, NY, who
'hired marketing
consultants and have
given an imaginative s▮
to almost everything t▮
suggested'.

A DISNEY SCHOOL FOR INSTRUCTION:[1]

PROGNOSTICATION FOR A NEW ORDER

Toby Newton

1

'Even if all the constitutive features of post-modernism
were coterminous to those of an older modernism'
writes Frederic Jameson '... the two phenomena would
still remain utterly distinct in their meaning and social
function'.[2] This is to say that it's not what you do, but
the time that you do it. Or, in other words, that as the
dominant discourses or psycho-social modes or the
condition of the period develop, change and shift, so
categories and categorisations which might persist as
materially or definitionally unchanged are nonetheless
altered in significance.

In Barthes' sense, even if the work should remain
identical, for all that the text is changed.

2 I Frederic Jameson,
*Postmodernism, or the
cultural logic of late
capitalism,* London:
Verso, 1991, p. 5.

145

Though perhaps shop-soiled, the post-modern condition represents something 'new', whether or not we are able to determine elements of its material development in modernism. Among its constitutive features a new lack of profundity is found , indeed scarcely even one pretended, beyond the need to justify a dollar; a commitment to the superficial, insofar as 'tradition'[©] is progressively eroded and any precedent is jettisoned in favour of whatever gets you through the night, right here, right now. Doing the job[©] in hand is the crux and given that the job[©] is mindless and without weight, the most casual verisimilitude that serves to do the job[©] or, in other words, staunch the wound, or, it might be said, survive in the infinite storehouse of greed, is admissible. Let it be said that it is not coincidental that we spectacularly worship the image, the icon, the simulacrum. The result is a 'consequent weakening of history' notes Jameson, 'both in our relationship to public History and in the new forms of our private temporality'.[3]

The bases for the spectacular society of the twenty-first century are twofold: first, the death of God, secondly, the unprecedented and inter-related developments in the *financescape*, *technoscape* and *mediascape* over the last two centuries. Prosaically, or maybe historically, both might be lumped together in the aftermath of the 'Enlightenment project' as the extension of a crisis of meaning that extends until tomorrow, amen. As has been pointed out, you can either have God and enchantment or Science and disenchantment but not, convincingly, both. With the intelligence of the death of God and his

3 I Ibid., p. 6.

attendant *diktats* – notwithstanding that, like the old saint in the forest, not everyone admits to having heard the news – humankind must get on with the job© of justifying under its own aegis the programme of cataloguing and *arbitration* previously done in the name of God. This represents a taxonomical undertaking of a moral, aesthetic, ethical and existential order as well as a material one: a truly comprehensive project of *worldmaking*. Nor can it be enough to refuse to carry through the news of the death of God to its logical conclusion. That is, the recognition of a *schmeaningful* but Meaningless world,[4] in which our science, soft and hard, tells truth exactly where to go, when and in what short order. A world in which science nominates what schmatters when it's sunk in 'nothing Matters'.

All of which is to say no more than that *worldmaking* (or, if you prefer, in part and significantly, the *move to categorise*) is an act of will and one which appeals not to Truth or Fact but to authority, and that, consequently, 'representation' is unmasked as a dictatorial enterprise. This last is neither a pejorative nor an adversely critical statement. Introducing order and formulating relationships where there were none is what human science and philosophy do. However, it is to commend that the process of *worldmaking* is recognised for what it is, i.e. an arbitrary and (in the widest sense) wilful programme, and that this recognition signals an end for our search for an aboriginal world beyond perception, conception, systematisation or whatever. Crassly, in a nutshell, and so as to proceed, we live in worlds of our own making.

4 I P. Carpenter & T. Newton, *At The End Of The Day*, Kent: Worple Press, 1999.

147

2

Jean Baudrillard has complicated Saussurian linguistic theory (and thereby the many and various social and literary sciences which adopted semiology as a guiding model) by reminding us that the supposedly innocent and natural 'referent', on which the economy of the sign is predicated, is itself actually deeply implicated in the significatory system that identifies it *as* referent. There is no pure reality, suggests Baudrillard, but only a divided continuum, the divisions of which are the consequence of a strategic operation that hides its deepest assumptions in the apparent obviousness of its denotative 'objects'; objects which are actually subjects of designation.

For Baudrillard, this is the opening move in the identification of a culture of pure simulation – the precession of simulacra – in which the real has disappeared, obliterated by the model of the real which precedes it.

> [...] the transition from signs which dissimulate something to signs which dissimulate that there is nothing, marks the decisive turning point... the second inaugurates an age of simulacra and simulation, in which there is no longer any God to recognise his own, nor any last judgment to separate true from false, the real from its artificial resurrection, since everything is already dead and risen in advance.[5]

Witness a contemporary Western lack of *faith* in traditional meta-narratives and consequently in the certainty (of categorisation and demarcation) which they provide (whether religious or secular/scientific).

5 ❘ Jean Baudrillard, *Simulations*, New York Semiotext(e), 1983, p. 12.

The age of simulacra heralds, or is heralded by, a system of general equivalence in which, through the intermediary of money and via the mechanisms of the market, capital has invoked an era of absolute correspondence whereby anything can stand in for or exchange with anything else. Long gone the sacred, the holy, the inestimable, that which is 'beyond value'.© The grand abstract foundation of the bourgeois symbolic order (taste, discrimination, judgement) is now so finely cut and so open to limitless dissemination as to effectively evaporate, to cease to exist; powerless to withstand or satisfy the demands made upon it to bestow a value on every promiscuous, every 'free and emancipated', sign *vis-à-vis* every other likewise promiscuous sign and, moreover, to allocate amongst them values on the basis of *no good reason*. In this new order, gone too, as an early victim, is the category 'Art', which can have no conclusive constituency in a system of 'genetic' simulation caught up in a spiral of (over)production: 'art enters into its indefinite *reproduction*: all that reduplicates itself, even if it be the every day and banal reality, falls by the token under the sign of art, and becomes aesthetic'.[6]

In a system where anything and everything is aestheticised and is rendered under the generalised, commutable sign of consumption, art boils down to shibboleth and the 'art community'© is disinvested of the prerogative of designating Art, a role that now falls to the 'community at large',© long and thoroughly tutored in VFM, which is, spectacularly, what schmatters. No wonder attempts to answer the question 'What is art?' characteristically end in frustration and confusion and a kind of bleating and clacking. The question is the wrong one. Rather, we should be asking *'When is art?'*[7]

6 I Ibid., p. 151.

7 I N. Goodman, *Ways of Worldmaking*, Indiana: Hackett, 1978.

The answer is to be found in artworks' salient feature: the capacity to symbolise, this includes those occasions on which the 'Art' is not a symbolic work, or even, has no subject/referent but nonetheless exemplifies, as a form of symbolism, its physical qualities. The point with symbolism is that it comes and goes depending on context. Thus the status of the artwork is transitory and contingent, resting on its symbolic properties at a particular moment. If, in a system of general equivalence, the most banal and quotidian objects assume *the power of the symbolic within the system*, then each and every object becomes as much an art work as not an art work. Indeed, the category of 'Art', infinitely extended, is rendered not merely Meaningless (the fate of all human discourse) but *schmeaningless*, i.e. without substance or proposition even in word games – a fate reserved for the humanly, which is to say truly, useless.

3

The postmodern condition or spectacular society might be characterised as either haunted by or delighting in the dissolving of those meta-narratives that once enabled the 'Enlightenment project', fed its teleological confidence and which reached their apotheosis in the period of 'high modernism'. The function of the m(a)us(ol)eum within the discourse of that period was as a repository of 'art and history', a place of legitimisation and categorical *faith*: 'museums preserve, collect, and educate the public and convey standards about art's value and quality...',[8] i.e. the modernist m(a)us(ol)eum asserts that standards *can* be ascertained, that the public *need* education and that artistic© 'value' and 'quality' *are* serious statements. As such, these institutions belonged to a world where the appointed canon of 'great art' was divorced from the

8) C. Freeland, *But is it art?*, Oxford: Oxford University Press, 2001, p. 90.

150

humdrummery of everyday life. Housed in cathedrals
of taste, art constituted a material sediment that puffed
out the vapours of a heady aesthetic brew, to be
inhaled only sporadically, in an attitude of sufficiently
high-minded solemnity.

Viewed from a more spectacular perspective, the
impossible self-assurance and 'otherness' of the
modernist m(a)us(ol)eum's project seems grotesque and
deluding. How is it then, with post-modernism now
distinctly old news, the project's presumption is not
generally seen as just that – presumptuous? In truth,©
two points can be made: first, practically, industrially, it *is*
generally recognised (and realistically dismissed) as
presumptuous, not to say absurd. In other words,
curators and financial directors stock and model to reflect
public taste and the punters treat their new Malls of
Culture with the consumerist verve and contempt they
deserve. Secondly, politically and academically, the
powers-that-be, locked into a pre-spectacular discourse
of supremacy and influence and tied to its obsolescent
vocabulary, have yet to realise the triumph of the
integrated spectacle[9] and, as a result, have failed to
notice or rearticulate their outmoded position. Thus,
for a short while, in the Establishment's imagination
and nowhere else, the m(a)us(ol)eum lives on.

4

In his *Comments on the Society of the Spectacle*, Guy
Debord notes: 'in all that has happened in the last
twenty years, the most important change lies in the very
continuity of the spectacle. This has nothing to do with
the perfecting of its media instruments, which had
already reached a highly advanced stage of

9 I Guy Debord,
*Comments on the Society
of the Spectacle*, London:
Verso, 1990.

development: it means quite simply that the spectacle's domination has succeeded in raising a whole generation moulded to its laws'.[10] Replacing the 'concentrated' and 'diffuse' models of the spectacle outlined in his earlier theorising, Debord identified the 'integrated' spectacle – a commingling of the earlier modes, by virtue of which 'the spectacle has spread itself to the point where it now permeates reality'.

Significantly for Debord, the current pilots of the spectacle are *not yet all of that generation born and bred under its tutelage* – a senior group of politicians, entrepreneurs and captains of industry live on and hold some sway, trapped in an older discourse that still retains a vestigial influence insofar as its language is remembered, vaguely, as having, once upon a time, made some sort of sense. So these pre-spectacular stegosauri legislate and promulgate, plan and respond, in a bygone *made-world* that does not yet seem quite ridiculous.

The practical influence of the spectacle outstrips the politicians (and academics) theoretical response to it: '... old prejudices everywhere belied, precautions now useless, and even the residues of scruples from an earlier age, still clog up the thinking of quite a number of rulers ...'.[11]
It requires no more than this insight to account for the moribund rhetoric which continues to animate the Establishment debate on 'culture and the arts'[©] and which, quite apart from Bradford's *Life Force Centre*, Cardiff's *Centre for the Visual Arts* and the *National Centre for Popular Music* in Sheffield, was also responsible for the early enthusiasm for a project as temporally misguided as the Millennium Dome.

10 I Ibid., p. 7.

11 I Ibid., p. 87.

However, if a waning political/cultural elite has yet to grasp the full significance of social transformation under the conditions of spectacular domination, the rest of society, both as producers and consumers, are busily creating and experiencing it on a day-to-day basis. Means and patterns of production, and more explicitly of *consumption*, are changing with the inception of the new order, with consumers willing to exert themselves on behalf of their own leisure. Fast food restaurants, ATM machines, self-service shops, self-assembly furniture and the entire rhetoric of DIY are each built on the premise of encouraging the consumer to undertake labour once reserved for paid workers. Productive or creative consumption becomes a crucial means of constructing self-identity in a world of ubiquitous 'branding', where the placed product insinuates itself into the minutiae of everyday life and where the brand has developed as the key tool in marketing. Emotion, attitude, intimacy, lifestyle, available *ersatz* on tap. Even the most oppositional and anti-establishment icons and sentiments become accessible for casual consumption as commodities. The key point being that, for example, what was once held to be a signifier of revolt is now held to be the sign of 'Revolt',[TM] just another – no more, and no less, empty – variety in the spectacular marketplace of equivalence.

No – nothing is *sacred*. Nothing is beyond branding, because nothing is beyond the market. Consumerism takes no hostages; not even the Houses of Art thrown up to replace the cathedrals when God died. Increasingly, the fashion is for 'themed environments' which can provide entertainment adjunctively and in their own right, quite apart from the junk they happen to

accommodate, and/or for fully self-contained building-kingdoms which 'aspire to being a total space, a complete world, a kind of miniature city...'.[12] These new themed environments are characterised by two fundamental qualities: the specious, jerrybuilt and slapdash quality of both their 'theme' and their avowedly 'popular' design, 'learned from Las Vegas'.

The pastiche, insensitivity and irreverence for authenticity found in the themes of these populist, crowd-swaddling and, in the best sense, *kitsch* new buildings are consonant with the fatal debilitation of a once-endorsed but now impossible inclination towards history. In the post-modern condition, the illusion of a 'real' history that might be reiterated neutrally is dispelled. Rather, we are condemned to review an imaginary history always degraded and distorted by the received wisdom we possess 'about' it. Such an erasure of history is both theoretically inevitable and practically imperative under the conditions of the spectacle.

The traditional m(a)us(ol)eum was mired in History – a concept wholly defunct in a world no longer arrested by the authentic or original. Once the spectacle becomes the focus, disencumbered of any claim to be 'true' or not, then the m(a)us(ol)eum's old discourse of *worldmaking* (predicated on 'Truth' and unmediated 'history'; rarefied and, therefore, precious) is left looking not merely irrelevant but, worse, without authority: outmoded by simulation – enthralled to the ersatz made-world of the spectacle: no surprise or contradiction, then, that a 'life-like' animatronic Tyrannosaurus Rex installed in the National History Museum should have its halitosis toned down for the sake of the punters; nor that 'under the

12 | Jameson, p. 40.

pretext of saving the original... the caves of Lascaux have been forbidden to visitors and an exact replica constructed 500 metres away... the very memory of the original caves will fade in the mind of future generations, but from now on there is no longer any difference: the duplication is sufficient to render both artificial'.[13]
Of course, the m(a)us(ol)eum's project was only ever an irrational act of will and its exposure as a peculiar and particularly unconvincing fiction is long overdue. It was always a loaded enterprise, steeped in the politics of a unitary worldview, serving an, at best paternalistic, at worst totalitarian, ideological vision.

The integrated spectacle has delivered no more than the logical extension of the corrosion of the 'aura': once the cult of the 'original' and the 'authentic' has fled, why patronise a store or a show or, indeed, a museum delimited by its insistence on these antediluvian precepts? In the age of post-colonialism, when artefacts are being reclaimed by their 'original homelands',© why not pursue the logic of reproduction to its denouement and have spaces devoted to inauthentic copies? Indeed, what's to stop every 'culture mall' hosting its own simulation of the Mona Lisa, a Tyrannosaurus, a hunk of moon rock or Mars rock, a Chagga's butt-plug, whatever the hell the punters want – what difference does it make?

Hence the rush to rebrand m(a)us(ol)eums as places of entertainment and spectacle – who would now open a new *Museum* when they can open a *Centre*? The semiotics of this newly fashionable appellation are revealing: the Museum is a dull and dusty mortuary, not only of artefacts but also of *a manner of conceiving of artefacts*; the Centre, meanwhile, situates itself at the

13 I Baudrillard, p. 18.

heart of something living and generative – a web, a
network, a force field – the margins and nodes of which
can transmute enlessly: who wants to be stuck with one
History when thousands are imaginable?

Not before time, the culture industry and the
entertainment industry are united under the sign of the
spectacle. As ever, it is the US that embraces the new
order with the greatest alacrity, where the 'museum-
scene' is currently on a high as a result of accepting the
'mall logic' of our spectacular times; and where the
managers of cultural institutions have come to terms with
the reality that there is absolutely no difference between
the Hard Rock Café or Planet Hollywood on the one
hand, and some no less *made-world* of jumbled
museum-history, on the other.

5

To stage one's own death is to insist that one has lived. In
much the same way, periodically, m(a)us(ol)eums are said
to be in crisis, so as to allege that they were once not so.
Actually, of course, they will not die or 'end' because that
would be to impute them too much vigour in the first
place, to imagine that they had ever thrived and that their
project had not always been deathlike and doomed.
They will drift on, metamorphosising as a consequence of
lack of faith into something similar but different – themed
malls, Planet Hollywoods, 'bak-foh-gung-si', cafés with
quite nice crap attached – until in time technology and the
power of simulation render them altogether redundant.
Then, if anyone cares, always last-to-know Governments
will employ a class of semi-professionals to visit them, to

lend some credence to their actual physical existence, because how else can anyone be expected to bother to make the journey? Meanwhile, the rest of us will be at home, with our 'ultra-max entertainment centres'™ or at a virtual holiday resort or bombed on soma, having completely escaped the tyranny of 'aura' and origin; and having answered the crucial question – who wants to live 'real life' at all, with all its attendant messiness and lack of resolution, when there is virtual reality on offer (even at its present primitive levels), providing mental excitation, teledildonic stimulation and somatic pleasure?

Museums are trapped in 'real life' – this is real, this really happened, they really lived like this, this is a real bit of moon – and thereby miss the point of our times: what does any of that schmatter compared to what they *might* have done, what we can believe as their having done, what we can *(re)create* as their having done – and all of which might have been ten, twenty, one hundred, a *zillion times* as *spectacular*?

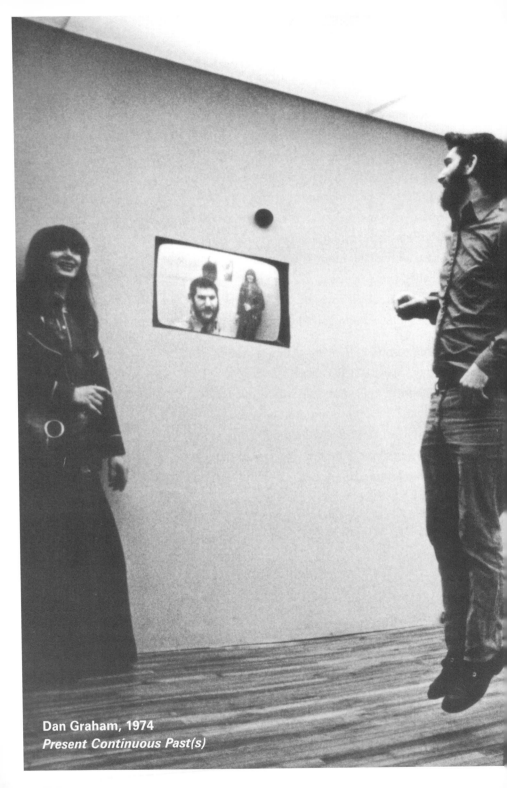

Dan Graham, 1974
Present Continuous Past(s)

BOW TIES & BRANDING:
Dan Graham on contemporary museum architecture

Kathy Battista
with Mark Morris

Dan Graham

Who's your favourite architect?

Kathy Battista

Right now I'd have to say Hasegawa.

Dan Graham

What about Sverre Fehn? He's a Norwegian architect, who won the Pritzer Prize a few years ago and has built many museums. He's doing a new museum in Oslo. He's the greatest living European architect.

Mark Morris

He did the Nordic Pavillion at the Venice Biennale and the Glacier Museum at Fjaerland, that was incredible.

DG

You people in London and France are very mixed up with fashionable architects who are just doing other people's ideas like Herzog & de Meuron, Rem Koolhaas, Jean Nouvel. But the great ones are on the margins. For a while Peter Zumtor had one great building, the thermal baths. But now he's getting boring. I was inside the baths. The great thing about the baths is that they're open to the landscape. In the sunset there are deeper and deeper shadows as you go in and it becomes a kind of labyrinthine situation. And you can see your head and other people's heads as Roman or Greek busts. And when you look down at the rest of your body you look like a fish. So it's the first architecture that has a lot to do with the feeling of the body, because you feel yourself in the water, and then in some places there are divisions using light blue two-way mirror glass. It's a very physical situation. Also it's wonderful as a sort of expensive, nineties, luxury Calvinist idea attached to a sixties hotel below that went out of business. You see a lot of architectural tourists there.

KB I finally saw the Signal Box outside of Basel a couple of weeks ago. It was rather a letdown compared to the documentation of it.

DG

There's almost nothing to Herzog & de Meuron's architecture.

KB It's all about the exterior.

DG

And supposedly people looking in from the outside. You have to identify with the people on the inside looking outside but you can't go in yourself.

KB The new Laban Centre that they are building in Deptford is a lot like that. It's a dance school. It will have opaque coloured glass so from the outside you'll see all the dancers in the studios, their silhouettes that is. And they can see you of course. I think that's what's interesting about the Tate. Because the building was already there, they couldn't do much, except add the glass

n Graham, 1981-91
/o-way Mirror Cylinder inside Cube and Video Salon.
oftop Park for Dia Center for the Arts

boxes. Their buildings are always so remarkable from the exterior rather than the interior. They lost that opportunity.

DG

They have no interiors! I think what's happening in London is people from England think the new building is fascist because they identify the 1930s architecture which was done in the 1950s with fascist architecture. So they think Herzog & de Meuron are just adding to fascist architecture. What they don't understand is that it's Calvinist. The English don't understand Calvinism.

Bankside and Battersea power stations were featured in a film **MM**
version of Richard III as a fascist backdrop so there is this kind of
history to it. I suppose the interior is so deadpan with the
colours, the grey and the black.

DG
I think the wooden floors are very important. Because there's a
sense of home-like elegance, so it means the general public can
be in a very nice walking place. It's the opposite of the Centres
George Pompidou, which is hard on the feet. I think it's a very...
lugubrious building. I've lost my hearing but I understand you can
hear the power plant from the turbine hall. It's supposed to be the
main feature! I think Herzog & de Meuron are very good at
industrial archaeology, but not as good as Cedric Price.

KB Yes, he's an underrated architect.

DG
It's because he doesn't have one of those big *El Croquis*
publications.

KB Back to the Tate. It had such good coverage here. However, in
America it hasn't been as well-received. Do you think it's a
criticism of the collection or the building?

DG
I don't know. I don't read anything from America.

It's a confusion of a branding. The American sense of what the **MM**
Tate is, hasn't migrated across the pond. There is still a very
stodgy conception of the other building, Tate Britain.
It'll take a while I think.

KB Mark, is there actually a model of the Tate?

There's a model of the Tate in the Tate. It's part of a new **MM**
tradition of museums. Each one now has, somewhere, a model
of itself like a reliquary. Some are used to beg for funding, others
are quasi-art objects in their own right.

DG

They've done something very stupid at the Tate – they've hung large photographs by Struth and Gursky of large social spaces in large social spaces.

KB And the photograph of the Goetz collection is like an advertisement for Herzog & de Meuron. It's like branding on the wall.

DG

People buy an architect to sell the building, to raise money. And they want from the architect a trademark. It should be a trademark of the architect itself and also for the museum. So Gehry gives Bilbao a trademark that looks like a sail which you can see from the airplane. And of course it's featured in the inflight magazine. And it also has to be classic Gehry. The interiors are not important.

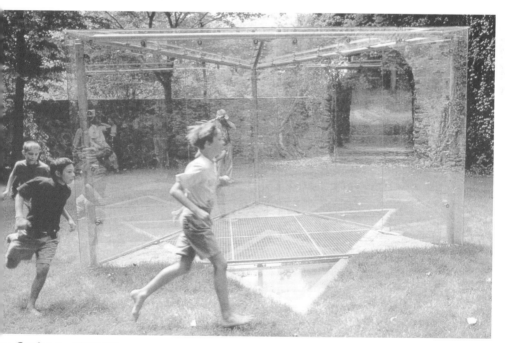

ın Graham, 1991-96
ar of David Pavilion for Schloß Buchberg

KB The interiors are really problematic in Bilbao.

DG
Well this is also true in the two museums by Siza. Incredibly bad. Siza began by doing site specific, inexpensive buildings, like his great swimming pool and also his very good restaurant. But finally Siza has become a symbol of Portugal, the way Gaudi became a symbol of Barcelona. He's on the television all the time. But you see it as a typical brand or trademark. Moneo's done that as well.

The Gehry icon is all about a kind of skin. In the Herzog **MM** & de Meuron case it's kind of the tattooed skin. In the Gehry case it's kind of an armour.

KB It's the St Tropez tan of buildings.

DG
The new Gehry Guggenheim…

KB For Vegas?

DG
No, for New York City. It reminds me a lot of Frank Stella's architecture. It's a huge influence on Philip Johnson. Stella's like many artists, he wants to be an architect.

His pieces can be read as models or landscapes, if only they **MM** were presented on the floor rather than on the wall.

DG
In a television broadcast that I did for Dutch TV, Philip Johnson says that he's working from the model of Stella, which has no windows. So he has a big problem figuring out where the windows are in his new architecture. Well Frank hasn't dealt with the problems of windows yet in his architecture.

KB But he hasn't had any of them built.

DG

Well Dresden was almost going to do a new museum. He actually teaches architecture at Yale.

Have you seen the Rock and Roll Museum by Gehry? He was **MM**
listening to things like *Purple Haze* when he designed it. That
looks like a Stella from one side.

DG

So you agree with my analysis!

Well I think you may be right. **MM**

DG

First Philip Johnson got interested in Frank Stella, now Gehry's interested in Stella.

Well if you get enough museums commissioned, and you **MM**
actually look at the work, maybe you get influenced by it.

DG

Well what are the best museums by architects? The Kimbell.

Wright's Guggenheim. **MM**

DG

I like Maki's museum in San Francisco across the street from the Museum of Modern Art. It's a beautiful little museum.

Have you seen the Wexner Centre? **MM**

DG

No. I've never been invited.

That's the product of an architect... **MM**

DG

An architect who's been castrated by his second wife. He's not a good architect. He was a brilliant writer. He wrote the first article about Terragni. Got me interested in Terragni and also a very good article on Sol LeWitt.

Sol LeWitt influenced The Wexner Centre. The white grid that **MM**
runs all the way through it is a friendly quotation. Eisenman's
Terragni article, that's been writing itself for ages. It must be the
most anticipated architecture book ever.

DG

He's building everywhere. The symbol of the bow tie and his
smiling face is on the cover of many magazines.

KB Dan, I know you've been working outside of museums and
galleries more frequently. What are you working on now?

DG

I'm doing the Yin/Yang Pavilion for a student lounge area in a new
dormitory at MIT in Boston. It's partly indoors as well as outdoors
so I don't know how well it's going to work.

Who gets the Yin and who gets the Yang? **MM**

DG

The two of them are together. It's my parody of Bill Viola and new
age art. Every time I see Bill Viola he's emerging from water like
John the Baptist. And of course he's doing corporate Zen Buddhism.

KB What do you think will happen with the new Zaha Hadid building
for the Museum in Cincinnati?

DG

I don't know. Unlike the people at the Architectural Association I'm
not a fan of her work.

KB Mark, you're from Ohio. How do you think it'll go down with the
locals?

They loved Eisenman's Wexner Centre and let him do the **MM**
convention centre in Columbus. I think Columbus, Ohio is a kind
of tabula rasa. They can try anything there and then move on
down the line. Zaha's modern art museum for Rome is like taking
a piece of LA highway and twisting it once or twice, and it's done.
The project for Cincinnati resembles a cube of jello salad.

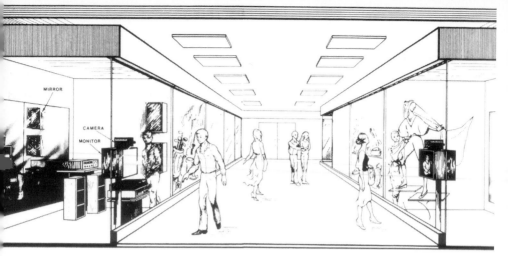

n Graham, 1978, *Video Piece for Shop Windows in an Arcade*

KB These museums are becoming such spectacles. The social role of the museum is changing from a place to study objects and things, which I suppose is a static role, to a place more akin to a shopping mall or a place for entertainment. It's all based on the event really.

DG
Well I think about ten years ago the new idea of the gift shop subsidising the museum became important.

KB That's certainly the case at the Tate.

DG
Well actually there's a very interesting thing that happened in Japan. It's a museum of Ando, which is also a hotel. The museum and the hotel are interlinked.

KB Are the objects dispersed throughout floors of the hotel?

DG
No, it's a separate area, but you can go through it. There's a restaurant and a private collection of a corporation. They are things that the owner of The Benisay corporation bought at auction. Actually unlike Buren and other people writing against the museum, what I love about the museum is the romantic meeting place lobby, the coffee shop, and the elevators can be very good. Iwona Blazwick says museums are becoming more like community centres.

KB Yes they are places to hang out and meet with friends and relations. But at the Tate this isn't possible because you can't get into the cafes and the elevators aren't big enough to accommodate all the push-chairs.

The idea that you assemble thin little galleries and that you have **MM** to travel up and down just doesn't work.

DG

Well to be honest Herzog & de Meuron do very bad interiors. They are like Jean Nouvel – special effects on the skin.

KB Have you seen the new Baltic Centre, Dan? It's quite similar to Tate Modern. It's a disused industrial building in Gateshead, in the North of England, which is being renovated into a 'factory' for contemporary art. It's great that they resurrect these buildings, but at times it becomes more about the architecture than the work inside. This is what is problematic about the Tate.

DG

The other problem is that the best architecture is done via discussions with a client to figure out what the programme is. The Director and the Curators never have a say in the programmes of the building.

If you have a competition and you make a brief, the brief is **MM** never what they really want at the time.

DG

Very few architects deal with the community. Hasegawa always consults with the community.

KB She does such important work.

DG

Herzog & de Meuron made a big mistake. They said one floor of the new MoMA should be for the work of Dan Graham.

KB Are they big fans of yours?

DG

Huge. Nobody knows the things they take from me and simplify. For the Canadian Centre for Architecture in Montreal – Kurt Foster is the new director – they're doing a huge Herzog & de Meuron show. And they wanted a work of mine from the show. Jacques Herzog says he's influenced by two people – me and Joseph Beuys.

Well, that's giving you some credit! **MM**

DG

But not in architecture magazines. They publish things that are absolute simplifications and copies.

This goes back to what you were saying about the community. **MM**
Part of the role of the architect, maybe it's a misguided one, is to be heroic and original and the artist. You wouldn't want to consult anyone.

DG

But I think architecture is about programme and trying to find new typologies, which is what I love about Hasegawa's Museum of Fruit in Japan. A new typology. It's for a wine-growing area near the low mountains outside of Tokyo. There are three buildings that are like winter gardens except they actually come from seedlings that are computer generated. The seedling shape relates to the landscape. I remember one has a very large video screen blow-up which is used by local families to watch golf. The other half of the building has a slightly slanted concrete floor for children. There are little booths where children can make sounds like 'Woooo' and you can hear it echoing throughout the building. So it's very much about the family of the area. It's a place where people can drive to on weekends. There's womens' centres, community centres...

And it all takes this kind of organic form. **MM**

DG

It's organic, yes. It's like a seed bank. But of course the engineering is something you can only do in Japan because they do such incredible craft engineering.

KB Hasegawa's also done that great Museum of Ceramics.

DG

It's also commissioned by a company. It was for the people in the company to do their own ceramics and show them. And she wants artists from around the world to be in residence to do ceramics.

KB It's interesting that Hasegawa occupies this area somewhere between architecture, education and community, which is something that art galleries are currently embracing quite seriously. Exhibitions are often funded through education projects these days.

DG

The money comes through education departments, otherwise things for children. The way I get my own projects is, I say they work as being photo opportunities for children and their parents on weekends.

There's a lot of state and federal funding so long as the project contains an educational element. So long as you can bus in the school kids along with anyone else you have a better magnet. MM

DG

Well many museums, like the one in Porto, not only on weekends, but during weekdays, are for young children. That's why I designed the CD-Rom Cartoon Computer Library and Daycare Centre, done originally for the Münster Skulptur Projekt, but not realised. And also the girls make-up room. Actually Jacques Herzog asked me to describe *Double Exposure*. This was a piece I almost did at Documenta that was turned down. It was a two-way mirror triangle with sliding doors so you could go inside.

Two sides two-way mirror and the third side is cibachrome. The cibachrome is an image from what would be inside the pavilion, 50 metres in front, on a spring day, around sunset. So inside you can look through it and see a double exposure – moving present time and the photographic time. And then a year later it almost coincides. The two-way mirror on the sides shows the landscape, and people inside and outside. So at the apex where the two-way mirror meets is an image of the landscape on the two sides, people inside and outside, and also looking through the cibachrome. I proposed it for Documenta, and we even raised a lot of money but Catherine David killed it. And it would've been done in Porto (for the retrospective there) but they ran out of money. But Marion's been showing the model and taking out the description. So Herzog asked me to please explain it.

Maybe it'll crop up in their work soon! **MM**

KB They've done things with photographic exteriors already. For example the early Pfaffenholz Sports Centre in Switzerland, which they describe as a tattooed surface.

DG

The Kramlich House and Museum for video has curved surfaces, two-way mirrors. Jacques said 'Dan, we're now using two-way mirrors.' It also has projections on the curved surfaces, like my *Design for Showing Videos*. It's getting huge press but nobody knows where it comes from.

KB So it's gone from architecture to art back to architecture. Because your work originally came out of architecture.

DG

Well I think that the *Design for Showing Video* in the 1980s came out of artists' designs during the 1960s, particularly Chamberlain's foam rubber coaches with videos. Also Claes Oldenberg and Artschwager's *Bedroom Ensemble*, Warhol's *Floating Pillows* and *Wallpaper*. I did an article about art as design, design in art, in *Artforum* in the mid-80s that was about that. And Flavin, of course.

The work you've done as models, did that grow out of the **MM**
alteration to a suburban house? Was it a natural growth out of
architectural interest or were they always art objects? There is this
confusion, as Kathy says, is it coming from art or architecture?

DG

No it comes from my seeing a show at the Leo Castelli Gallery of
the New York Five models. I thought after I did the *Public Space,
Two Audiences*, for the Venice Biennale, I wanted to do something
where there was an actual window instead of a white cube
situation. Turning things almost into architecture. So I came up
with about ten projects. Some were halfway between pavilions
and sculpture, and the other half were modifications of suburban
situations, like the clinic.

KB And like *Alterations to A Suburban House.*

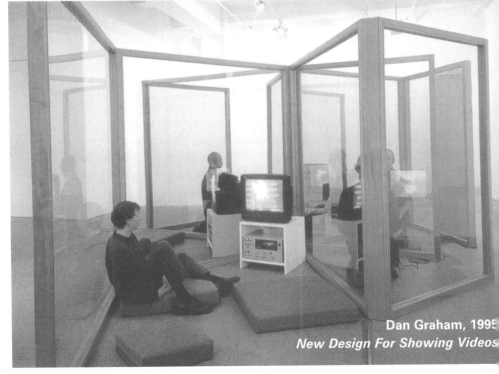

Dan Graham, 1995
New Design For Showing Videos

DG

Yes. And I thought the best way to present them would be as architectural models, because it would fuck the system up if artists did things that were like architectural models. Also like architectural models you could pose those as propaganda for things actually to be built. And I figured that the modifications of suburban situations would be too fantasy oriented or quasi-filmic to actually be built. But the sculpture pavilions could actually be built. In fact two were built three years later, *Two Adjacent Pavilions* was in Documenta and *Sculpture Pavilion for Oregon* was done in an atomic research centre outside of Chicago.

But in the suburban models the models were enough to hold the **MM**
fantasy or is that where you were worried that...

DG

They were both together.

KB But you're still producing models of projects, for example the library for children.

DG

Well, it was proposed for the Münster show, which was 1997. The idea of the Münster show was brilliant. The idea was to do something on the city plan. One piece on the bicycle path blockway on the edge of the city plan, and the other was the addition to the new museum on the Domplatz, near the cathedral in the centre of the city. So the outdoor piece, which you know, was done on the edge, and then I wanted another thing dealing with the curves of the city plan, the CD-Rom for *Children's Day Care Centre*. And they ran out of money.

KB So you just produced the maquette?

DG

Well, it was actually realised by Marian Goodman and nobody could come up with enough money to ship it during the retrospective. You see, I wanted the retrospective to be about people lying down, little children rolling around in the library area, and also *The Design for Showing Video* was to be for teenagers

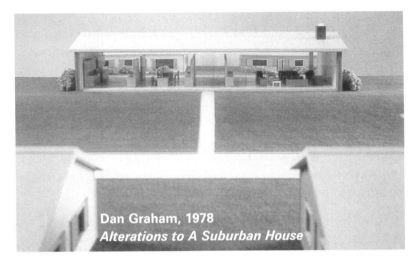

Dan Graham, 1978
Alterations to A Suburban House

and other people lying down. It was to be horizontal and not to be instantaneous. So much art is spectacle and instantaneous, or designed to overwhelm.

Immediate gratification. **MM**

KB But your work is reflected in many artists who are now working with miniature structures, for example Julian Opie and Langlands and Bell. Now it has become a dominant form.

DG
Well it's boring.

KB Why do you think it's boring?

DG
It just is. I think these are people who come from art school and can make things that are very saleable. My things are tiny, very vernacular.

So when you were doing models there was never any intention **MM** that these things would manifest themselves in real buildings?

DG

No. I wanted to make a show and also propaganda for things actually to be built, which is the way architects work. They show a mixture of things which don't actually happen and propaganda to make things happen.

Instigation artists. **MM**

KB I think often architects regard artists as tools for making things rather than equal collaborators.

DG

The artist does a flat thing on the wall. But actually if you go to the Herzog & de Meuron office they have all my catalogues stacked up to get ideas. Many architects do this.

As a profession, or even when you are in school, it is all about **MM** collaging other people's work so by the time you take your degree or licence you probably don't even think about it anymore. Even when they go to the press, it's probably 'only their work'.

DG

Well Hejduk is very important to me because he and Neil Lombas are the biggest influence, and Seguiro Vant. I've seen three Seguiro Vant buildings in Japan. They are amazing.

It must be like catching someone on the street, like a relative, **MM** that you recognise.

END

This interview is published on the occasion of the launch of *Dan Graham*, published by Phaidon Press Ltd, and a major retrospective of his work travelling to Porto, Paris and Amsterdam.

When the time comes to commission a museum of art for
a major metropolitan centre, we are all by now familiar
with the choreography that this entails: the debate
surrounding its objectives, the competition, the jury, the
shortlist of high-profile architectural partnerships, the
exhibition of the contenders' proposals in the form of
models, the final selection, and finally the construction,
the unveiling and the branding. All this unfolds under the
tight scrutiny of the media. Once realised, the museum
finds itself engaged in the schizophrenic activity of
juggling between its role as leading tourist attraction,
major contributor to the cultural industries and its role of
an educational institution with a responsibility to local
communities. In the midst of this, one often wonders
where nowadays its responsibility to Art lies. When a little
known provincial city decides to enter the global inter-city
race, to take a chance at biting off a chunk of what the
'big fish' have already claimed as their own, the process is
much the same: the search for the architect that can offer
a building which will become the city's flagship and will
brand it for life, consequently offering it the chance to
move from the position of 'satellite' to the much desired
position of 'centre'. Tate Modern in London and the
Guggenheim in Bilbao are, naturally, the prime examples
of this 'dance'.

Since the commodification, commercialisation and
depoliticisation of the traditional and historical centres is
all but complete, it is perhaps timely to reconsider the
state of the province, its present and its future, from
perspectives other than urban regeneration. The space for
the alternative, the avant-garde, the 'new' is being
squeezed beyond the urban boundaries of the major
metropolis. Where will these pools of energy end up?

The province is a place that constantly mediates its identity between a desire for proximity to the closest urban centre and its desire for distance in order to establish an independent autonomous identity. History testifies to the role art plays in this process. In Israel, a primary example of a state that lies in the geographic margins of Europe but has evolved rapidly with an eye to everything American, art has always struggled to reconcile the ideas of 'here' and 'elsewhere'. For over half a century Israel's museums have in general been preoccupied with the need to strike the 'right' balance between the two, in order to paint that 'right' picture of the past which will serve as the basis for the new tomorrow. While this has been predominantly the activity of the history museums, it hasn't failed to also affect the art museums, which had to fight hard in order to maintain their autonomy from the ideological, social, political, historical and cultural pressures.[1]

In a country where distance is no distance, a city a mere half hour drive south of Tel-Aviv finds itself engulfed in this struggle of identity, prompted by a heated debate surrounding its public spaces into which a Museum of Art was to be inserted. Here, however, there was no sign of the familiar choreography traced above, since the province, as the story below will reveal, 'has its own ways'. Its odd 'inception', described in the tale that unfolds here, has led to a unique architectural project that not only offers an alternative way of negotiating the display of art and its context but also sheds light on the heated debates that surround the museum today and opens up a window onto the province and its urban future.

— **Nina Pearlman**

1) Ariella Azoulai, 'With Open Doors: Museums and Historical Narratives in Israel's Public Space', in *Museum Culture: Histories, Discourses, Spectacles*, ed.s Daniel J. Sherman & Irit Rogoff, London: Routledge, 1994, p. 91.

When Ashdod – a provincial city located in the dune lands of the southern Israeli coast, started engaging in a debate on whether and how to build its municipal museum for the occasion of its 30th anniversary, ghosts from its recent past were awakened . For its inhabitants, immigrants of diverse origins, the museum building, its content and architecture, became the first major civil issue around which differences were asserted.

The aesthetics and spatial organisation of the resulting building became the embodiment of intense cultural and political clashes – it seemed as if the city's larger narrative was cast into the building's architectural frame. Beyond that, the building could not have performed its task as a museum, or as anything else for that matter. The realisation that the building had to be transformed became apparent only minutes after its unveiling. Our architectural team was commissioned to rethink the museum's structure, its use and curatorial strategy. Our work was soon drawn into a process similar to archaeology – a study of the materialisation of local processes. In order to engage with the modern ruin that stood before us we had to correlate the adaptation of material constructions and spaces to the social conflict that was still unfolding before us.

What follows is a descriptive and reflective account of the different stages of the research and design process, our attempt at mediating the different powers and interests, as well as the city's conflicting tastes within a strategic spatial arrangement.

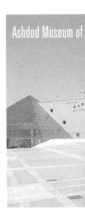

Ashdod Museum of

A LOUVRE OF SUBURBIA
Re-constructing the Ashdod Museum of Art

A PROJECT BY RAFI SEGAL, EYAL WEIZMAN & MANUEL HERZ ARCHITECTS

Ashdod is not a very pretty town. It was planned from scratch as a medium sized workers-town and built in the early 1960s around two major infrastructural projects – an electric power station and a deep-sea port. The town was carefully positioned halfway between the two cities that define the contradictory poles of the southern Israeli coast – Tel-Aviv and Gaza.

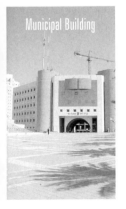

The choice of location was motivated by military logic: the power station and the port, two strategic functions of national importance, were placed at a safe distance from the hostile border of Gaza, and far enough from Tel Aviv so as to minimise collateral damage in the event of an aerial attack at a time of war. Ashdod was therefore located not according to considerations of proximity (from other cities or services), but rather because of a desire for relative distance. These motivations became crucial in the formation of the city's self-perception and identity as a province.[1]

It was neither planners nor architects that shaped the spatial organisation of the city, but state technocrats and infrastructure engineers. The city was built to serve the modern icons of post-war city planning – infrastructure of transportation and speed – the port, the truck and automobile. These called for a highly utilitarian pattern of urbanisation. Ashdod was planned on the basis of a grid of fast moving arterial roads, generating a series of large rectangular sites that define each of the city's eighteen quarters. The wide streets and fast moving traffic made the squared quarters partially independent and free to form their own versions of a different and autonomous suburban fantasy.

The quarters, products of an abstract and synthetic planning, were constructed and inhabited in succession. Upon the arrival of each wave of immigration to the city, another quarter was built and populated, while the remaining ghost quarters were left as empty sand dunes

1) Zvi Efrat, *The Israel Project*, Tel Aviv: The Tel Aviv Museum of Art, 2001.

180

surrounded by roads. The first modern settlers of Ashdod were primarily Jewish immigrants of Moroccan descent that arrived to work within and around the port and the power station. The successive arrival of other communities led to the rapid growth of the city. Two complete quarters were reserved for ultra-orthodox communities. The latest and by far the largest in-coming community were the Russians. When, after the collapse of the Soviet Union in the early 1990s, unprecedented quantities of Russian immigrants arrived in Israel, the population of Ashdod was almost doubled and the new immigrants started to inhabit the last six quarters of the city's grid.

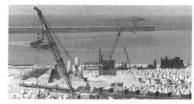

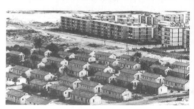

The city plan of Ashdod was so abstract that its present day mayor, Zvi Zilker, declared: 'Practically, it is possible to relocate this plan to every point on the globe...'[2] Not only has the world relocated in parts to Ashdod, through constant waves of immigration, but Ashdod itself could now, in turn, become an abstract model city, and be relocated globally. For this reason a semblance of uniformity was needed in order to guarantee an homogenous suburban lifestyle on the sandy dunes. Accordingly, Zilker went on to recommend that 'for the landscaping of the area, a layer of 10 to 20 cm of good soil is sufficient to make the sand suitable for gardening and lawn growing.'[3] Indeed, the dunes were covered with 'red' soil brought in by the otherwise empty in-going trucks on their way to the port, importing with the earth a foreign suburban microclimate and the biological life-forms it supports.

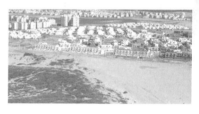

2 | Zvi Zilker, *Planning for the City of Ashdod According to Planning Principles of the 20th Century*, Haifa: The Technion Institute of Technology, Urban and Regional Planning Faculty, 1967-68.

3 | Ibid.

The Empty Square

At the centre of the city's grid, surrounded by six residential quarters, one full square was sanctioned to become Ashdod's common civic centre. The communities inhabiting each of the city's surrounding neighbourhoods observed proposals for the empty square – the last ghost neighbourhood on the chequer-board of the city plan.

When the new Russian arrivals, former citizens of great metropolitan centres, they demanded a museum, claiming that 'Ashdod is not a City if it doesn't have a museum',[4] a controversy engulfed the city. The veteran population rejected the demand for a Museum in favour of counter demands for sports and welfare projects.

In *The Love of Art*, Bourdieu argues that rather than to collect, preserve, study, exhibit or interpret objects of art, the social function of a museum is 'to reinforce for some the feeling of belonging and for others the feeling of exclusion'.[5] Beyond a sincere wish for cultural exposure, it seems the Russian community attempted to establish its social status by elevating culture over need.

The confrontation culminated during the period leading up to the immanent municipal elections. The ex-Russian community supported en masse the mayoral candidate

4) Vadim Cherniko, 'Russians to overrule compromise on the Museum', as quoted in *Kol Hadarom*, Ashdod's local newspaper, 27th September 1998. (my translation from Hebrew

5) Pierre Bourdieu & Alain Darbel, *The Love Art*, Cambridge: Polity Press, 1997.

182

that promised to build a museum for the city. A few weeks later, a Mayor was elected and had to build a museum. A jury representing the different communities of the city was chosen, an open national competition was announced, and after a winner was declared, and the 'necessary' changes were introduced to his scheme, a building based upon and resembling, in all its visual and spatial characteristics, a shopping mall, was promptly erected.

On top of the structure, presumably to make it similar to the desired ideal of museum design, a glass pyramid (that might recall Pei's extension to the Louvre in Paris) was set. Alas, in the hot southern-Mediterranean climate, the glass roof created a 'green house effect' – an excessive glare and the kind of over-heating that makes even a short stay in the interior of the building intolerable.

The 'Shopping Mall'

The building of the Ashdod Museum was conceived as a consequence of the inevitable and much foreboded clash between two architectural typologies that for a while now have been riding along colliding trajectories – the shopping mall and the museum. In Ashdod, this typological clash goes beyond the ubiquitous tendency by which expanded museum shops become the focal points of high profile metropolitan museums. Ashdod uses the mall as an architectural aesthetic suitable for the display of art, just as it might be suitable for shopping activities. The existing building is a post-modern manifest that relates to signs of the second and the third degree. Its aesthetics are further complicated with an eclectic choice of expensive looking materials: a glass elevator travels through the building's marble clad atrium, its details are made of shiny brass. The exhibition area is partitioned into two large and visually separate galleries placed one on top of the other, connected through a narrow set of exterior stairs. The museum's basic needs for storage and access are not catered for at all.

Regardless of its nature, Ashdod had a museum and its communities began to engage in the debate surrounding its content: should the museum be dedicated to the city's local history or to the Arts? To Local Art or to international 'Classic Art'? To the sea and ships? To biblical era of philistine history? To national Zionist history? Should it be an architectural museum or a science museum?...

If before we had Art for Art's sake, now we have the Museum for the Museum's sake!

Sponsorship

Museums have become public corporate ventures. Because of the scarce resources of public funding, every museum is engaged in a constant competition with others for its share of corporate sponsorship and private donations. Private donors of money and art, fuelled by tax incentives and accountancy loopholes, are the engines that run public museums. However, funding and collections do not arrive without specific demands and agendas.

After amassing their fortunes in business, millionaires typically assemble 'aristocratic' art collections to be placed in their own Mausoleums. There is never a millionaire who doesn't want his art collection to serve as his personal or family memorial.

Ashdod Museum attracted two different private collections:

An American gallerist and art collector was, upon his 80th birthday, seeking to donate his collection of old-master oil paintings to the state of Israel. He contacted the Israeli Minister of Culture and offered to donate his collection, in memory of his late mother, to the Israel Museum in Jerusalem. But the Israel Museum couldn't accept any more private collections, or perhaps did not wish to accept this one.

The Minister pointed out to the collector that a new museum was recently built in Ashdod. 'Where is Ashdod?' asked the collector. 'Ashdod is about 30km south of Tel Aviv!' replied the Minister. And so the deal was signed, and the collection of paintings was on its way to Ashdod.

A second collection arrived from a small Gallery located off the Rue de la Seine on Paris's Rive Gauche. The Gallery, selling art of a decorative nature, donated a few million dollars towards the completion of the building. In return, it was initially agreed that one of the two museum floors would be allocated to the gallery's curatorial choices – most probably a selection of its artists.

Corporate or private art collections donated to a public institution are in most cases required to be displayed in their entirety, overriding the curatorial autonomy of the museum. On the other hand they arrive with a sum of money that can financially support other museum programmes. The willingness of the museum to sanction prominent space for the private choices of a donor confronted us with a curatorial problem:

How to resolve the gaps between the pressing curatorial obligations and the programmes of contemporary art the museum wanted to display within the tightly limited space?

The re-design of the museum became, thereafter, an attempt to synthesise the politics, finance and modus operandi of a museum with the post-modern aesthetics of the building's form.

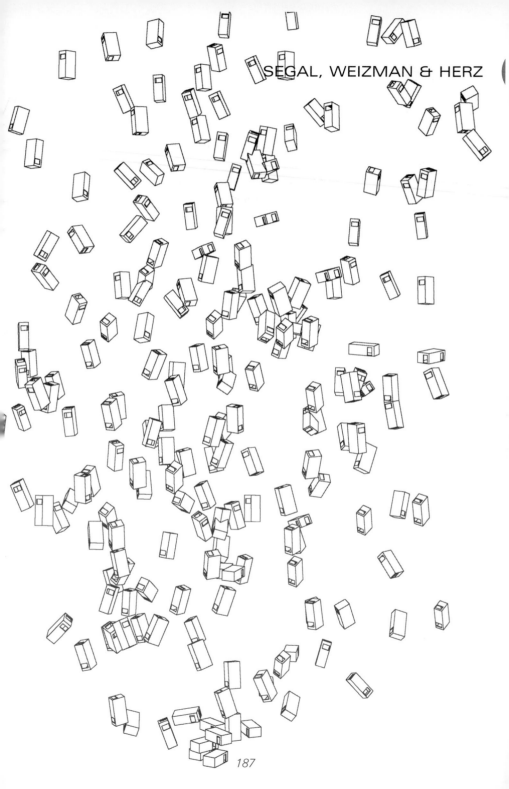

SEGAL, WEIZMAN & HERZ

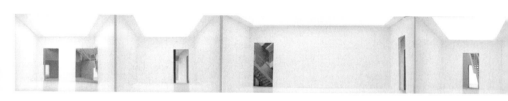

Scattering White Cubes[6]

We started with an ideal – the White Cube.

We imagined a rain of White Cubes over Ashdod.

Some have landed in the city and some within the museum environment.

More then any other typology, the White Cube is a modern 'ideal'. Its dimensions rectangular, its walls painted white, devoid of windows and natural light, shadowless, introvert, artificial, hygienic, clinical – the White Cube embodies the cultural aesthetic of modernism. Within these abstract frames, spaces, capsules of placeless inferiority, art can take on its own life.[7]

The proposal for the conversion of the Ashdod Museum of Art both accepts and challenges this notion, it takes the possibilities embodied in the typology of the White Cube further by treating it as a free standing object whose outer perimeter, explicit and usable, creates a dialectics with its interior. The White Cube is multiplied and independent units are amassed against the existing structure of the building.

6 | This is a reference t[]Brian O'Doherty's *Insid[]the White Cube, the Ideology of the Gallery Space,* London: University of California Press, 1986, on which this proposal is based.

7 | O'Doherty, p. 7.

Move 1: We proposed to void the interior of the building of its architectural content, removing internal walls and destroying large parts of the floor that separate the two exhibition galleries, thereby transforming the building into an empty shell.

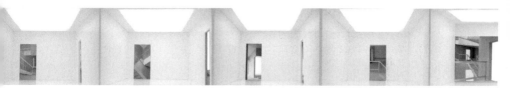

Move 2: We proposed to scatter and pile a series of identical White Cubes (4m by 8m wide and 3.5m high) haphazardly on four levels.

A building within a building: a new and independent structure made of the repetition of the uniformly dimensioned White Cubes is constructed within the existing shell.

Two kinds of spaces are thus created: The White Cube interiors – small and introvert, white and flooded with light – and the rather large, irregularly shaped, and shadowed 'left over' spaces trapped between the exterior of the White Cubes and the interior envelop of the existing building.

Visitors move between these spaces, in and out of the White Cubes.

As for the existing building – its context becomes content. The modernistic typology of the White Cube throws a retroactive and subversive challenge to the post-modern interiors of the museum. In a peculiar reversal, the series of repetitive objects introduce a degree of coherency into the museum space against the backdrop of the eclectic existing architecture. The contrast between the pile of cubes and the existing building allows for a heterogeneous exhibition system. The two kinds of spaces do not only formally enter a dialectic with each other but also programmatically, as they allow for a proximate and interwoven placing of two distinct museological objectives: the changing programme of contemporary art and the museum's permanent collections. The outcome is an ambiguous structural and curatorial circuit that runs through the different parts of the exhibition spaces. The visual, spatial, and material elements of the design create a composition that promotes chance discoveries and unexpected encounters.

Photos Danny Bau

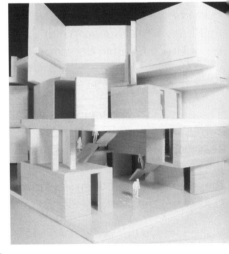

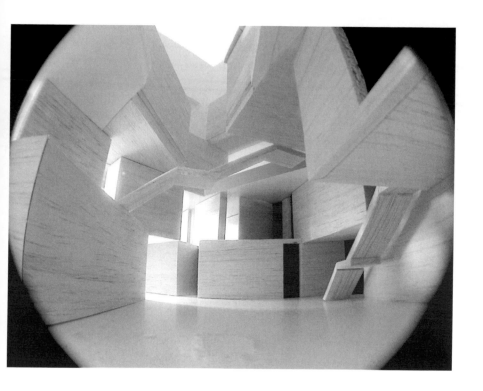

A Faustian pact is signed between the museum and its donors. The money generated by accepting donated collections, that are to be displayed in their entirety without the possibility of selection or editing, will be used to activate the museum's contemporary art programme.

The proposed architectural intervention reflects the economy of museum organisation and management. This relationship between sponsoring and sponsored art prompts the creation of two configurations that will inhabit the spatial dialectics created in the museum's interior.

Two fantasies or nightmares of museological practices that utilise the relationship between the inside and the outside of the White Cubes can be speculated upon:

First nightmare (or fantasy)

in which the 'left-over' spaces financially support the activities within the White Cubes.

The 'left-over' spaces are used for the display of the 'sponsoring' permanent collections.

The White Cubes are used as capsules of insulated project space, critical laboratories of contemporary culture.

The White Cube remains independent, while its exterior is marked by institutional surrender to the logic of private sponsoring. The relationship between the two spaces becomes symbiotic: the exhibitions within the cubes, a series of fifteen single one-person shows, corresponding to the proposed number of White Cubes within it, depend on the finances generated by the donations that arrive with the collections placed at their exterior. The latter benefit from the social, cultural and symbolic capital generated from within the cubes, which is then disseminated in the form of prestige outside.

The museum's permanent collections become interesting at last! By being amassed outside of the cubes, they activate an experimental art program inside.

'... The space stirs and mutters; the white cube, now a brain in a bowl, does its thinking...'[8]

8) O'Doherty, p. 99.

Second nightmare

A possible reversal in which the 'left-over' spaces are financially supported by autonomous Mausoleums of White Cubes

The 'left-over' spaces are used as the backdrop for a display of a changing programme of contemporary art.

The interiors of the White Cubes are used for the permanent collections.

The White Cubes provide the equivalent of a series of Mausoleums – ego-memorials containing each a collection of an individual donor.

Rather than 'Museum as Monument!' we have 'Museum as Container of Monuments!' (for donors). These monuments are meant to enable a living cultural practice in the 'left-over spaces'.

The left-over spaces, irregular and non rectangular, their walls baring different materials and colours with unexpected openings to natural light, shadowed and sometimes dark, extrovert, artificial, chaotic, eclectic, inadequate – embody the cultural and aesthetic ideology of post-modernism. Within these disproportionate frames, spaces of locality and specificity, art can still 'take on its own life'.[9]

The Mausoleums of the White Cubes are left as pockets of permanence trapped within an environment of constant change, like space capsules floating in a sea of flux. Orientation is established and lost, as fixed islands of tranquillity create, paradoxically, a chaotic and labyrinthine space.

With direct and tactile proximity to the existing shell and its architectural aesthetics, the original museum building itself might become a subject of examination.

9 | The sentence is a (negative) rewrite of the O'Doherty inspired sentence. See footnote 6.

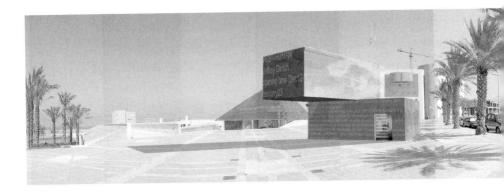

Urban Seeding

The identical White Cubes are 'seeded' within the urban fabric of Ashdod, dispersed and ready for use in each of the separated utopias that inhabit the city's rectangular grid, their use to be negotiated and employed by the different communities and municipal institutions of the city. Three are located on traffic islands, two on the seashore, four in the port, one near a school, two at the northern entrance to the city and a further two near the local hospital.

Philistines

A short historical account of Ashdod, printed on the reverse of the city map, states:

'Along with other new cities in Israel, the new city of Ashdod, was established where an ancient city of a similar name had flourished in biblical times. The ancient city of Ashdod...had been one of the five Philistine cities mentioned in the bible... it gradually became neglected, its inhabitants deserted it and the sand took over... At the time of the establishment of the state of Israel, the only thing emerging from the sand dunes was a small tomb...lone remnant of the glory of Ashdod in past days.'10

10 I Municipality of Ashdod, The Spokesperson's Office, *Ashdod, Beyond All Imagination, October 1999* (my translation from Hebrew).

The one fact this historical account about the city neglected to mention was that the place was not completely deserted. Although, indeed, the glories of ancient Ashdod diminished, 'at the time of the establishment of the state of Israel' a small Palestinian village by the name of Asdud remained on the dunes, testifying at least linguistically for a historical continuity with its Philistine past. On the 15th and 16th of October 1948, the days of the Israeli war of independence, the village of Asdud was targeted by artillery and raided from the air, then quickly occupied by the Israeli army, and its inhabitants made refugees in another ancient Philistine site – the city of Gaza. The village was destroyed and its ruins were buried under the sand dunes.

The deliberate erasure of or emphasis on certain historical facts in the writing of the modern history of Israel, together with their physical manifestations in the choice of construction of monuments and historical museums, is telling of the state's continuous attempts to re-establish a historical link between the Jewish people and its land of Israel, while at the same time disguising those of others. In this context, even the clear assertion of a Philistine, rather then Israelite origin of the city (not to mention its Palestinian history) is quite bizarre.

The Philistines were a naval people that occupied the southern Canaanite coastal plain during the 12th Century BC, and settled there for the following 600 years. Ashdod was one of the five urban centres that made up the Philistine Pentapolis – an economical network of glass and iron production. The word Philistine served under the later Hellenic period as the name for the whole country, and has survived in the etymology of the word Palestine. The conflict between the Israelites and the Philistines that dominated the 12th to 6th centuries BC is nowadays mirrored by the conflict between Israelis and Palestinians over the very same territory and place-names. If the Israeli historical justification for the return of the Jewish nation to its 'homeland' relies upon the ancient Israelites kingdoms, the Palestinian construct theirs through a genealogical connection to the Philistines to whom they owe their name.

With all that in mind, it is even more bizarre that a small exhibit of Philistine history exists in Ashdod, albeit for the use of young school children. The ancient enemy, whose ferocious image was softened by time and long succession of victories, has become quaint enough to be displayed in a sympathetic theme-park style. The provincial nature of the city has allowed it to step unknowingly or un-noticeably out of the national line. But in a country whose museums are made to serve the Israeli national ethos, the small exhibit goes a step towards the resurrection of the buried history of the destroyed Palestinian village, that like many others are left underneath the modern towns of Israel and thus towards telling a part of local history that has been excluded from the official narrative.

In order for the Philistine exhibit, originally compiled without political intentions, to be exposed to a wider audience, and to partake in a national debate, we are currently seeking to include it amongst the permanent collection of the Ashdod Museum of Art, within or around one of its cubes. Disguised as a theme park, the Philistine display will bring about another level and meaning to the museum's own context, but will just as well, act to reflect upon the role and use of the national museum culture of Israel.

Laboratory

In the attempt to incorporate the conflicting forces of Ashdod in the spatial syntax of the building, we have proposed a space of trialectics, where works of distinct nature that possess different values, are confronted with irony. Works of alternative languages and value stand side by side – the revolutionary with the conservative – at times embodying, reinforcing and celebrating the social values on which the museum was founded, at times operating to destroy its very institutional order.

The museum's spatial configuration becomes a mechanism that specifies and limits the type of shows it can display. There is no other way by which peripheral museums can make an impact other than by promoting themselves as alternatives to the large, capable and versatile metropolitan spaces. The periphery can not be competition, but it can be an alternative. Rather than offering flexibility, it offers the kind of limitation and tension. In its particular restrictions lie its potential.

In the Ashdod Museum, the process of its inception was a double edged sword – producing an inadequate and vulgar building when 30 seconds later accepting the insertion of an architectural subversion that criticises the institutional order from the inside – the Trojan horse passed through so quietly that it went un-noticed. The building's larger narrative – its own – is held to scrutiny within the transformation of its architectural frame. If the political and corporate mode of the museum is parodied, it is meant beyond a mere cynical critique of its aesthetics, the local politics that conceived it, the urban fabric that contains it, and the financial methods that fund it. The museum itself becomes simultaneously the object enabling exhibition and the subject of the exhibition enquiries. It does not merely exhibit 'works of art', but could rather be used to exhibit 'exhibitions'.

Design Collaborat
Gali Bar
Amy Cheung
Julika Gittner
Sari Segal
Merav Twig

1787: About nine o'clock in the evening, the 2nd of November last, the *Ann Elizabeth* was driven on a rock near Margate; the sea ran high... bursting thro the cabin windows... At ten the cabin was full of water, and the waves washed c the deck; the crew, consisting of five men and a cabin boy, about 15 years of age hopes of saving themselves... were compelled to quit their retreat and seek ref in the shrouds, climbing the mast and lashing themselves to the cross-trees; ab three in the morning Roger Mares [the cabin boy] appeared totally exhausted v cold and fatigue... and at about six they supposed him dead... The horror of night had, even on those who were on shore, awakened the most serious app hensions for the many distresses which the next morning might bring to light, as soon as the day appeared, the sloop *Anne and Elizabeth* was discovered in utmost distress, all the people on board being seen hanging from the shrouds... soon as the ebbing of the tide would allow... a boat went off to them... It was v great difficulty the sloop could be boarded, and the mariners rescued, who suffered most sensibly from the wet and cold of so dreadful a night and the mena of surrounding death... All the crew were safe landed; but the boy, supposed to dead, remaining lashed to the shrouds. Among the spectators on shore who waiting with anxiety the return of the boat, was Nicholas Styleman, Esq; Norwich, who was on a visit at Margate and, perceiving that though they brought away the people there still remained a lad tied in the shrouds, he expres his wonder that the boy was left behind; the answer of all the people who came shore, was that the boy had been dead several hours. Mr. Styleman earne entreated the boatmen to go back and fetch the boy; this they objected to... as vessel could not be boarded without great danger... but being allured by the rew of Five Guineas, which this gentleman offered to them, to bring the body, whet dead or alive, they returned, and brought the body from the vessel. It was lan under every appearance of confirmed death, perfectly cold, limbs stiff, the e fixed, and the jaws locked. Mr. Styleman had him put into warm blankets.... usual endeavours of restoring heat and mobility by warm flannels and frict being found very ineffectual, he was carried to a warm bath in the nei bourhood... In about an hour laborious and convulsive reparation return sometimes at very long intervals; the heart commenced its action, and a sli pulsation was soon afterwards perceptible... he then lifted up his eyelids, but eyes appeared motionless and the pupils widely dilated... At about nine in evening he swallowed some broth with difficulty, but with much avidity... He full of gratitude to his deliverer, but knew nothing of what had happened; remembered the vessel going on the rocks, and the sea bursting into the cabin, here his recollection closed; all that after occurred was lost in oblivion, so that may be said to have undergone death without knowing it... On the boy be happily restored to life, [Mr. Styleman's] kindness was again conspicuous, as purchased clothes for him, and likewise took him repeatedly to church, in orde return thanks for the great mercies received... A great number of genteel fami enjoyed infinite satisfaction from the recovery of the boy, and contribu to fitting him out in the most comfortable manner for the naval servic

OUT IN THE COLD:
FANTASIES OF REVIVAL

John Tercier

So uncertain is men's judgement that they cannot
determine even death itself.

— Pliny the Elder[2]

Absolute Death

How does life's countenance differ from the mask of
death? It would seem self-evident. The dead are silent,
cold, and still.

Many, various, and even opposite appearances,
have been supposed to indicate the total extinction
of life. Formerly, a stoppage of the pulse and
respiration were thought to be unequivocal signs of
death: particular attention in examining the state of
the heart and larger arteries; the flame of a taper,

1 I Humane Society,
*Reports of the Humane
Society Instituted in the
year 1774 for the
Recovery of Persons
Apparently Drowned.*
For the Years 1787,
London: Humane Society,
1788, pp. 105-113.

2 I *Historia naturalis*
7 liii 52.

a lock of wool, or a mirror applied to the mouth or nostrils, or a cup of water to the scrobiculus cordis;[3] were conceived sufficient to ascertain these points: and great has been the number of those who have fallen untimely victims to this erroneous opinion. Of late, some have formed their prognostic from the livid, black, cadaverous countenance: others from the heavy, dull, fixed or flaccid state of the eyes; from the dilated pupil, the foaming at the mouth and nostrils, the rigid and inflexible state of the body, jaws, or extremities; the intense and universal cold, &c... it is evident, that these signs will not afford certain and unexceptionable criteria, by which we may distinguish between life and death.[4]

As Kite and other physicians of the eighteenth century pointed out, none of the signs of death is absolute – loss of breath, pulse, and consciousness; lack of movement, dilated unreactive pupils; cold flesh, pallor, stiffness – none are a sure indication of death.[5] It is no easy thing, even today, to identify death. The so called 'vital signs': consciousness, pulse, and breath, are signals sent out by the vital triad of brain, heart, and lungs. They are important signs of life, but their absence, at least in certain cases, does not absolutely indicate death. There is, in certain circumstances, a problem in distinguishing the appearance of death from the reality of death: in distinguishing 'apparent death' from 'absolute death'.

> Previous to the origin of this new branch of healing [resuscitation of the drowned], which indeed constitutes a remarkable area in Science, death apparent and absolute had long been considered as almost synonymous terms. For the subjects of both appear to have been alike consigned to the silent mansions of the tomb, without it ever being dreamt

3) Pit of the stomach.

4) Charles Kite, *An Es on the Recovery of th Apparently Dead*, London: Dilly, 1788, p 92-95.

5) A. Fothergill, *A Ne Inquiry Into the Suspension of Vital Action in the Cases o Drowning and Suffocation*, Bath: S. Hazard, 1795, p. 92.

that such a vast proportion of the former, might, by a few simple means, have been recalled to life, and all the endearments of social happiness.[6]

The dilemma of 'apparent' and 'absolute' death was particularly related to a specific, though in many ways occult, mode of death – hypothermia (that is, death from exposure to cold), and in particular, hypothermia as it presents itself in the victim of drowning. At its extreme, cold kills, but up to a certain temporal and pathophysiological point, it saves. And, importantly, the form this defence takes mimics death. It was hypothermia, especially that related to cold water drowning, that allowed for the eighteenth-century distinction between absolute and apparent death, that inspired the drama of reanimation, and that revived the atavistic fear of premature burial.

In the late 1700s, philanthropic societies were set up in a number of European cities such as Amsterdam, Milan, and Hamburg, for the purpose of developing and promulgating protocols for the treatment of victims of drowning. The London Humane Society[7] as founded in 1774 and in that same year published its first 'Methods of Treatment for the Drowned'.[8] The dramatic revival of the apparently dead by the Humane Society's protocol gave proof of science's ability to triumph over death. It is no accident that this mode of death and a specific therapeutic approach expressed as a formal protocol came to prominence in the late eighteenth century, a result of and accessory to the birth of the modern. That particular mode of 'modern' death continues to haunt our expectations of death three hundred years on. The unacknowledged vision of the hypothermic patient awakening from the dead is a secular fantasy that continues to drive the drama of resuscitation. A fantasy that embraces both the hope of resurrection and the fear of being buried alive.

6] Fothergill, p. xiii.

7] Initially the 'Institution for Affording Relief to Persons Apparently Dead from Drowning' the name was soon changed to the 'Humane Society' and in 1783 it became 'The Royal Humane Society'.

8] Humane Society, *The Plan of an Institution for Affording Relief to Persons apparently dead, from Drowning...*, London, 1774.

Buried Alive

Thousands have been hurried to the grave without that confirmation of death; and no doubt, amidst such numbers, many have revived to feel all the horrors of a second, and more dismal dissolution.[9]

The fear of premature burial was to reach almost hysterical proportions around the turn of the eighteenth century.

A lady in Hampshire was buried three or four days after her supposed death, the next day, a noise being heard in the vault, it was opened, and she was found just expiring. Maximilian Misson tells us of Francis de Civille, of Rouen in Normandy, who is recorded to have been three times dead, three times buried, and as many times raised from the dead. Upwards of half a dozen stories are related of persons who, being buried, were roused from their trance by the attempts which were made to rob them of valuable rings which they had on their fingers; and a greater number of instances were said to have happened, where persons being prematurely confined to their coffins, have not only devoured their shrouds, but have been reduced to the necessity of eating part of their own flesh. Many more similar cases might be given; but, in all probability, what has been said will be thought fully sufficient.[10]

Quite!

Legislation was passed in Germany, Austria, England and France requiring some delay – as much as three days – before burial, so that putrefaction might be allowed to occur.[11] The first public mortuary constructed for this purpose was opened in Weimar in 1792.[12]

9) Humane Society, 1788, p. 64.

10) Kite, pp. 189-220.

11) Jan Bondeson, 'Th[e] Plight of the Living Dea[d]' THES, 20 April 2001, p.19.

12) M. S. Eisenberg, *Life in the Balance: Emergency Medicine [and] the Quest to Reverse Sudden Death*, New Y[ork] OUP, 1997, pp. 69-70.

The signs of 'absolute' death were not much different from those used today:

> Obvious signs of irreversible death: decapitation, decomposition, rigor mortis, or significant dependent lividity...[13]

However, most physicians and families, then and now, were and are unwilling to wait for putrefaction to set in, and would no doubt balk at decapitation before considering the patient dead. Other precautions have always been taken. The vigil or death watch over the body had a practical purpose over and above showing respect for the deceased and giving an opportunity for prayer. The boisterousness of the wake is not unconnected to making enough noise to 'wake the dead'.

Medical therapeutics has also always played a part in the identification of the dead. Bleeding was a therapeutic technique practiced in the eighteenth, and even into the nineteenth century. However, alongside its therapeutic use there was also a more occult diagnostic purpose. In the moribund patient, the absence of a brisk 'bleed' on opening a vessel and a dark colour to the blood was indication of the patient's failed respiratory and circulatory systems.[14] Folk custom in some locales, and even occasionally written wills, required the opening of a vein prior to consigning the corpse to the grave. This was not merely to make certain that the diagnosis of death was correct, but should that diagnosis be wrong, the opened vein itself would insure that, in due time, it would be made right. If the victim was not dead, he or she soon would be, and thus be spared the horror of awaking to find him- or herself mistakenly interred. Thus, in the context of the deathbed, bleeding fulfilled a triple role: it might restore life, it helped diagnose death, and it insured against awaking in the tomb.

13 | Robert Neumar, Kevin Ward, 'Cardiopulmonary Arrest', *Emergency Medicine: Concepts and Clinical Practice*, ed. Peter Rosen, St. Louis: Mosby, 1998, p. 35.

14 | Falling blood pressure and deteriorating blood gases perform a similar prognostic function for today's physicians.

Physiologic Characteristics
of Hypothermia

SIGNS AND SYMPTOMS
AT CORE TEMPERATURES (°C)

37.6 Normal core body temperature. Pulse= 60
35 Shivering maximal.
34 Amnesia. Speech difficulties.
33 Incoordination. Difficulty with movement.
32 Stupor.
31 Pulse = 40. Cardiac output drops.
30 Cardiac arrhythmias.[15]
29 Coma. Pupils dilate.
28 Respirations drop.
27 Loss of reflexes.
26 No response to pain.
25 Cerebral blood flow drops.
24 Blood pressure drops.
23 Loss of corneal reflexes.
22 Maximal risk of Ventricular Fibrillation.[16]
20 Pulse = 20.
19 Electrical silence on electroencephalogram.[17]
18 Asystole – heart stops. Death. Pulse = 0.
16 Lowest accidental hypothermia survival – adult.
15 Lowest accidental hypothermia survival – child.
9 Lowest therapeutic hypothermia survival.

— **adapted from Danzl**[18]

15) Abnormalities of th electrical conducting system of the heart resulting in disturbance in the pattern of the heart beat.

16) Ventricular fibrillatic (V-fib) is a fatal arrhythmia where the electrical activity of the heart is completely chaotic and no blood is pumped. It can be reversed by an electrica shock (defibrillation).

17) No electrical activi in brain. One of the criteria of 'brain death'.

18) Daniel Danzl, 'Accidental Hypothermi *Emergency Medicine: Concepts and Clinical Practice*, ed. Peter Rosen, St. Louis: Mosb 1998, p. 966.

But why, at the turn of the eighteenth century, were the dead awaking so inopportunely?

Stone Cold Dead

In many, probably most, instances they were not so much dead as cold. One of the most obvious differences between the living and the dead is that the living are warm and the dead are cold. But 'to draw the line that separates life from death' is especially difficult in the case of the victim of hypothermia. Hypothermia is the clinical syndrome that accompanies a drop in body temperature, usually occasioned by exposure to low environmental temperatures: the motorist stranded in a winter storm, the pensioner in an unheated room, the climber high on the mountain, the sailor pitched into the sea. Like the hedgehogs, studied in their winter torpor by eighteenth-century naturalists, the heart slows, breathing becomes imperceptible, and consciousness fades: apparently dead, you live. Hypothermia is, *par excellence*, the living death from which absolute death must be differentiated. And, as importantly, the recovery from hypothermic near-death is one of the most awe-inspiring, almost magical, of physiological phenomena.

In hypothermia, one can chart the ebbing of life against core body temperature. As temperature drops the signs of life wane consecutively; until, at some imperceptible point, long after the image of death has marked the body, the line is crossed and death himself, finally, arrives.

Because of the difficulties involved in diagnosing death in the hypothermic patient: 'No one is dead, until they are warm and dead.'[19]

19 | The American Heart Association recommends that core temperature be raised to above 35°C before the patient is declared dead. (A task, I might add, that is not easily accomplished in all situations.)

Hypothermia is usefully, albeit artificially, broken down into a triple relation with death:

A cause – Cold as the cause of death

The body's physiological processes function within a very narrow temperature band. When ambient temperature decreases, it triggers a number of automatic and behavioural changes designed to maintain internal core temperature. When these compensatory mechanisms are exhausted or overcome, the body begins to lose heat and its temperature sinks below levels critical for metabolic function. If the core body temperature sinks low enough, respiration and circulation cease, and, as outlined above, death ensues from the combined effects of hypoxia[20] and ventricular fibrillation brought on by the drop in core temperature.

An effect – The cold body as a result of death

Body heat is the product of the metabolic process of energy production. When the animal dies and cellular metabolism ceases, heat production ceases and the body becomes poikliothermic, i.e., like a cup of coffee cooling on the desk, its temperature drops to ambient temperature.

A defence – Cold as a therapeutic technique

The physiological changes produced by hypothermia can act to protect the living animal against further damage. It may seem paradoxical that the loss of heat, which threatens life, also acts to preserve it, but such is the case. Hypothermia acts as a defence against hypoxia. As temperature decreases, metabolic processes slow down, decreasing the cells' requirements for oxygen and glucose. Respiration and heart beat are slowed to the point of being imperceptible, but because of decreased metabolic requirements they remain adequate to the task

20 I Decreased oxygen the blood.

of providing the necessary metabolic substrates.[21] This is particularly important in the heart and the brain, the two organs most sensitive to hypoxia, and the two organ systems from which the major signs of death are derived.

The ambivalent relationship between cold and death is, at least at the phenomenal and corporeal levels, a manifestation of and trigger for fear of the 'living dead'. One can argue over whether fear of the 'living-death' is universal and a result of nature and of human consciousness, or whether it is a cultural construct specific to certain places and times. Nevertheless, the question remains: Why has it taken the form it has in our particular culture and why in the eighteenth century?

The Watery Grave

The eighteenth century saw enormous advances made in the knowledge of combustion and, what we would now today call, animal metabolism. Animal heat which started the century as an occult, divinely inspired (in both the most literal and figurative senses of these words) force, ended it as a biological process analogous to the flame of the candle in the external world. Both were known to require oxygen and carbohydrate substrate, generating heat and carbon dioxide, producing energy in the form of light in the latter and life in the former.[22] Eighteenth-century science, armed with this knowledge, saw practical application for it in the treatment of the drowned. Antoine Ferchault de Réamur's *Notice In Order to Give Help to Those Believed to Be Drowned,* published in 1757, which gave instruction for rewarming, ventilation, and stimulation, has fair claim to being the first modern resuscitative protocol.[23] His recommendations found their way into the institutional protocols of Humane Societies throughout Europe.

21 | The preservative effect of intentionally induced hypothermia is what allows certain cardiac operations to be done when, for technical reasons, cardiac bypass is not feasible.

22 | Roy Porter, *The Greatest Benefit to Mankind. A Medical History of Humanity form Antiquity to the* Present, London: Fontana, 1999, p. 325.

23 | Antoine Ferchault de Réamur, *Notice In Order to Give Help to Those Believed to Be Drowned,* (1757), trans. L. Brown, Los Angeles: K. Garth Huston Jr., 1990.

Though physicians had long treated the moribund, their participation in deathbed activities was limited. Once they had bled the dying patient, induced him or her to vomit or have diarrhoea, there was little more assistance (or damage) they could give, and so the physician usually made a strategic exit, making room for the priest.[24] The drowning protocols of the Humane Societies were part of the growing medicalisation of death.[25] They were the first attempts at a secular intervention at the deathbed organised as broadly and comprehensively as religious deathbed ritual had been. Like the deathbed rituals practiced by the church, these scientific/medical protocols required an extensive institutional structure, participation by both professionals and the laity, a theoretical doctrine, and a certain amount of faith. These eighteenth-century protocols for the treatment of the drowned were the heralds of modern medicine's declared war against death. It is no accident that a major skirmish was fought over the bodies of the drowned; for, as those awakening in the tomb were not so much dead as cold; the drowned were more cold than wet. This will require some explanation.

Drowning is commonly thought of as being a form of asphyxia, that is, exclusion of oxygen from the lungs and subsequently the blood stream, resulting in hypoxia. And so it is, but hypothermia is also an inextricable and important part of drowning, at least in the waters of the temperate and polar zones. Careful review of the detailed case reports presented in the London Humane Society's publications of the first ten years of its operation reveal that over 90% of successful resuscitations from drowning were resuscitations not from hypoxia, but from hypothermia.[26] With hindsight, it is apparent that those who were pulled dead from the water and stayed dead died, for the most part, from the combined effects of

24 | Porter, 1999, p. 30

25 | The other major therapeutic change occurring at this same time and contributing t the increased presenc of the doctor at the deathbed was the growing use of opium. See P. Ariès, *The Hour Our Death*, 1977, trans H. Weaver, Oxford: Oxford University Pres 1991, p. 409.

26 | J. A. Tercier, 'The Contemporary Deathbed', Dissertatio University of London, 2001.

hypothermia and asphyxia; but those who responded to resuscitation were almost universally hypothermic, and the successful response to the protocol was in the vast majority of cases more a response to rewarming than to any of the other manoeuvres in the protocol (such as mouth-to-mouth ventilation, which though recommended was seldom performed).

Though the importance of rewarming was recognised and given its due, the somewhat complex cause/effect relationship of decreased body temperature to symptoms remained unclear. Death in drowning, though known to involve the loss of animal heat, was attributed to apoplexy[27] in the early eighteenth century, and then, around the time of the Humane Society's founding, to asphyxia. The difficulties in linking physiological cause (apoplexy, asphyxia, loss of animal heat) to symptomatic effect (pulselessness, apnoea,[28] decreased body temperature) resulted in a plethora of anecdotally attested and inadequately theorised therapeutic techniques being lumped together in the protocol. Physical stimulation in the form of agitation. Chest and abdominal compressions. Friction with alcohol, friar's balsam, or sal ammoniac. Bleeding. Ventilation by mouth-to-mouth or bellows. Tobacco smoke enemas. Electrical shocks. All were all frequently used, and frequently given credit for, the successful effects that the removal of wet clothes and placement near a fire had humbly and, for the most part silently, accomplished. The nature of the underlying pathophysiological condition, be it hypoxia or hypothermia, remained occult and the apparent successes of the multiple therapeutic manoeuvres instituted became justified in various theories which with hindsight we can see as, for the most part, false.

27 | The theory that death was caused by the congestion of blood in the brain caused by collapse of the lungs and restriction of the pulmonary circulation.

28 | Lack of respiratory movement.

The incompletely recognised presence and import of hypothermia made it impossible to determine which of the many manoeuvres in the protocol was responsible for its dramatic effect. The fact that the revival of the dead body depended upon a humble, albeit important, manoeuvre enacted on an obscurely recognised cause – was to haunt both the comforting image of deathbed revival and the more disturbing image of burial alive throughout the nineteenth century. Once the Humane Society and its protocol were well established, the dramatic revivals publicised by it fed not only people's wonder at Science's power, but also their fear of Nature's duplicity. Still today, our images of life and death owe much to the efforts of the Humane Society and the unacknowledged fantasy of hypothermic near-death.

Breakdown on the Road

> Life is the sum of all the functions by which death is resisted.
>
> **— Marie Francois Bichat, 1800.**[29]

The general trend towards secularisation occurring during the early modern period, the advances in physiology and biology brought about by the empiricism and experimental method of the Enlightenment, and religion's faltering attempts to deal with these changes could not but affect the perception of death. New definitions of both life and death were coming into being. With increasing doubts as to the literal accuracy of Biblical revelation, and increasing uncertainty as to the operation of the transcendent realms of heaven and hell, it became increasingly difficult to see death as the journey of a substantial, though subtle, entity, a

29) Bichat quoted in C. Seale, *Constructing Death: The Sociology (Dying and Bereaveme(* Cambridge: Cambridg(University Press, 199(p. 77.

mysterious 'divine spark' (a soul, which somehow continued to embody life) towards some transcendent realm. This, of course, did not do away with the idea of the soul as a moral entity surviving death (that would take another hundred years) but the ties that had bound the physiological processes of life to this moral entity were loosened. The Christian soul began to revert to its archaic dual form of psyche – life-soul, and thymos – conscious-soul, but unlike the Greeks whose psyche survived death and thymos was destroyed by it, the post-Enlightenment Christian's life-soul was forfeit to the survival of his or her moral-soul.

The mechanical philosophy of the early eighteenth century began to see 'Life', less as a divine gift, and more as a set of interdependent functions determined by structure. The corollary of this was that death became defined as the breakdown of those vital relationships. Even within the Vitalist conception of 'Life', which, as part of the nineteenth-century Romantic backlash to Enlightenment empiricism, reverted to the concept of a life-force, the vital spark was less than divine. Rather than God's will and divine grace, it required the breath of man and animal heat, generated in the newly discovered processes of metabolism, to keep it lit. At least as far as the 'life-soul' (as opposed to the moral-soul) was concerned, a functional definition of death began to replace the transcendental one. If life was a set of functional interdependencies, and death the loss of function, then the possibility of human intervention to restore function was possible. Experiment in the natural sciences had proven this, and the Humane Society's protocol put it into action and confirmed it. Science did have something to offer at the deathbed. Something could be done. This was quickly reformulated into the imperative that something must be done.

What developed was 'an obvious contest... between the skilful practitioner and the overwhelmed powers of nature: [where] attention and care was necessary on his part in order to insure victory'.[30]

The imperative to save life, to do something, became embedded in the language of empire and war (a trope that medicine has retained to this day in the language it uses to confront death). The transcendental journey of the soul appeared to be replaced by a battlefield immanent within the body. But both these metaphors had always been and would always be present; it was their relation to each other that was altered. The deathbed had always been a site of struggle, in that there was assumed to be a fight between the forces of good and evil over the soul of the victim. But with increasing secularisation, as manifest in the introduction of the protocols for the resuscitation of the drowned, the struggle shifted. The adversary was no longer a transcendental force, the devil, and the reward a transcendental state, heaven. The adversary now became the process of transcendence itself – death. And the reward was now a postponement of that transcendental journey – a return to life.[31]

But not all journeys were postponed, and, failing the return of life, a means of identifying death, as a failure of function, was necessary. Function is only visible in its enactment. Loss-of-function is demonstrable only through the failure of an act. Death, as a loss of function, was demonstrable in the body's response, or rather lack thereof, to the enactment of the resuscitative protocol – no response, no function, no life.

> The process above-mentioned [the Humane Society's protocol] should be continued the full space of 3 hours, with very few intermissions, unless the vital functions should be restored sooner.

30 | Humane Society, 1774, p. 14.

31 | See Illich, *The Limit* to *Medicine,* for what has become the standar argument criticising modern medicine's militaristic approach to death and Porter's *Deat* and *Doctors* for the counter argument I. Illich, *The Limits to Medicine: Medical Nemesis: The Appropriaion of Health,* Harmondsworth: Penguin, 1976 and Roy Porter, 'Death and Doctors in Georgian England', *Death, Ritual, and Bereavement*, ed. R. Houlbrooke, London: Routledge, 1989, pp. 77-94.

If, at the end of that period, the unfavourable
symptoms instead of diminishing should increase,
attended with other evident signs of the extinction
of life, the case may be considered as utterly
hopeless and therefore the process should be
discontinued.[32]

The failure of the resuscitative protocol becomes the
successful identification of death. Formal resuscitative
protocols for the reanimation of cold drowned sailors
came into being, at the time they did and in the place
they did, not only because of the growth of a mercantile
empire dependant upon rivers and oceans, not only
because the great ritual edifices of religion were in decay,
not only because of the appalling weather of Northern
Europe, not only because of the remarkable scientific
advances of the Enlightenment, though all these were
necessary conditions, but because death was no longer
what it had been, a new definition of it had come into
being and with that a new means of identifying it.

Dark Diagnosis

The declaration of death is, still today, in many cases,
made on the basis of the classic physical signs outlined
by Fothergill in 1795: the absence of pulse, breathing,
neurological reflexes and consciousness; the presence
of dilated pupils, coldness and rigor. These are signs of
what physicians now term 'clinical death' and except in
unusual circumstances, though not absolute signs of
death, are considered 'good enough'. Good enough for
those deaths where death is to some extent expected

32 | Fothergill, p. 165.

(usually in the chronically ill or elderly) and where there are no complicating factors such as hypothermia or drug effect. These are usually the 'good deaths' as exemplified by (though not restricted to) the paradigm of the hospice patient – deaths accepted as the completion of life's journey. In these 'good' deaths, time of death is usually recorded as the moment of permanent cessation of respiration and circulation. But today fewer and fewer deaths are 'expected', even in the chronically ill and the elderly. Expectation is not merely a matter of statistical probability, but of desire. In 'sudden death', that is, deaths occurring in individuals who fall into categories of low statistical probability, and in deaths of individuals in whom, for whatever reason, death is unwelcome, more is always required. More effort in terms of saving that particular life and, should that fail, more certainty in diagnosing the ensuing 'absolute' or biological death.

The enactment of modern resuscitative protocols allows the physician not only to insure that death has in fact occurred, but precise and correct enactment of the protocol allows him to say: 'We did all we could.' 'Modern Death' is identified, guaranteed, and justified by the enactment and subsequent failure of the resuscitative protocol:

1787

The incontrovertible testimony of a series of experiments for several years, has demonstrated the possibility of ascertaining any other criteria of a perfect extinction of a vital principle in the instances of its sudden disappearance, than the ineffectual application of resuscitative means.[33]

33 | Humane Society, 1788, p. 67.

1993

Excluding patients with persistent ventricular fibrillation, resuscitative efforts can be terminated... when normothermic adults with unmonitored, out-of-hospital, primary cardiac arrest do not regain spontaneous circulation within 25 minutes following standard advanced cardiac life support.[34]

The above criteria – failure of return of spontaneous circulation after 25 minutes of advanced life support (with associated caveats) – is, more or less, the medical consensus on the identification of sudden death.[35] How does the paramedic, intern, house officer know when the patient is dead? When the patient no longer responds to the resuscitative protocol. The failure of the resuscitative protocol may be the failure of revival, but it is the successful identification of death. Death is identified by the inability of the protocol to restore function. From the eighteenth century to the twenty-first, the fantasy of revival is shadowed by the need to establish the reality of death. Though the overt purpose of resuscitative protocols is therapeutic (the revival of life), it conceals a covert intent that is diagnostic (the identification of death). Though resuscitative protocols are initiated to save life, they much more frequently, at least in the hospital, end up diagnosing death. There is some point in beating a dead horse; to insure that it is dead.

(I should make clear that my argument is analytical, not expository, and 'for the sake of argument' I have used extreme, though I believe not invalid, cases. Contrary to much that has been written elsewhere, physicians are not entirely without humanity or judgement, and not every patient is beaten to death. Every death is, to some extent, a compromise of competing needs not only from competing players, but often from the same player.)

34) Marni Bonnin, Paul Pepe, Kay Kimball, Peter Clark Jr., 'Distinct criteria for termination of resuscitation in the out-of-hospital setting', *JAMA*, 1993, 270 (12), p. 1457.

35) F. H. Ali, P. R. Verbeek, 'Survival after failed out-of-hospital resuscitation from cardiac arrest by automated external defibrillator-equipped paramedics: Abstract', *Annals of Emergency Medicine*, 2000 (35), p. S11.

Fantasies of Death

In the eighteenth century, expectations of revival from all forms of sudden death came to be based on the special case of near-death due to hypothermia, and I would maintain that those expectations remain, at least in the popular mind, in operation today. The vision of hypothermia, both in its dramatic reversal and treacherous mimicry of death, haunts us yet. The portrayals of resuscitation in TV shows, such as *ER* and *Casualty*, though they are resuscitations from heart attacks, trauma, drug overdoses, etc., remain in their overly optimistic statistics[36] and dramatic re-awakenings more rooted in the occult fantasy of the hypothermic death than the reality of the emergency room. The paradigmatic resuscitative protocol, CPR – cardiopulmonary resuscitation, which is practiced in ambulances and emergency rooms, though its therapeutic aspect was evolved to deal primarily with the cardiac death, still harbours, in its occult diagnostic purpose, the traces of eighteenth-century drowning protocols engendered by the 'apparent death' of hypothermia. When failure of CPR occurs, as it ultimately will for many of us, it is this occult aspect of the resuscitative protocol, stretching back to the birth of modernity, which will identify, guarantee and justify our deaths. Even though present day resuscitative protocols are centred on the middle aged man felled by a heart attack, the toddler struck by a speeding car, or the teenager succumbing to an overdose, it is the image of the frozen cabin boy awakening from death that still drives our fantasies of resuscitation. Every resuscitation aspires to Mr Styleman's script where a boy with 'every appearance of confirmed death' is 'happily restored to life' 'full of gratitude to his deliverer', returning 'thanks for the great mercies received', to the 'infinite satisfaction' 'of a great number.' That, at least, is our fantasy.

36 | Rates of survival in television shows are in the 65 to 75% range, compared with the 5 to 12% of real life. See S. Diem, J. Lantos, J. Tulsky: 'Cardiopulmonary resuscitation on television – miracles and misinformation', *N Engl J Med*, 1996, 334 (24, pp. 1578-1582.

Kathy Battista received her BA in Art History and English Literature from Fordham University, New York, and her MA in Art History from the Courtauld Institute of Art London. She is Interaction Co-ordinator at Artangel and Research Fellow at the London Consoritum. She is co-author of *Recent Architecture of the Netherlands* (London:Ellipsis, 1998), *Art New York* (London: Elipsis, 2000) and currently completing her doctoral dissertation on feminist artists in 1970s London.

Robert Clough graduated with first class honours in Sociolgy from the University of Leeds in 1997, where he was awarded the Zygmunt Bauman Prize for his dissertation on modern surveillance. He completed the MRes programme at the London Consortium in 2001.

Francis Gooding has an MA in Social Anthropology from SOAS, London, and graduated from the London Consortium MRes course in 1999. His doctoral research focuses on modernist approaches to history.

Pierandrea Gebbia has degrees from the Università di Palermo and the Università di Roma and is currently completing his doctoral research at the London Consortium. His research interests are cultural theory, music and performance art

Lorens Holm is an architect in the UK and Massachusetts. He teaches architecture history/theory at the Bartlett School of Architecture, the AA, and the Mackintosh, Glasgow. Before coming to London, he was Assistant Professor of Architecture at Washington University in St. Louis. He is currently writing on problems of space, perception, and representation in architecture and psycho-analytic theory.

Catherine James has worked throughout the BBC Radio Network and also as Studio Manager at the World Service. She has a First Class BSc Hons in Music from City University, London, and won the Worshipful Company of Mercer's Prize for outstanding Performance. She is a visiting lecturer at Central St. Martin's College of Art, London. The title of her thesis is 'A Cultural History of Gravity'.

Mark Morris trained at Ohio State University where he received the American Institute Medal for Excellence in the Study of Architecture. He has published articles in the US, UK, Italy and Germany. Recently awarded a Royal Institute of British Architects grant, his doctoral research focuses on scale models. Mark is Research Fellow at the London Consortium.

Toby Newton has a degree in Film & Literature from the University of Warwick. He took an MA in Social Anthropology at SOAS, London, and an MRes in Cultural Studies at the London Consortium. He is currently researching for a PhD in Psycho-analytic Studies at Brunel University. With the poet Peter Carpenter, he is co-author of *At The End of The Day* (1999).

Nina Pearlman gained a BA Cum Laude in Fine Art from the University of Haifa, Israel and an MA in Sculpture and Critical Theory from the Slade School of Fine Art, London. Her doctoral research develops a new approach to the problems of public space and public art in the built environment.

Barbara Penner has a BA in English Literature & Art History from McGill University, Canada, and an MSc from the Bartlett School of Architecture, London. She is a lecturer at the Bartlett and is co-editor of *Gender Space Architecture* (London:Routledge, 1999). 'Alone at Last: Honeymooning in America' is the title of her doctoral thesis.

John Tercier B.Sc., M.D., F.R.C.P.(C). John is a specialist in emergency medicine. His publications include research on child abuse and disaster response. He was editor of *Whiteness*, the first issue of Room 5 and is currently Research Fellow at the London Consortium. The title of his PhD research is 'The Contemporary Deathbed: The Ritual of CPR'.

Fabrizio Trifiro received his BA in Philosophy from the Università di Bologna with a dissertation on the Neo-pragmatism of Richard Rorty. His current doctoral research at The London Consortium centres upon anti-foundationalist ethics.

Bernard Vere gained a BA from the University of East Anglia in Literature and Philosophy, and an MA from Nottingham University in Critical Theory. He is researching English avant-garde art (or the lack of it) and has published review articles in *Textual Practice* and *New Formations*.

Eyal Weizman AA Dip. is a practicing architect working in Europe and Tel-Aviv, and currently teaching at the Bartlett School of Architecture, London. Besides built work his office is involved with urban research such as the one commissioned by the Israeli human rights organisation Betselem. His published books include *Random Walk* and *Yellow Rythms*. 'The Politics of Verticality – Architecture and Occupation in the West Bank and Gaza' is the subject of his doctoral research.

PHOTO CREDITS

Francis Gooding: pp. 8, 16
Bruce McLean, *King for a Day*, 1972. Photo Dirk Buwalda.
From Mel Gooding, *Bruce McLean*, London, Phaidon
Press, 1990.

Barbara Penner: pp. 24-37
Urinettes, London, circa 1898.

Plan of gentlemen's and ladies' convenience (with urinettes), circa 1898. From George Davis and Frederick Dye, *A Complete and Practical Treatise upon Plumbing and Sanitation* (1898).

Experimental Squat Water Closet Incorporating Suggested Criteria, From Alexander Kira, *The Bathroom*, (1966).

Typical Squatting Postures. From Alexander Kira.

FEMME?pissoire, Chateau Marmont, Los Angeles.

Femmep-system pant. From Sunil Bald and Yolande Daniels, *Projects,*in *Young Architects: Scale,* Princeton Architectural Press, New York, 2000.

Mark Morris: pp. 38-51
Hansel and Gretel Eating the Gingerbread House of the Witch. Theodore Hosemann (1807-1875).

The Primitive Hut. Frontispiece, second edition of Marc-Antoine Laugier's *Essai sur l'Architecture*, 1755.

All food illustrations: *Food and Drink, A Pictorial Archive from Nineteenth-Century Sources*, 3rd ed., New York: Dover Pictorial Archive Series, 1983.

Catherine James: pp. 52, 58, 60
Jean-Honoré Fragonard, *The Swing*, 1767, Wallace
Collection London.

Yinka Shonibare, *The Swing (After Fragonard)*, 2001,
courtesy of Stephen Friedman Gallery, London.

Karen Knorr, *In the Green Room*, from *Sanctuary*, at
The Wallace Collection, London, 2001.

Lorens Holm: pp. 74-95
All images by author.

Fabrizio Trifiro: p. 96
Richard Rorty photo courtesy *The Atlantic Online*.

Pierandrea Gebbia: pp. 106-125
Gospel singers – photo: Heinz Heinicke.
Blues – photo: William Claxton.
Harlem – photo: Josep Werkmeister.
Minton's – photo: William Gottlieb.
© J. E. Berendt Archive
Bop City – photo: uncredited. © Metronome Magazine.
Five A.M – Photo: Gjon Mili. © Time Inc.,1980.

Bernard Vere: pp. 126-143
© VG Bild-Kunst, Bonn.

Kathy Battista: pp. 158-175
All images from Phaidon Press, London.

Segal, Weizman & Herz: pp. 176-199
All images Segal, Weizman & Herz unless otherwise
specified.

No other Masters or PhD programme in the world offers to its students the resources of a major international art gallery and museum, one of the world's most famous arts centres, a renowned university, and the cutting-edge Architectural Association. These resources are matched by the intellectual ambitions of the London Consortium which provides a rigorous, challenging and exhilarating programme of study leading to either a Masters or PhD degree in the Humanities and Cultural Studies. The Master of Research degree entails course-work and a dissertation; the PhD degree course-work and a thesis. Both programmes lead to a degree of the University of London. As befits the four participating institutions, the courses provide a mixture of the most rigorous academic argument with the opportunity to test those studies against the work of organisations that make cultural policy decisions on a daily basis. The Consortium has an internationally distinguished regular and visiting faculty. Students are taught by an extraordinary range of leading scholars and practitioners, ranging from architectural theorists and designers through specialists in art history and curatorial work, to cinema critics and film-makers, historians, literary scholars, artists, political theorists and philosophers. All students automatically have privileged access to the event programmes and resources of the four participating institutions, including Tate Gallery exhibitions; ICA Cinema screenings, Talks, Exhibitions, Live Arts and New Media Programme; Architectural Association exhibitions and debates and a host of seminars, exhibitions, conferences and other events.

The London Consortium
Institute of Contemporary Arts
12 Carlton House Terrace
London SW1Y 5AH

Telephone: +44 (0)20 7839 8669
Facsimile: +44 (0)20 7930 9896
Email: loncon@ica.org.uk
Website: www.londonconsortium.com